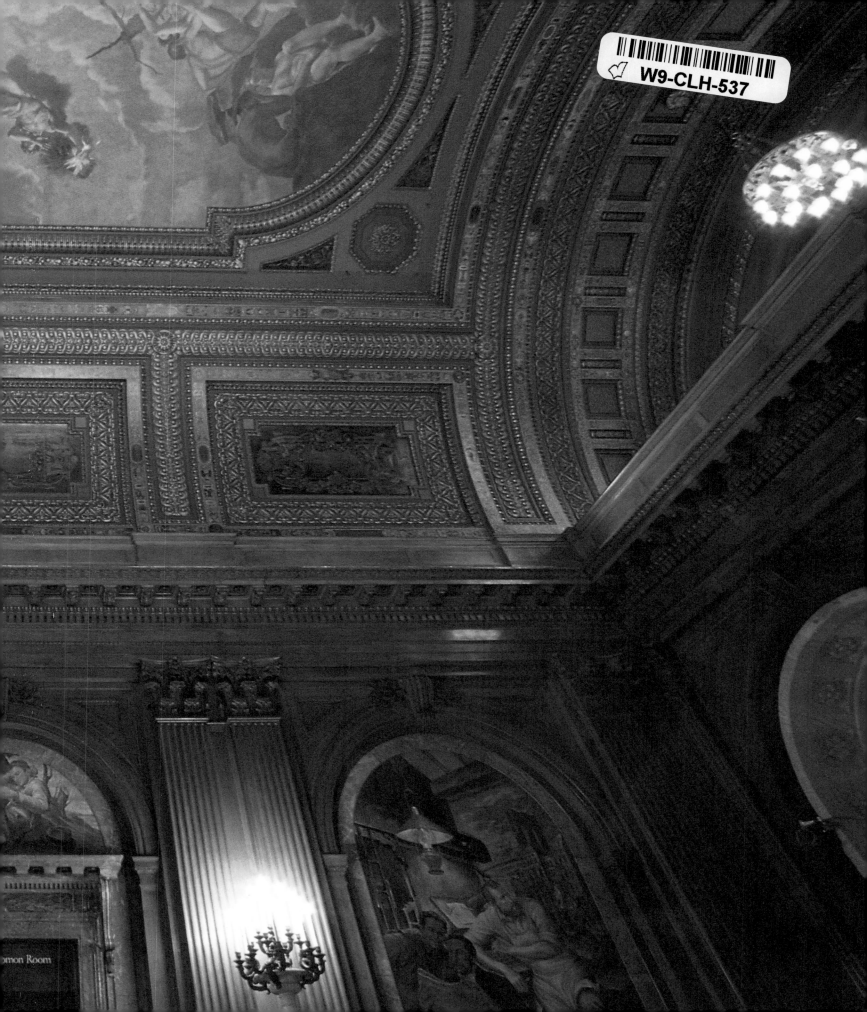

omon Room

INSIDE NEW YORK

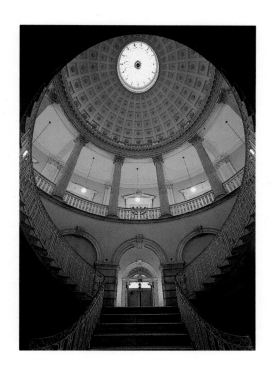

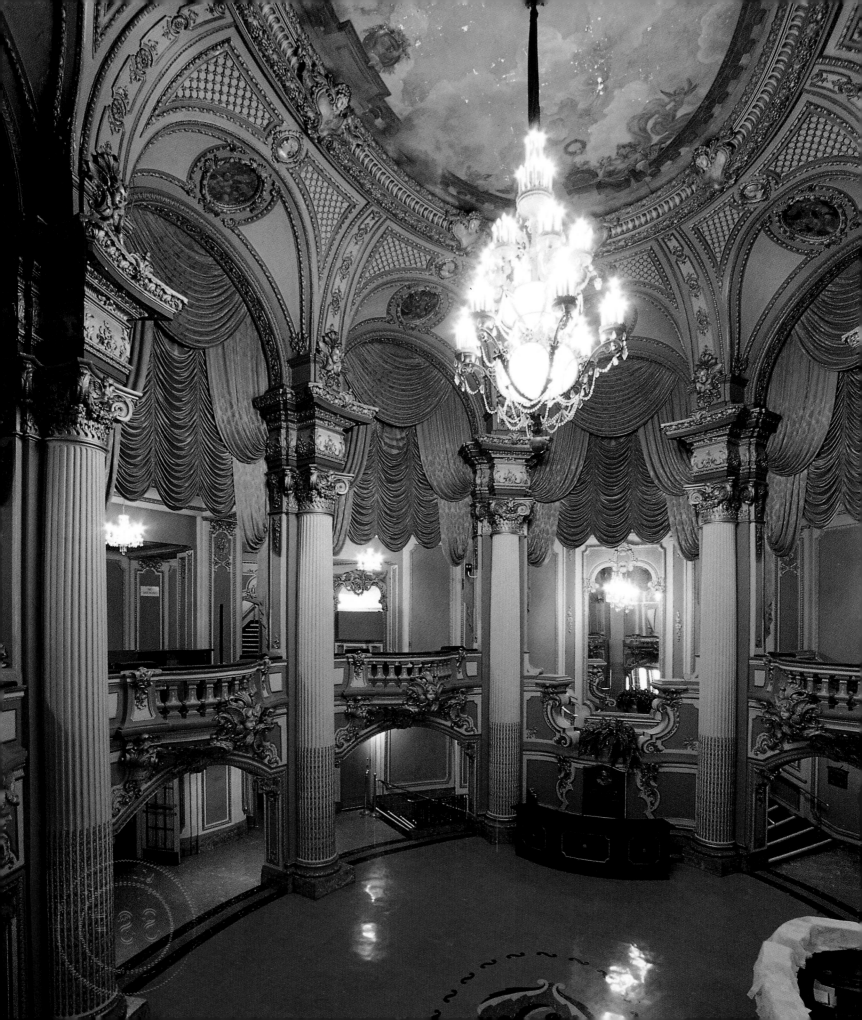

Discovering New York's Classic Interiors

INSIDE NEW YORK

JOE FRIEDMAN

Photography by
RICHARD BERENHOLTZ

For David

Phaidon Press Limited
140 Kensington Church Street
London W8 4BN

First published 1992
© Phaidon Press Limited 1992
Photography © Richard Berenholtz, 1992

A CIP catalogue record of this book is available
from the British Library

ISBN 0 7148 2630 8

Designed by Julie Fitzpatrick

Printed in Singapore

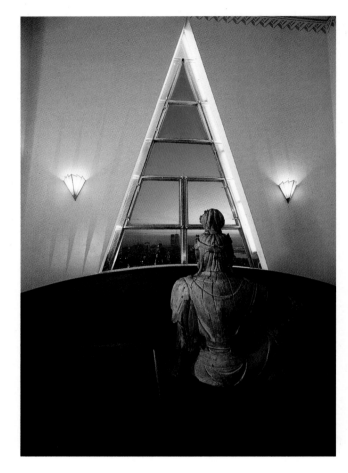

CHRYSLER BUILDING
Midtown, Manhattan
A stylish suite of offices with its own private
elevator occupies the top floor of the Chrysler
Building, commanding a spectacular view of
Manhattan *(left)*.

endpapers
MCGRAW ROTUNDA
New York Public Library
(for description see page 31)

front cover
RCA BUILDING
Now the GE Building
Rockefeller Center, Manhattan
Rockefeller Center is an outstanding example of
twentieth-century urbanism, the most ambitious
and arguably the most successful development of
its kind in New York. The architecture marks a
transition from the figuration and symbolism of
Art Deco to the greater abstraction of the
International Style, and is remarkable also for its
synthesis of art and architecture. The lobby of the
old RCA Building has murals and ceiling
paintings by the Catalan artist José-María Sert.
The theme is 'Man's Conquests', illustrated here
by a Herculean construction worker staggering
under the weight of a giant rafter. Sert's paintings
replaced an earlier set by the Mexican artist, Diego
Rivera who, despite repeated warnings from the
Rockefeller organisation, defiantly painted a
Marxist critique of Capitalism, including a
likeness of Lenin, only to find himself
frogmarched from the building and his mural
covered over and ultimately destroyed.

page 1
CITY HALL
Civic Center, Manhattan
(for description see page 20)

frontispiece
MARK HELLINGER THEATER
Times Square Church
Theater District, Manhattan
First it was a movie palace, then a theatre; now it is
an evangelical church, although the lobby suggests
rather some fairytale palace in maddest Bavaria, or
even, as the architect allegedly intended, a
Baroque cathedral. The building dates from 1929
and was designed by the leading theatre and
cinema architect, Thomas Lamb, for Warner
Brothers. Originally known as The Hollywood, it
was among the first movie theatres in New York
to make the transition, architecturally, from silent
pictures to talkies, and is the last surviving
building of its kind in the district.

6 INTRODUCTION

15 GOVERNMENT AND
CIVIC BUILDINGS

25 BANKS

31 MUSEUMS AND LIBRARIES

37 SHOPS

41 SUBWAYS

45 CORPORATE BUILDINGS

61 SCHOOLS AND COLLEGES

71 THEATERS

77 PLACES OF WORSHIP

83 BARS AND RESTAURANTS

93 HOTELS

101 CLUBS AND INSTITUTIONS

113 DOMESTIC INTERIORS

122 ACKNOWLEDGMENTS

122 BIBLIOGRAPHY

123 GAZETTEER

128 INDEX

INTRODUCTION

I did not so much arrive in New York; I collided with it. They have recently restored the old immigration hall on Ellis Island as a museum of the immigrant experience. But if you want the real immigrant experience take your place as a simple tourist in the two to three hour queue in the immigration hall at Kennedy Airport. Mentally I developed a four-day stubble and a thick foreign accent, while my luggage turned to cardboard and string in my hands. I was almost grateful when I passed through immigration and they did not take away my old name and give me a new one. It did not help matters when the immigration officer looked up from the form on which I had written my New York address—a sub-let apartment in Alphabet City—and commented 'I hope you brought your gun'. As it happens, there was a shoot-out the following week on the next block but one; and when I reached the apartment, rang a friend, and told him where I was staying, he first congratulated me on making it there alive and then explained that it was one of those 'cover me, I'm going down for a newspaper' neighborhoods. I developed eyes in the back of my head and sonic vision at night. I also mastered the art of dressing on the bus, boarding the vehicle in a T-shirt and jumper and changing into a respectable coat and tie the moment I was safely past Union Square. And yet to be in New York, within easy reach of the city's buildings and monuments, was worth any amount of queuing, personal danger, and public embarrassment, and the moment I glimpsed the skyline of Manhattan, high above the rooftops of suburban Queens, I was enslaved.

New York, by which I mean Manhattan, the original New York, to which the outer boroughs form a recent and sometimes reluctant appendage, is the most architectural of cities. The city has no real topography; architecture has taken its place. City planners have ignored the thoroughfares carved out by nature and imposed a strict geometric grid designed to facilitate architectural development. North of Houston Street New York is assembled from rectilinear blocks and on maps looks more like a floor-plan, or a wall of bricks, than any earthly city. The original Native American settlers called this place *Mana-Hatta*, or Island of Hills, but those hills have largely been levelled, to be replaced by an architectural landscape that is positively mountainous, a kind of second Grand Canyon in brick, stone, glass and steel, caricaturing the original lie of the land.

In this environment nature itself turns to architecture. What is Central Park if not a sequence of scenic effects craftily contrived by a landscape architect? Rectilinear in plan, it lies like some overgrown city block, dotted with pavilions, hemmed in by powerful masonry walls, and overshadowed by towering skyscrapers gazing down greedily on so much unexploited real estate. Even the river seems to exist only for pleasure-boats to take day-trippers on a tour of

the island for a better view of the buildings, or to enhance the appeal of shore-side developments.

I know of no other city where the culture of the place is so clearly expressed in its architecture; nor a city where the architecture contributes so much to the culture. If you want to know why New Yorkers walk faster, work harder, aim higher, look to the architecture. At times it is hard to believe that people produced the buildings and not the reverse.

New York was founded as a trading port and it remains the trading capital of the United States. While Washington is planned around a complex of buildings housing the apparatus of state, New York is dominated by commercial buildings, by banks, corporate headquarters and office blocks, which are not only among the tallest and most conspicuously sited buildings in the city, but also some of the best in terms of their design. They tower above New York just as surely as Notre Dame, Westminster Abbey and other great cathedrals towered above the cities of medieval Europe. The message has been reversed of course. These are temples to Mammon; they proclaim the triumph of commercial values over religious faith and the rise of big business at the expense of the church. But the architectural means are broadly the same, and in the case of the famous Woolworth Building, a skyscraper in the Gothic style that was for many years the tallest building in the world, the parallels could not be more explicit. The builder himself, Frank Winfield Woolworth, head of the world-famous chain of variety stores, described his creation as a 'Cathedral of Commerce'.

In many ways New York is a city built in the image of the American dream. The metaphors are everywhere. The avenues run straight and unobstructed to the horizon, suggesting infinite possibilities. Soaring towers reach for the sky, the embodiment of thrusting ambition, stretching themselves to the limits. The grid plan evokes ideas of democracy and equal justice, of pragmatism and rationality. Ultra-modern buildings stand as monuments to renewal and progress.

But at a deeper level there are tensions and unresolved dualities. The grid was an attempt by planners to impose a uniform pattern of development and to bring the city under the rule of logic and reason, but few of the buildings give in. Most are monsters of egotism and follow their own idiosyncratic directives. While some occupy only the narrowest plot, others fill a whole city block. Some may rise to only two or three storeys, while others look down on anything lower than seventy. Alongside a building in brick you will find another in limestone, or sandstone, or steel, or glass.

If the architecture of New York has any common denominator, if there is any one tradition to which a majority of the buildings can be said to conform,

it is fantasy and theater. It is almost as if the values of show business and popular American culture had somehow fed into the high art of architectural design. The city is full of gags and wisecracks, one-man shows and lineups, variety acts of every description, buildings that will go to any length, and generally do, for a share of the limelight, a laugh, a round of applause. Look at almost any skyscraper, even those devoted to the serious business of trade and commerce, and you will see that while the middle section is some times rather plain, even monotonous, the roof usually produces an explosive *coup de théâtre.* It might be the chevron helmet on the Chrysler Building, or the gabled extravaganza over the apartment buildings of Tudor City, or the Chippendale pediment atop the AT&T Building. It sometimes seems as if a party was in progress, some endless fancy-dress ball with all the buildings lined up like revellers in glad rags and party hats. Irrational outbursts and sudden fits of temper and wit give even the tallest building a surprisingly human and even vulnerable quality, and one moves around them as one might around a group of friends. Perhaps this explains why people feel so strongly about these buildings and can identify so closely with them. In a city like New York it is almost impossible not to form a warm personal attachment to the architectural environment.

It is true that commercial buildings dominate the skyline, and that more than any other city New York seems to symbolise the triumph of material and secular values; but it is worth remembering also that New York has the largest Anglican cathedral in the world, St John the Divine, and countless churches of other denominations, as well as synagogues, mosques, Buddhist temples and other places of worship, all of which reflect the religious and ethnic diversity of the city's population and testify to the persistence of religious faith, honed and reinforced by daily encounters with the harsh social conditions that underlie the city's apparent prosperity.

New York is in some ways the archetypal modern city. In any snapshot it is the buildings of the twentieth century that dominate the picture. Few cities have tried harder or more successfully to project themselves into the future through the medium of their buildings. In the twentieth century New York became a kind of architectural laboratory. If an idea was tested anywhere, it was tested here. As a result the city is full of buildings that broke new ground. There are some of the earliest steel-frame skyscrapers and probably the greatest concentration of high-style Art Deco buildings in the world. From the postwar period there are masterpieces of the International style as well as Post-Modern buildings which have brought the skyline right up to date. At the same time, however, New York has remained to the most surprising extent a city of the nineteenth century. The grid was conceived as early as 1811; Central Park was laid out from the 1850s; and many of the city's buildings, per-

haps the majority, date back to the latter part of the nineteenth century or the first few years of the present century. Indeed there are whole areas, especially in the outer boroughs, that are more or less unchanged in almost one hundred years. In the period between the end of the Civil War and America's entry into the First World War, New York's architecture reached a peak of sophistication and confidence. The buildings of this period are among the best in the city and as good as anything produced in Europe. The Upper East Side, with its limestone mansions built for the Vanderbilts, the Astors and other leading New York families, is easily the equal of the Faubourg Saint Germain in Paris and the eighteenth-century residences erected for the French nobility. The brownstone row-houses of Brooklyn are easily a match for the Georgian terraces of London, and the private clubs around Fifth Avenue are generally bigger, and arguably better, than their equivalents in Pall Mall and St James's. There are the grandest public theaters and concert halls from this period, and pioneering apartment buildings that revolutionized urban living. The cast-iron factories and warehouses of Soho and Chelsea are among the finest examples of industrial architecture anywhere in the world, and it would be hard to find public buildings of equal splendor and vision to the New York Public Library or Grand Central Station. It is astonishing to find that late twentieth-century New York is still run from City Hall, a diminutive, almost toy-like structure dating from the Federal period, and there are other fine examples of early nineteenth-century architecture, including the Greek Revival houses of Gramercy Park and Washington Square, the Federal Hall National Memorial, and a scattering of brick and timber-clad churches.

There are even buildings dating back to Colonial days. In the heart of Manhattan's Financial District, overshadowed by towering office blocks, is the magical chapel of St Paul's, a perfect mid-Georgian Classical church, little changed since its construction in the 1760s. As you head out from Manhattan the examples multiply. A personal favorite is the Friends Meeting House in Queens, a modest late seventeenth-century Quakers' prayer hall set back only a few feet from a ten-lane freeway, which has been in continuous use for almost three hundred years. Whatever may be lacking in the way of genuine historic buildings is amply made up by the most glorious replicas and fakes. New York is historicism run riot. The city was founded in the seventeenth century, and large-scale development did not get properly underway until the nineteenth century, but there are examples of every architectural style dating back to antiquity. New York probably has more Renaissance *palazzi* than Rome and Florence combined, more Louis XV and Louis XVI *hôtels particuliers* than Paris, and many more Gothic skyscrapers and Elizabethan apartment buildings than London. The point that these buildings were erected so long

after the originals does not make them inferior. In fact the builders would probably have argued that they were better, since they were designed with the benefit of hindsight and could be modelled on all the best historical examples, with the added advantage of modern conveniences such as electricity, running water and central heating.

In addition, there are all the many examples of genuine historic buildings, or fragments of buildings, shipped from other parts of the world and reconstructed. The Cloisters is probably the most famous example, an amalgam of architectural fragments from medieval buildings all over Europe. Less well known is the library of the House of the Redeemer believed to have been salvaged from the sixteenth-century palace of the Dukes of Urbino in Italy. On one level the emulation and reconstruction of historic buildings and interiors can be seen as the ultimate expression of rampant American consumerism, as if history were some giant supermarket stacked with architectural delicacies to which shoppers in the form of patrons and architects were free to help themselves. But on another level it shows that however committed New York may be to ideas of progress and renewal, its people retain a deep romantic longing for the past. Europeans may laugh but in the end New York laughs loudest for it has the best of both worlds.

Given its extraordinary diversity, and the tensions of an architectural environment in which buildings seem to pull away from the plan and even from each other, it is a wonder the city holds together at all; still more astonishing that it works so well as an urbanistic whole. But we are probably wrong to suppose that uniformity and standardisation are necessarily the key to successful city planning.

As New York shows, the issue is not really one of size, or style, or materials; of five storeys versus fifty, Classicism versus Modernism, or brick and stone versus glass and steel. In the end it is a matter of design, of creating dynamic relationships between buildings. It is the coexistence of the old and new, the juxtaposition of different styles and periods, the sudden shifts in scale and building materials that give New York its special power and excitement. Now, more than ever, New York has something to teach us.

Inside New York sets out to explore a different side to the city, one that will probably be unfamiliar even to most New Yorkers. Although many books have been published on the buildings of New York, the interiors of these buildings have never before been the subject of any special study and are generally little known. And yet, as I hope this book will show, the interiors of New York account for some of the most important and exciting examples of architectural design in the city. While *Inside New York* is in no way intended to be comprehensive, I have aimed to present as wide a selection as possible in order to

reveal the tremendous wealth and diversity of the architecture which lies hidden and often forgotten behind the facades of sometimes familiar buildings.

In the first place I have tried to include as many different types of interiors as possible. Most of the books and magazines published on the subject of interiors focus almost exclusively on domestic interiors: on bedrooms, drawing rooms, bathrooms, kitchens. But today, as always, domestic interiors can only be understood against the wider background of other types of interior, and in *Inside New York* I have given as much space and more to the interiors of theaters, banks, schools, shops and other locations.

I have also tried to present a wide range of different periods and styles. I particularly wanted to illustrate the point, made earlier in this introduction, that if New York is a city of the twentieth century, it likewise has a foot in the past. Wherever possible I have tried to include interiors from the nineteenth, eighteenth and even seventeenth centuries. Many of the people I spoke to along the way were dubious about my chances of finding any such examples. For them, as for others, I hope this book will be an eye-opener. If it changes their perceptions even half as much as it changed my own, I will be happy.

Having met a good many New Yorkers who had rarely ventured outside the confines of Manhattan, I was determined that *Inside New York* should also cover the outer boroughs. In addition I have tried to explore areas of Manhattan that tend to be overlooked. Most of the interiors featured are located in parts of Manhattan that will be familiar to anyone who knows the city but I hope that there are enough from the more neglected areas to show that these too have their riches and deserve far greater attention.

Some of the interiors in *Inside New York* are entirely private and cannot be visited by the public. On the whole, however, I have given priority to interiors that are open to all, and I include a gazetteer with addresses, telephone numbers and other details. I hope that readers will be encouraged to visit these locations and perhaps strike out for themselves.

This is the age of the museum and the art market and we tend to think of art as something remote from everyday life, available only to the very rich. When museums start charging for admission, as is increasingly the case, and holding exclusive receptions for wealthy benefactors, a deadening circuit is completed which obscures a basic truth. I hope that *Inside New York* will be a reminder that art in fact is all around us and that the greatest museums of all are our cities, for which, as yet, there is no admission charge. Cities are not only museums of architectural history, but of sculpture, painting and the decorative arts. If you are interested in painting you should certainly visit the Metropolitan Museum and the Whitney, but be sure to see the murals at Rockefeller Center or the Woolworth Building *(page 58)*. If you are interested in sculpture do

not miss the reliefs in the lobby of the Chanin Building *(page 55)* or the elevator doors in the lobby of the Swiss Center *(page 48)*. If you want to see outstanding mosaics and ceramics, travel on the Subway *(page 40)* or put your head through the door of the Osborne *(page 120)* or the Irving Trust Building *(page 27)*.

On another level, *Inside New York* is intended as a reminder of an important distinction that seems to have been lost from sight: the distinction, that is, between interior decoration and interior design. By interior decoration I mean the dressing up of existing spaces, the coordinating of paintwork and fabrics, the choice and arrangement of furniture and bibelots, the hanging of a new set of curtains, and so on. This can produce comfortable rooms, attractive rooms, but it will never achieve anything of lasting artistic value or substance and rarely rises above the level of the banal and the meretricious. Interior design on the other hand is a branch of architecture. It extends to architectural considerations such as volume, planning, perspective; to the design of fixtures and even furniture and fabrics, producing at its best fully integrated interiors governed by a single, cohesive aesthetic in which complementary elements fulfil the same unifying purpose. Interiors such as these are works of art no less important than paintings and sculptures. To put it crudely, interior decoration is what you might do yourself at home on the weekend. Interior design is the staircase of Michelangelo's Biblioteca Laurenziana in Florence, the nave of St Paul's Cathedral in London by Wren, Mansart's Galerie des Glaces at Versailles, or, in the case of New York, the rotunda at City Hall *(page 19)*, the reading room of the Gould Memorial Library *(page 62)* or the lobby of the Paramount *(page 99)*.

And yet interior decoration and interior design are often confused, largely because in books and magazines they are generally represented as one and the same thing. The focus of *Inside New York* is interior design, as opposed to interior decoration, and I hope the book makes clear the distinction.

Inside New York also fulfills, I hope, a greater purpose. In 1963 the original Pennsylvania Station was demolished to make way for the Madison Square Garden Center. Designed by the leading American architectural practice, McKim Mead & White, the station was completed in 1910 and was rightly considered to be among the finest buildings of its kind in the world and a major city landmark. In spite of a furious public outcry, the demolition of the building went ahead since at the time there was no official body in New York with statutory powers to prevent it. Two years later a commission was finally established to list and protect historic buildings and other landmarks in the New York City area. Known as the New York City Landmarks Preservation Commission, it set to work with energy and determination and within a short

time was able to secure the protection of dozens and even hundreds of landmarks. However, its jurisdiction was initially confined to the fabric and exterior of buildings. It was not until 1974 that the Commission's powers were extended to the protection of interiors, and to date fewer than one hundred examples have been designated. On the whole, interiors are considered to be less important than the exterior features of a city's architecture. The argument runs that the outward appearance of a building is of greater public concern than the appearance of the interior, which does not have the same measure of public exposure. It is hard to counter this argument. The destruction of the lobby of the Chanin Building would never have the same impact on the city as the destruction of the Chanin Building itself. There is not the same interaction with the urban environment. But to me, and I hope to others, the lobby of the Chanin Building is an important landmark, a vital part of the architectural fabric of New York; and if it were ever destroyed both the building and the city would be the poorer, just as surely as if a fire destroyed the contents of a gallery at the Whitney or the Museum of Modern Art.

It is a fundamental tenet of every architectural aesthetic, Modernist as well as Classical, that the exterior of a building should express the interior; that the two should relate so closely as to be almost indivisible. Whenever I see a fine historic building which once had an interior of equal merit but has lost it, I cannot escape the feeling that the building has also lost its integrity and much of its original meaning. Although it is sometimes possible for an architect of vision to revitalise a building by inserting a modern interior consistent with its structure and purpose, on the whole we need to take a broader view and to realise that interiors are important not only in themselves but also as part of an equation that involves both the interior and the exterior of a building.

It saddens me to think that of the interiors featured in *Inside New York* fewer than half have been designated; the rest could disappear tomorrow. My greatest hope for this book is that by raising awareness it will stimulate the kind of discussion that might eventually lead to a review of policy with regard to the protection of interiors. For some it is already too late. I might have written another book on the many outstanding interiors New York has lost, even in the last twenty years or so. But by drawing attention to surviving examples, I hope to show the benefits of conservation and to ensure that these and others like them will still be here for future generations to admire, in reality as well as in photographs.

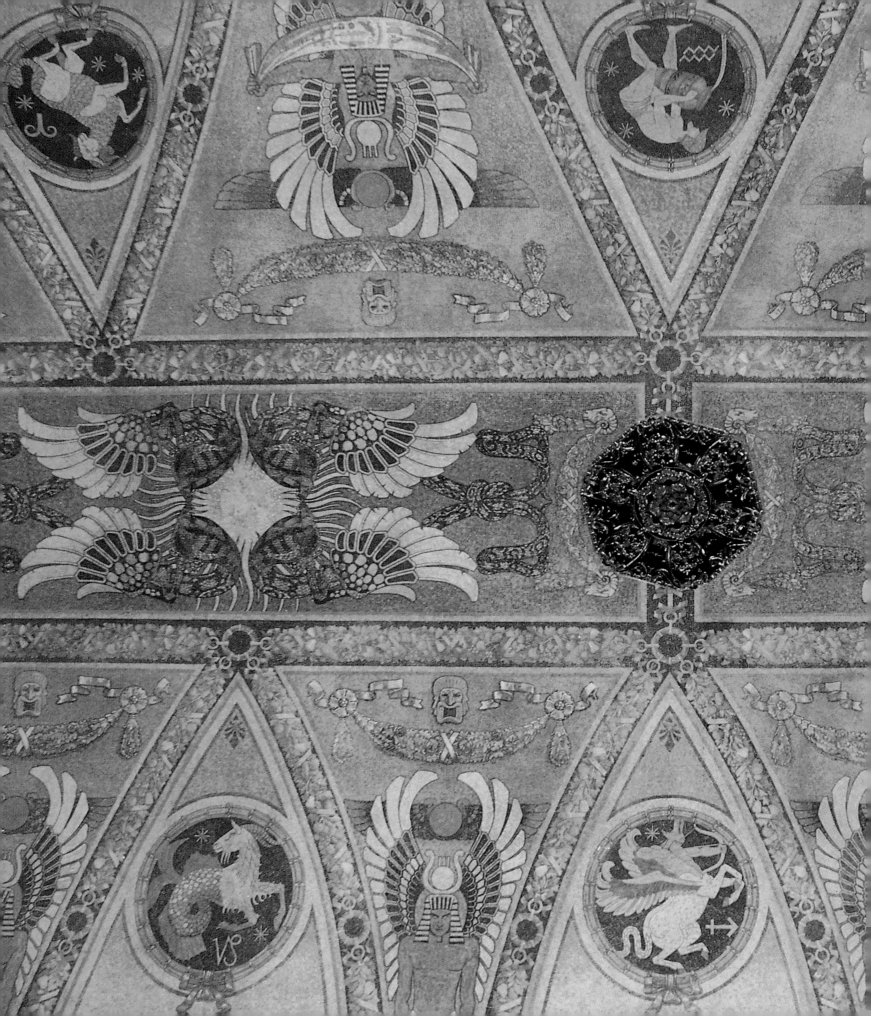

GOVERNMENT AND CIVIC BUILDINGS

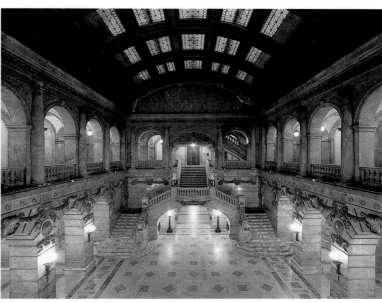

SURROGATE'S COURT
Civic Center, Manhattan

Begun in 1899 to the designs of architect John R Thomas, the lobby of the Surrogate Court, formerly the Hall of Records, is a theatrical Beaux-Arts interior in the tradition of Garnier's Paris Opéra, a cavernous marble chamber defined by superimposed arcades and a glazed and vaulted ceiling. The decoration of the entrance is equally opulent, with vibrant mosaics by William de Leftwich Dodge representing the signs of the Zodiac, interspersed with Egyptian symbols. The building took over ten years to complete, at a cost which far exceeded the original budget, but the result is one of the most beautiful and dramatic public spaces in New York.

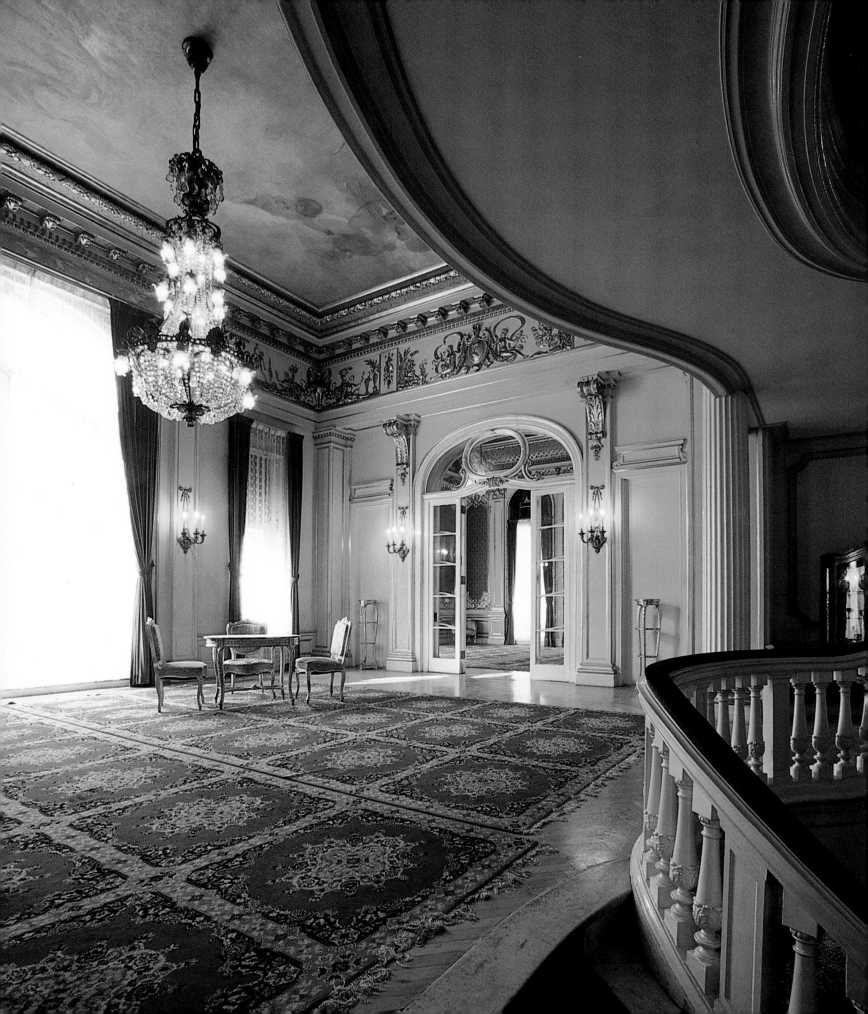

CONSULATE GENERAL OF THE POLISH PEOPLE'S REPUBLIC

Formerly the Jospeh R DeLamar Mansion
Murray Hill, Manhattan

The old DeLamar Mansion on Madison Avenue, occupied today by the Polish Consulate, is an extravagant *tous-les-Louis* palace, built around the turn of the century for Joseph Raphael DeLamar, a Dutch expatriate who through shipping, salvage and ultimately gold-mining amassed a fortune of well over $30 million. The house was designed by C P H Gilbert, architect, with Alfred J Stenhouse, of the Otto Kahn Mansion *(page 61)* and other famous New York landmarks, and cost almost one million dollars to build. How much more was spent on furniture and pictures, specially imported from Europe, one can only guess. A sinuous staircase leads from the entrance hall to the first-floor landing, which communicates in turn with a Pompeian gallery and a Louis XV ballroom. According to the daughter of the original owner, the ballroom was never used. Shortly before the house was completed DeLamar divorced and became a virtual recluse, shuffling about his gilded palace in a pair of bedroom slippers.

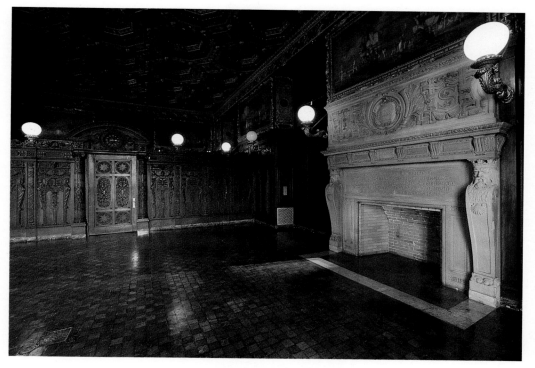

US BANKRUPTCY COURT

Formerly US Custom House
Financial District, Manhattan

This is a colossus of a building, public architecture of heroic proportions, a masterpiece of Beaux-Arts design conceived by Cass Gilbert, architect of the famous Woolworth Building *(page 58)*. Completed in 1907, it originally served as the headquarters of the Custom Service, and was intended as a symbol of New York's primacy as the country's leading port for commercial shipping. The principal rooms now stand empty and disused; there are clear signs of decay, but the original decoration is largely intact and the scale and quality are breathtaking. The Rotunda *(overleaf)* rises to a Guastavino skylight, ringed by allegorical and historical paintings by Reginald Marsh. The Conference Room *(above)* is smaller in scale but equally impressive, its seventeenth-century style decoration consciously recalling the period of the foundation of New York and its connections with shipping and the sea, with marine paintings and a chimney-piece flanked by figures of Neptune.

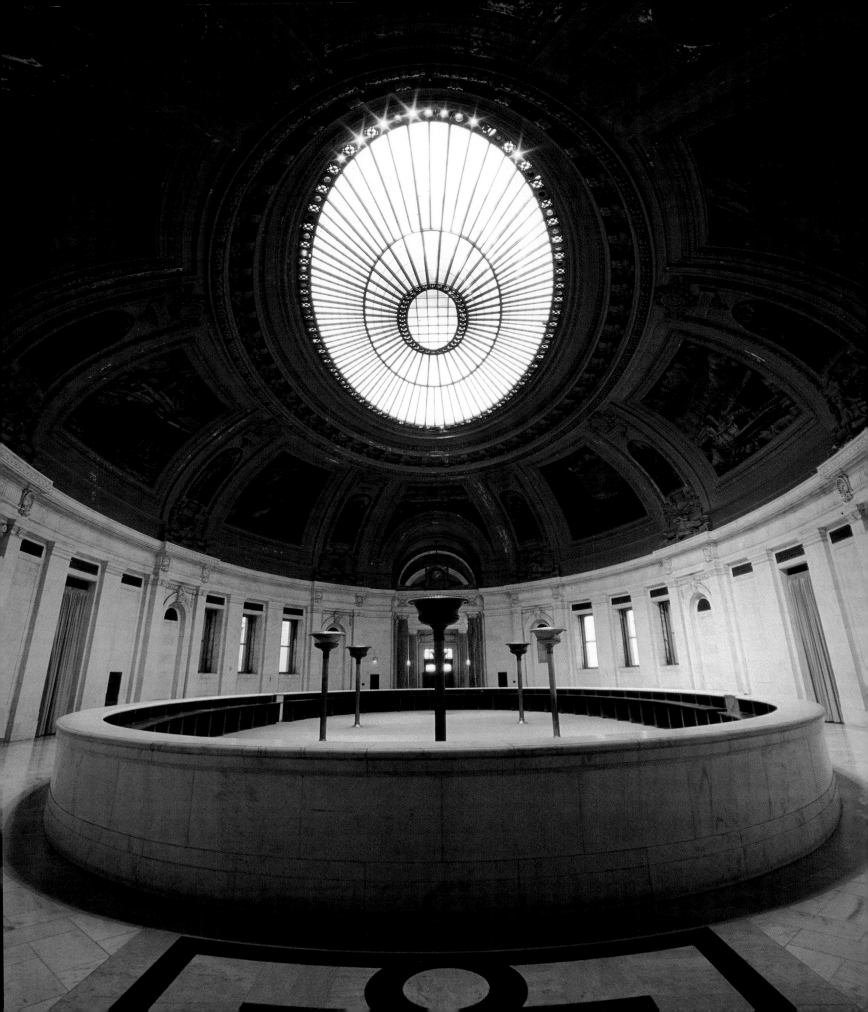

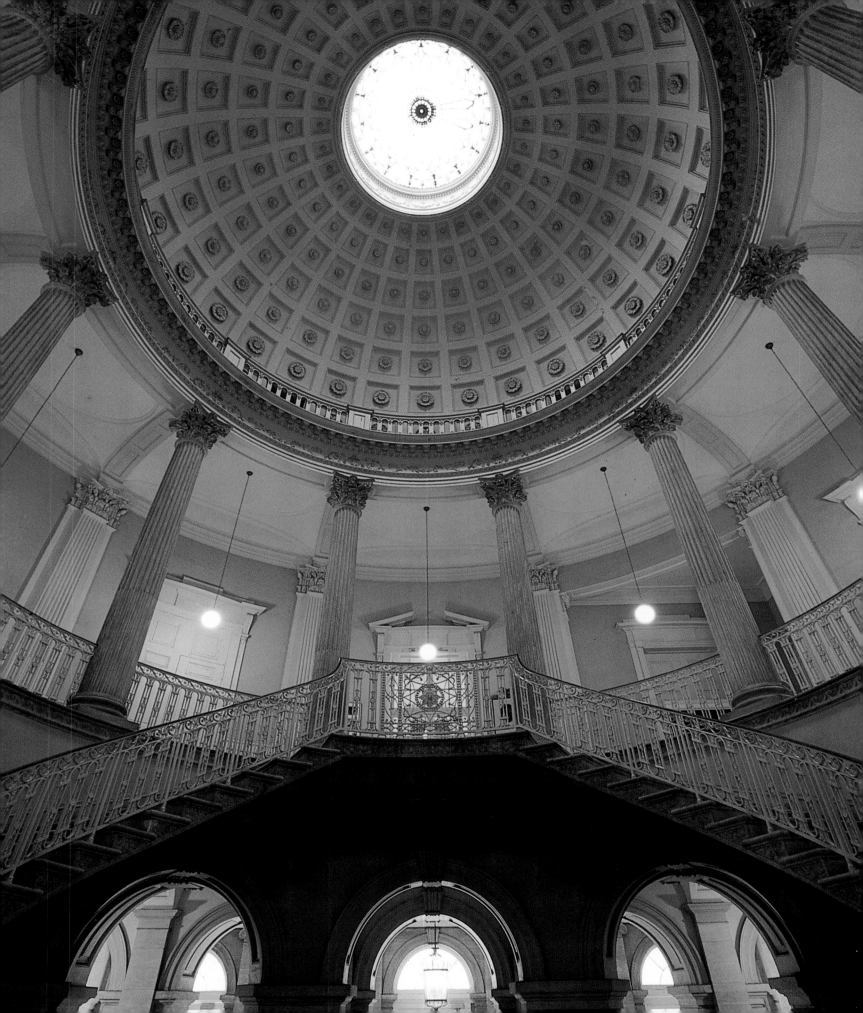

CITY HALL

previous page

Civic Center, Manhattan

The Rotunda of City Hall is surely the sanest spot in all New York. How ironic, though, that the tallest, busiest and most up-to-date of cities should be run from this dainty, early nineteenth-century doll's house. City Hall was built by the partnership of John McComb Jr, reputedly the first American-born architect, and a Frenchman, Joseph Mangin; and there is a corresponding duality in the architecture – the exterior French, the interior Anglo-American. The Rotunda looks back to the work of Robert Adam and other Neo-Classical architects of the eighteenth century. With its sweeping cantilevered staircase ringed by Corinthian columns, it is both a masterpiece of architectural design and a feat of engineering, a trial of strength carried off without the least sign of stress.

SEVENTH REGIMENT ARMORY

Upper East Side, Manhattan

It is a mystery how the Seventh Regiment, the epitome of patrician New York, ever came to commission so outlandish an interior as the Veterans' Room *(right).* The interior was designed by Louis Comfort Tiffany and is perhaps the most complete surviving example of his work in the city. The decoration was carried out under Tiffany's supervision by a team of artists and craftsmen known collectively as the 'Associated Artists'. A notable feature is the painted frieze, which represents the history of warfare from the Stone Age to the Civil War. The chimney-piece is decorated with turquoise mosaics and a relief showing an American eagle crushing evil and injustice in the form of a serpent. The colonettes on either side have capitals composed of patterned rollers of a type used in the nineteenth century in the printing of wallpaper. Another remarkable feature, unique perhaps, is the aluminium stencilling on the ceiling, which reflects the influence of Japan.

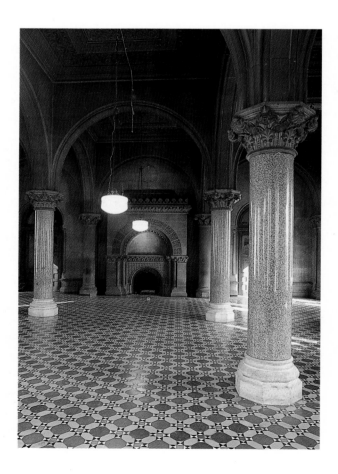

TWEED COURTHOUSE

Civic Center, Manhattan

Classical on the outside, Romanesque on the inside, the Tweed Courthouse is a stylistic compromise typical of the nineteenth century. The story of its construction is a tale of greed, corruption and the misappropriation of public funds; of long delays and gross overspending. The project was managed by William M ('Boss') Tweed, a member of the Courthouse Commission, whose name has become a byword for political and financial skulduggery. Construction began in 1861, and through kickbacks and other illegal dealings Tweed was able to cream almost $9 million from the budget before the whole sorry saga was exposed in 1871, leading to his immediate downfall. The original architect, John Kellum, died the same year, and his designs were substantially revised by his successor, Leopold Eidlitz, who completed the building in 1881 and was responsible for the Romanesque Revival interior.

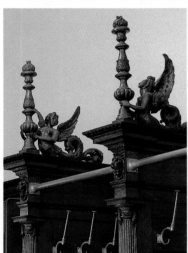

APPELLATE COURTHOUSE
Gramercy, Manhattan

Decoration accounted for one third of the cost of construction of the Appellate Courthouse; and it shows. It is hard to see where the architecture ends and the sculpture and painting begin. By bringing together some of the most outstanding artists and craftsmen of the period, the architect James Brown Lord was able to realise a fusion of the fine and decorative arts which seems to evoke the palace of some Renaissance prince rather than a functioning court of law. Capped by a resplendent stained glass dome, the courtroom *(above and right)* retains its original suite of carved mahogany furniture, thrown into relief by the marble-panelled walls, gilded Corinthian capitals, and allegorical murals on the theme of law and justice. The robing room *(left)* is another remarkable interior, unique in that the cubicles retain their original elongated brass hooks for top hats.

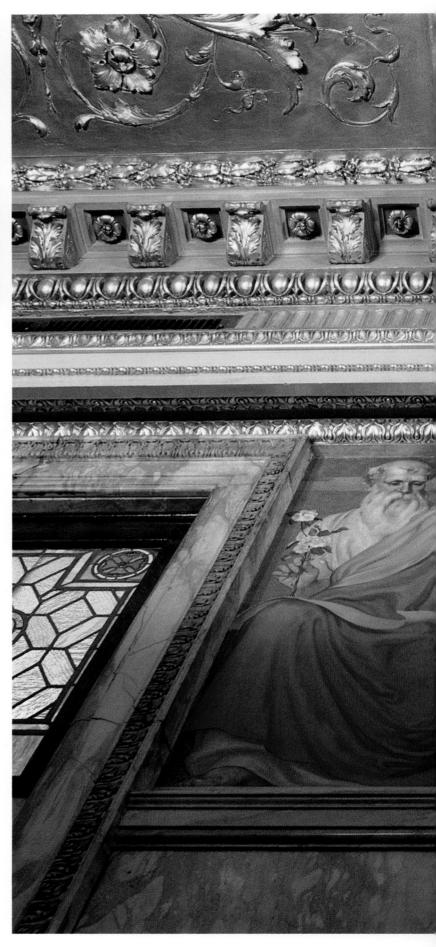

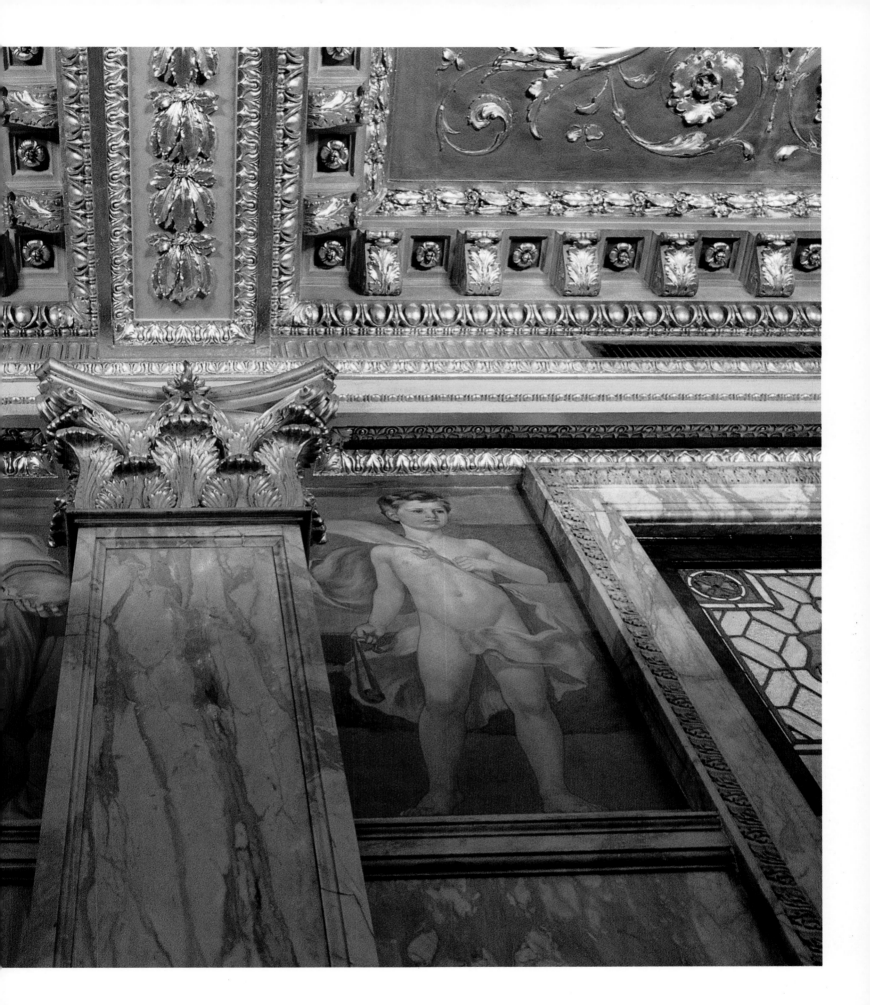

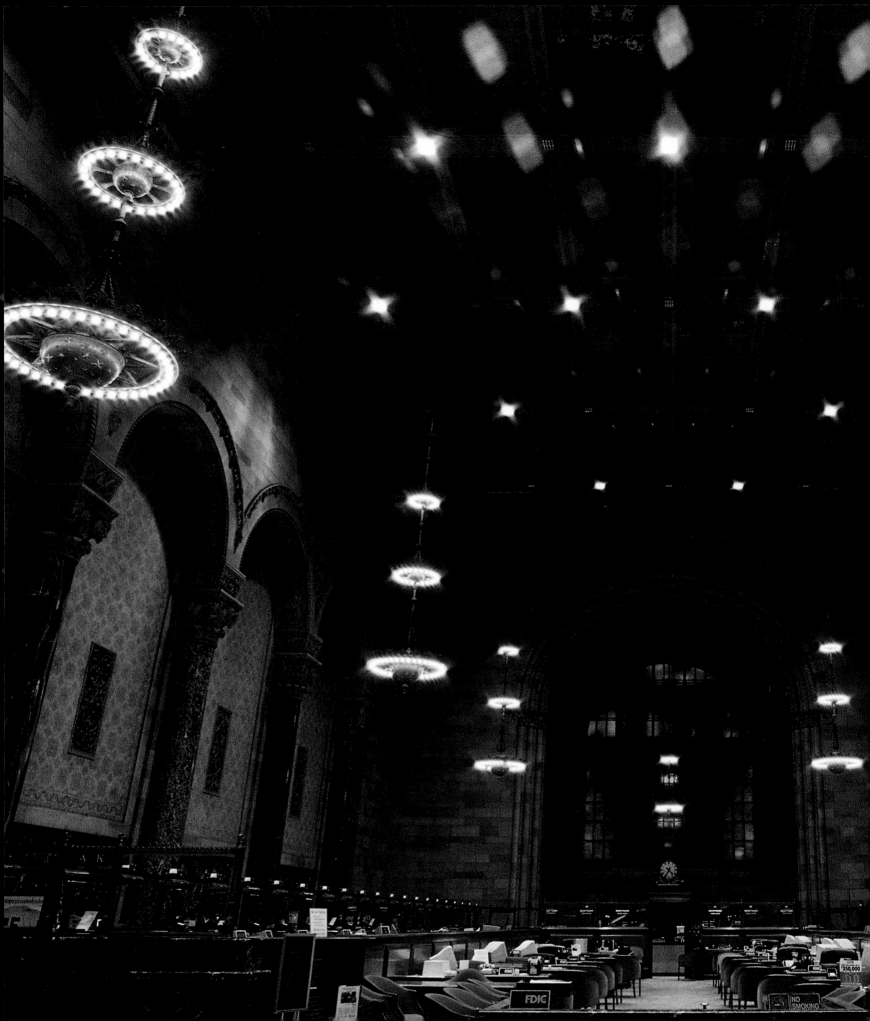

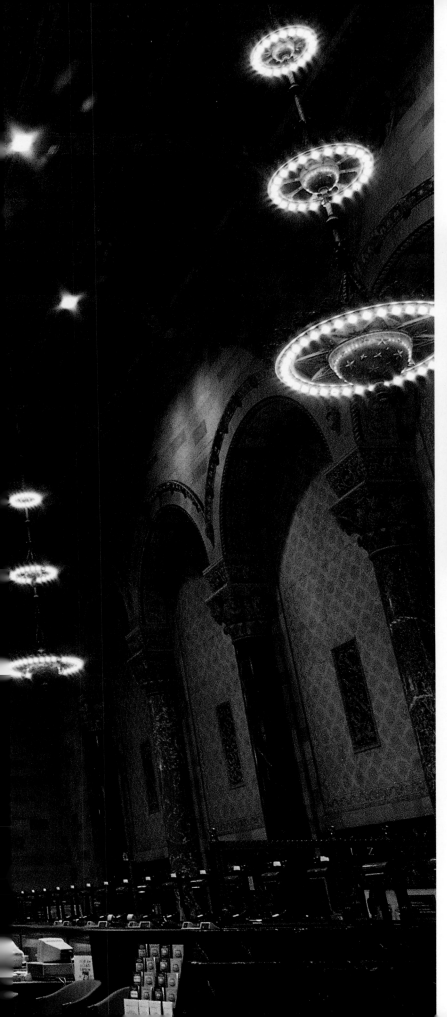

BANKS

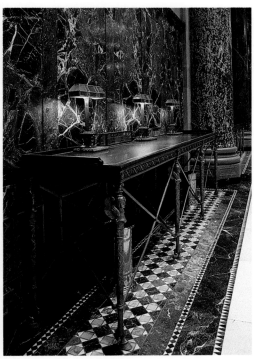

BOWERY SAVINGS BANK
Midtown, Manhattan

The Bowery Savings Bank is conceived as
a temple to finance, and a quasi-religious
atmosphere hangs over the cavernous
and dimly-lit banking hall *(left)*, designed
in imitation of a Romanesque basilica.
The interior is framed by parallel arcades
supported by mighty columns, and the
furnishings include a remarkable if
somewhat incongruous suite of Empire
Revival side tables *(above)*. In the center
sit the tellers, officiating like priests as
customers file forward as if to take
Communion.

WILLIAMSBURGH SAVINGS BANK
West Central Brooklyn

This was, and still remains, the tallest and most Priapic commercial building in Brooklyn. The banking hall has the same soaring quality as a Gothic cathedral. Towering piers advance down the central axis, supporting a vaulted canopy, in a show of strength and daring that symbolises the confidence and prowess of the bank itself.

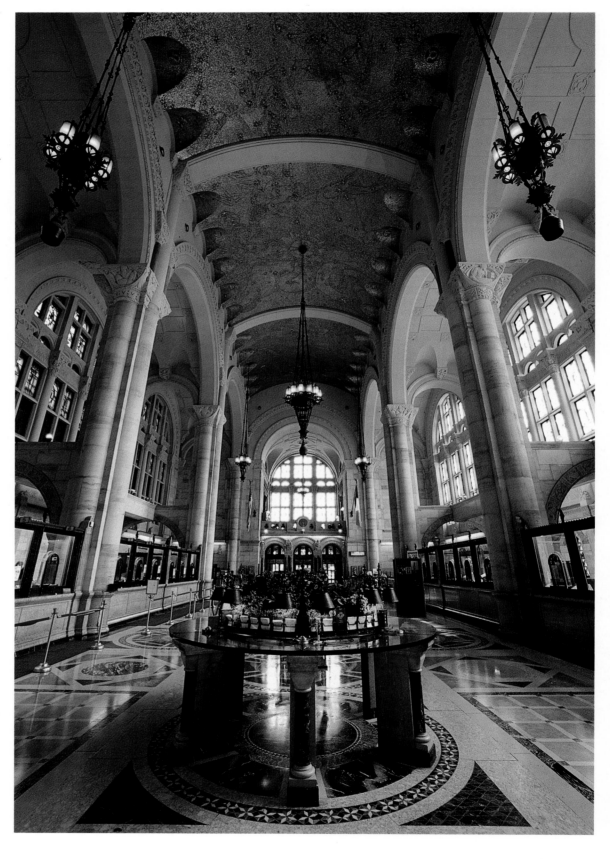

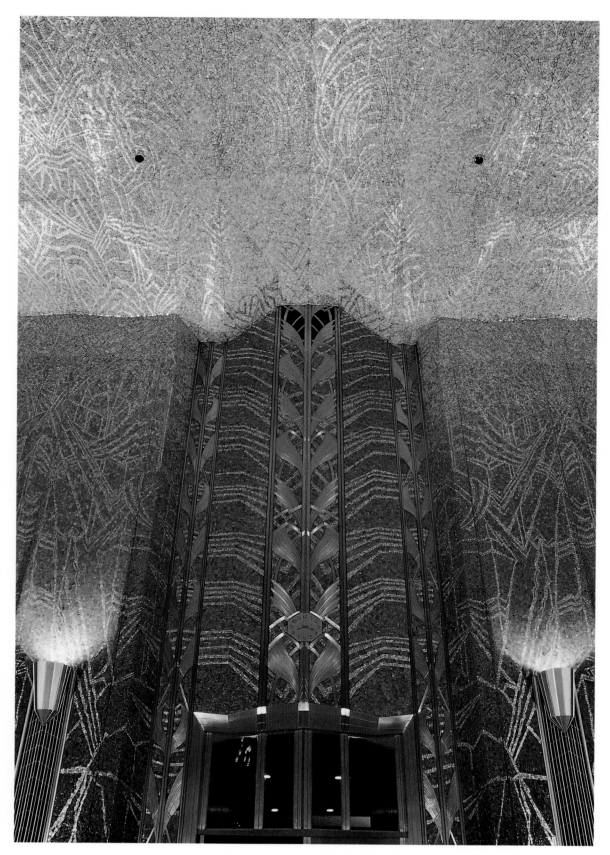

IRVING TRUST BUILDING
Wall Street, Manhattan

With an address like No 1 Wall Street, this just had to be a first-class building. The site itself was said at the time to be the most expensive on earth. Completed in 1931, the building rises to forty-nine storeys and was designed by Ralph Walker, architect of the Barclay-Vesey Building *(page 44)*. The principal interiors were designed in consultation with Hildreth Meiere, one of the artists involved in the decoration of Radio City Music Hall *(page 71)*, and include a double-volume roof-top observation lounge (now the board room) with a faceted ceiling coated in opalescent kepa shells. But the chief glory is the two-storey banking hall *(left)*, an intoxicating Tequila Sunrise in graduated bands of red and orange mosaics.

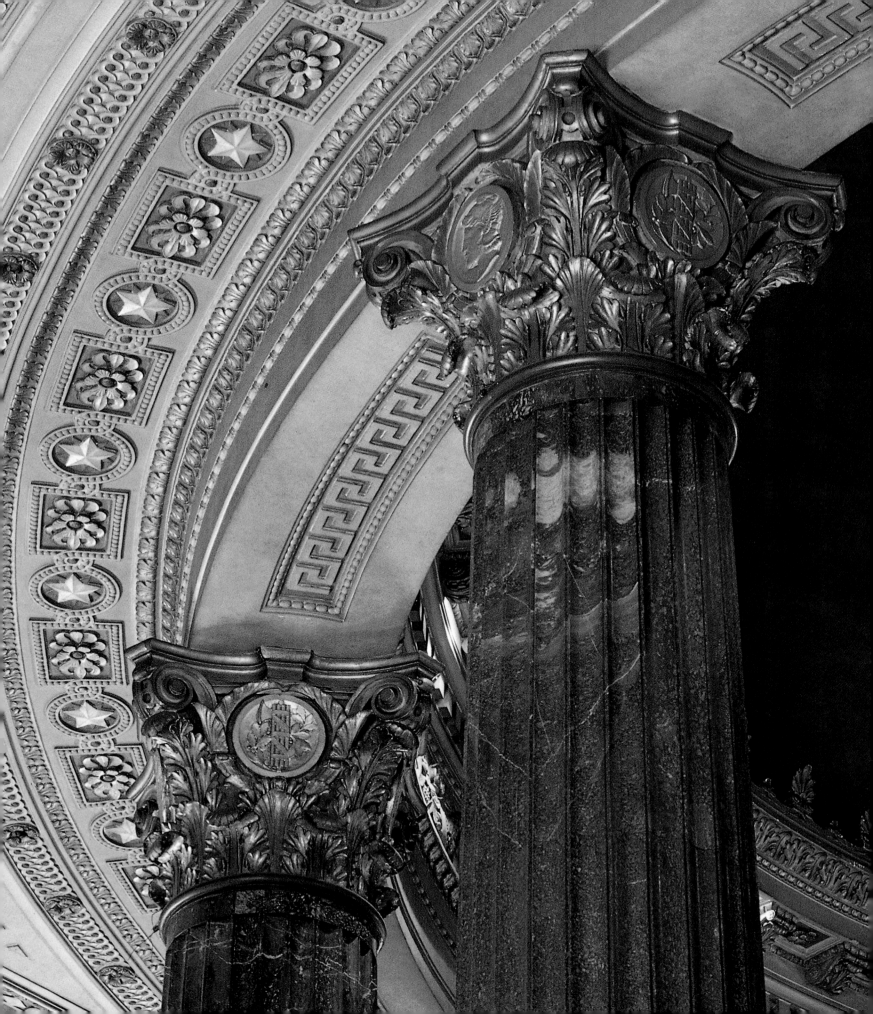

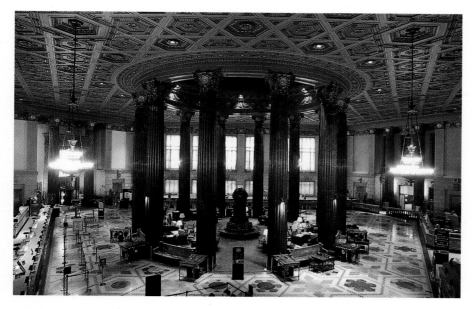

DIME SAVINGS BANK

Fulton Street, West Central Brooklyn

Fulton Street is a little like Athens under the Turks, with the remains of fine Classical buildings rising above a sprawling bazaar of modern shops and market stalls. The Dime Savings Bank is one of the best of these Classical buildings, a perfect Greek Temple in crisply-carved limestone, completed in 1907. The interior is especially handsome. The two-storey banking hall *(above)* is built on a triangular plan, and as the visitor enters diagonal sight-lines shoot to left and right, while in the center rises a towering rotunda, capped by a cupola painted to represent the open sky, and ringed by monumental Corinthian columns, the capitals studded with giant emblematic dimes *(left)*.

KING'S COUNTY SAVINGS BANK

Williamsburgh, Brooklyn

Completed in 1868, this is one of the oldest surviving banks in New York. The Second Empire exterior presents a noble appearance, and despite the blundering vandalism of previous occupants, the banking hall is still largely intact, retaining its original counters, gas lights and other nineteenth-century fittings. Mercifully the building is now being treated with the respect it deserves, and a purposeful if leisurely program of restoration is underway.

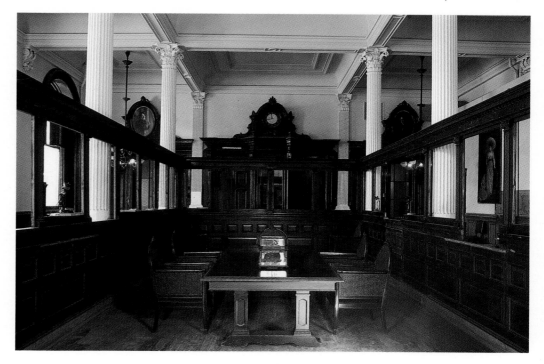

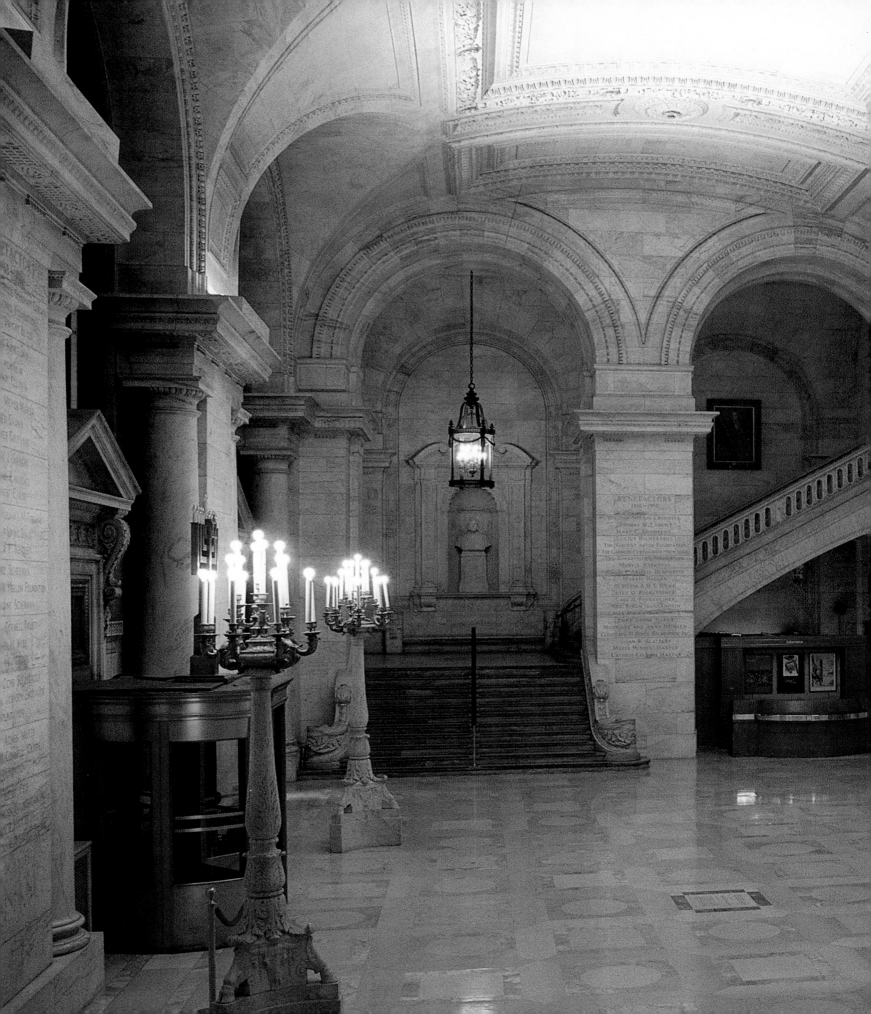

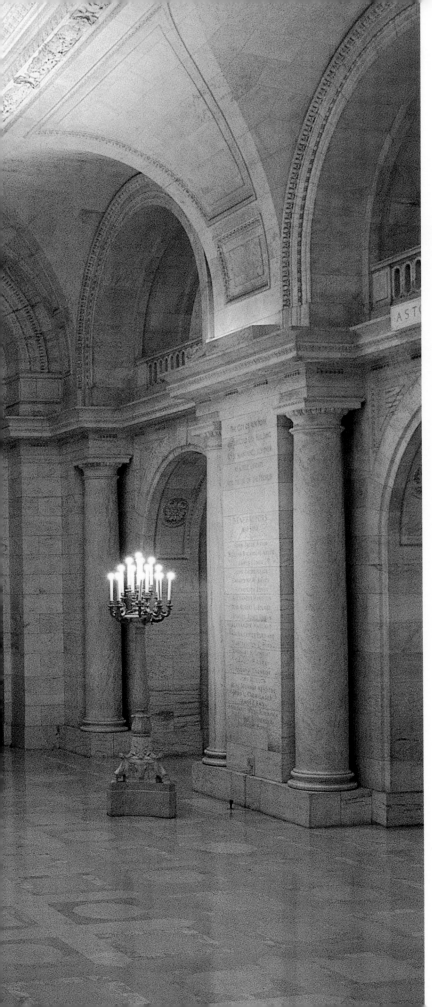

MUSEUMS AND LIBRARIES

NEW YORK PUBLIC LIBRARY
Midtown, Manhattan

Completed in 1911, the New York Public
Library is a masterpiece of Beaux-Arts
design, combining the monumentality of
Ancient Rome with the refinement of
eighteenth-century France. The building
was designed by Carrere and Hastings,
architects of such famous New York
landmarks as the Frick mansion and the
triumphal arch at the approach to the
Manhattan Bridge, and its construction
involved some of the foremost artists and
craftsmen of the period, who together
produced the murals, sculptures and
furnishings which so enhance the
architecture. Astor Hall *(left)* is typical of
the high level of design and execution; it
is as if the whole interior had been carved
from a single piece of marble. The hall is
named in honor of John Jacob Astor, the
real estate millionaire and bibliophile
whose personal library forms the basis of
the present collection, together with
those of James Lenox and Samuel Tilden.
In the rooms and passageways at first-
floor level sobriety gives way to the
exuberance of richly-colored murals and
ceiling paintings *(see endpapers)*.

THE MOORISH ROOM

Brooklyn Museum
Prospect Park, Brooklyn

The old Rockefeller Residence in Manhattan now spans two boroughs, for whereas the house itself has been demolished, the bedroom and dressing room are in the Museum of New York City on Fifth Avenue, while the Moorish Room has been transplanted to the Brooklyn Museum. The Moorish Room is one of the best surviving examples in New York of a fashionable domestic interior of the 1870s. The design reflects the period's fascination with the Orient and typifies the Artistic Style, which swept America in the last quarter of the nineteenth century. A single insistent vision governs every feature, from the definition of space to architectural fixtures, furniture, fabrics and ornaments, all designed and arranged to create a fully-integrated composition.

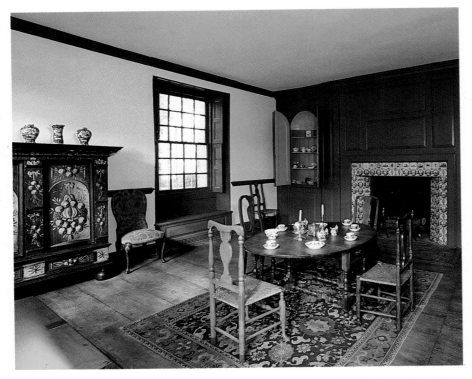

VAN CORTLANDT MANSION

Van Cortlandt Park, The Bronx

The Van Cortlandt Mansion is one of those remarkable survivals from the Colonial past, a mid eighteenth-century manor house standing in several acres of parkland in the heart of the Bronx. It was built by the descendants of Oloff Van Cortlandt, an early Dutch settler, and remained in family ownership until the late nineteenth century, when it was acquired by the National Society of Colonial Dames and restored as a museum. The parlor retains its original eighteenth-century fittings, comple-mented by suitable furniture and objects. In the late nineteenth century, with immigrants of every nationality and religion flooding into America, there was a movement to preserve as many examples as possible of buildings erected by the original English and Dutch settlers. The Van Cortlandt Mansion is one such example, interesting not only architec-turally but also politically as an obvious gesture of reactionary defiance and a monument to the old WASP ascendancy.

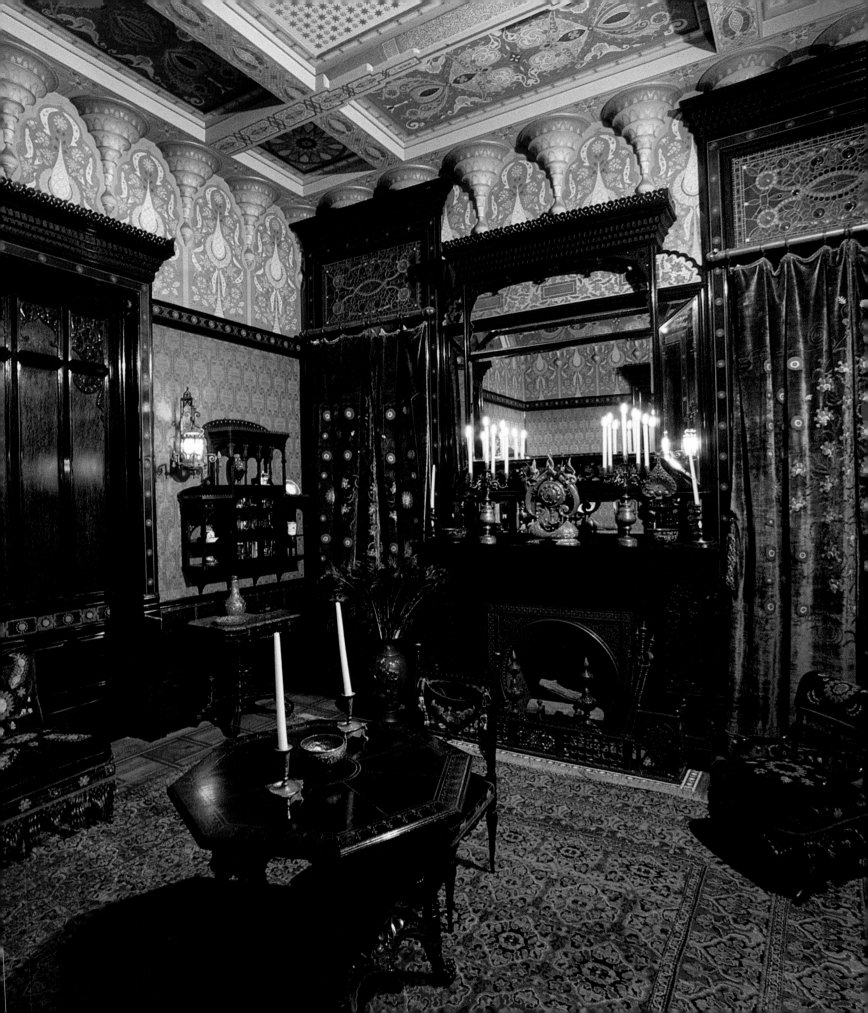

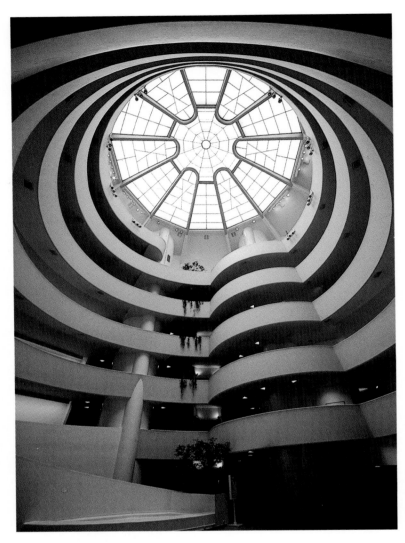

SOLOMON R GUGGENHEIM MUSEUM

Upper East Side, Manhattan

Nothing in the Guggenheim Collection quite matches the visual impact of the museum itself. The interior is clearly in the tradition of the great top-lit cantilevered staircases of the eighteenth and nineteenth centuries; but to plan a museum around a staircase or ramp, rather than the customary sequence of interconnecting galleries, was a master stroke of originality and lateral thinking. The building dates from 1959 and was designed by the American architect Frank Lloyd Wright. Like all of Wright's best work it hovers between the organic and the tectonic, the figurative and the abstract. Modern in its construction, precise in its delineation, yet naturalistic in its imagery, it recalls some living form from the animal or plant world.

THE PIERPONT MORGAN LIBRARY

Murray Hill, Manhattan

The Morgan Library represents a high point in the history of American art and architecture. The building was conceived by J Pierpont Morgan, banker, philanthropist and collector, and was designed under his direction by architect Charles McKim. Its primary purpose was to serve as a repository for Morgan's collection of books and manuscripts, one of the most important ever formed; architecturally its significance lies in its perfect fusion of the fine and decorative arts, and in the synthesis of principles and elements derived from some of the most outstanding buildings of the Classical tradition. Structurally the building looks back to Ancient Greece in its use of *anathyrosis,* the fitting together of marble blocks more or less without mortar. The principal elevation is modelled on the Villa Giulia and the Villa Medici in Rome, and virtually every feature in the Rotunda *(below)* and the East Room *(right)* is derived from some specific source in the architecture of the Italian Renaissance.

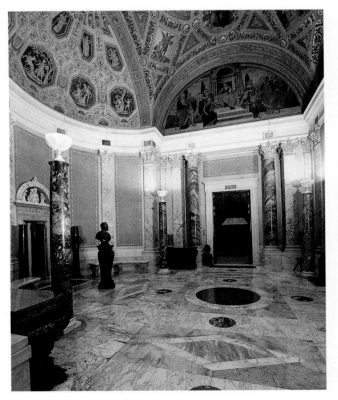

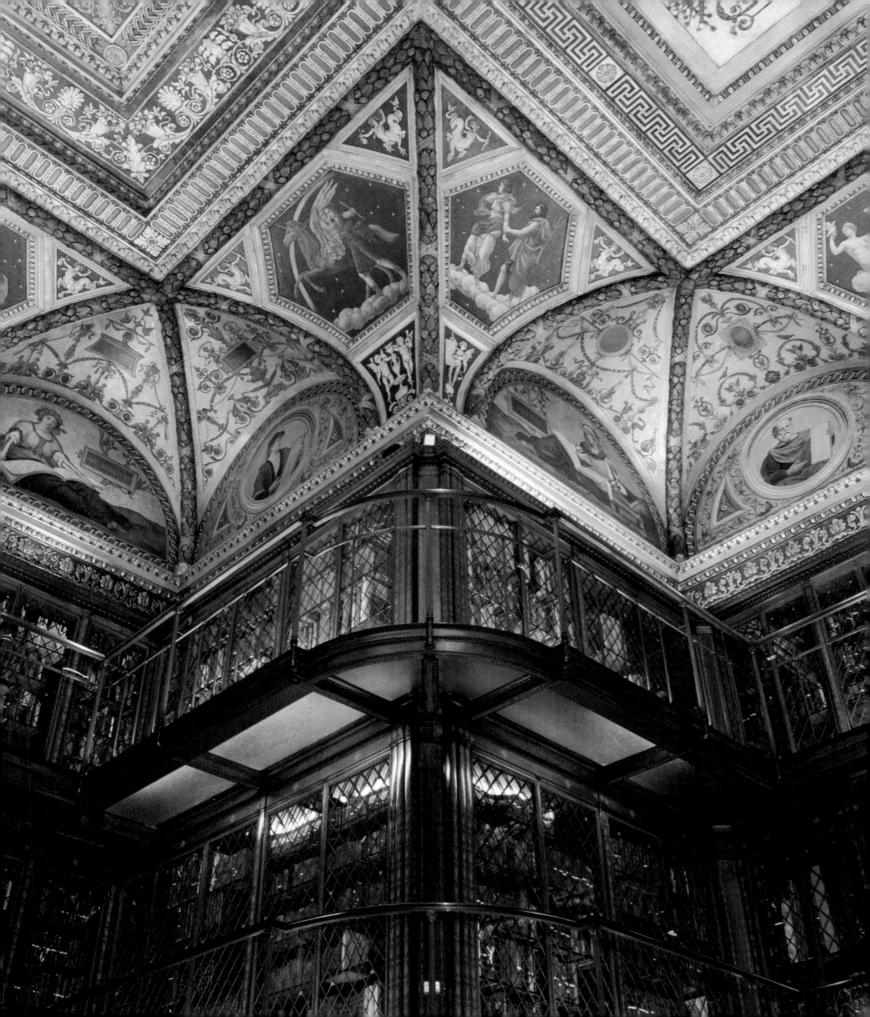

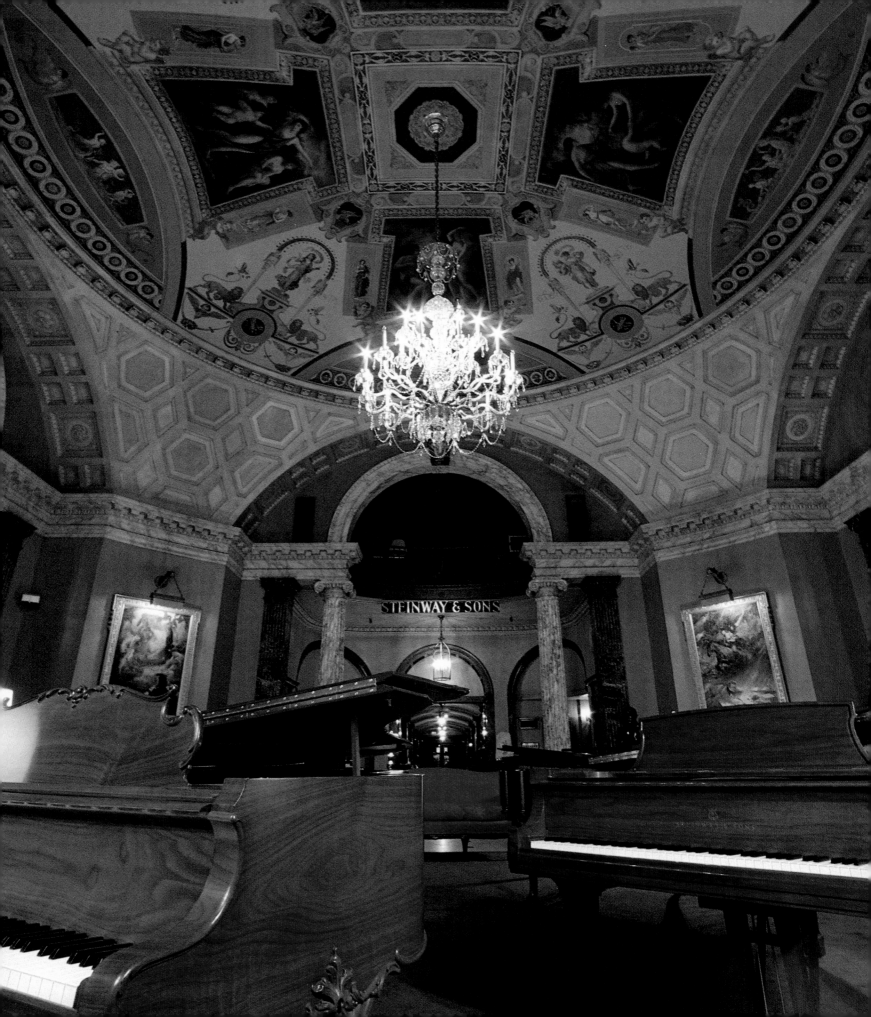

SHOPS

M MARSHALL BLAKE FUNERAL HOME

Formerly the James Anthony Bailey Mansion

Hamilton Heights, Manhattan

Harlem was once a prosperous middle-class neighborhood, but in the nationwide recession that followed the San Francisco earthquake of 1906 the area went into a steep decline from which it has struggled to emerge ever since. There are many fine buildings left over from the first optimistic phase of development, though few are protected, and one of the best is the old Bailey Residence on Sugar Hill, a freestanding limestone mansion, part Romanesque, part Flemish, which was built in 1886-8 for James Anthony Bailey of Barnum & Bailey Circus fame, and which since 1950 has served as a funeral home. The interior is little changed, retaining most of its original late nineteenth-century fittings. The staircase hall has many typical features of a period that delighted in color and ornament, including an inlaid parquet floor and resplendent stained glass windows.

STEINWAY SHOWROOM

Midtown, Manhattan

The Steinway Showroom *(left)* dates from 1925, but the design stems from the eighteenth century, with Neo-Classical ceiling paintings and columnar screens inspired by the work of Robert Adam and James Wyatt. The architects were Warren & Wetmore, best known for Grand Central Station *(page 43),* and there is something of the same monumentality in the scale and grandeur of what must surely be the most magnificent shop interior in the world.

BROADWAY BARBERSHOP
Upper West Side, Manhattan

The Barbershop at 2713 Broadway is one of the sights of the Upper West Side; the interior is the oldest of its kind in the city, with fittings, furniture and even some implements dating back to the early years of the century. The terrazzo floor, marble basins and pressed tin ceiling have been spotlessly maintained by the owner, Kay Demetriou, a barber of the old school who can deliver a crew-cut with scissors in sixty seconds and a shave with his eyes closed using only one lather. Demetriou was born in Soho, London, and was already cutting hair at the age of ten, standing on a box to reach his customers.

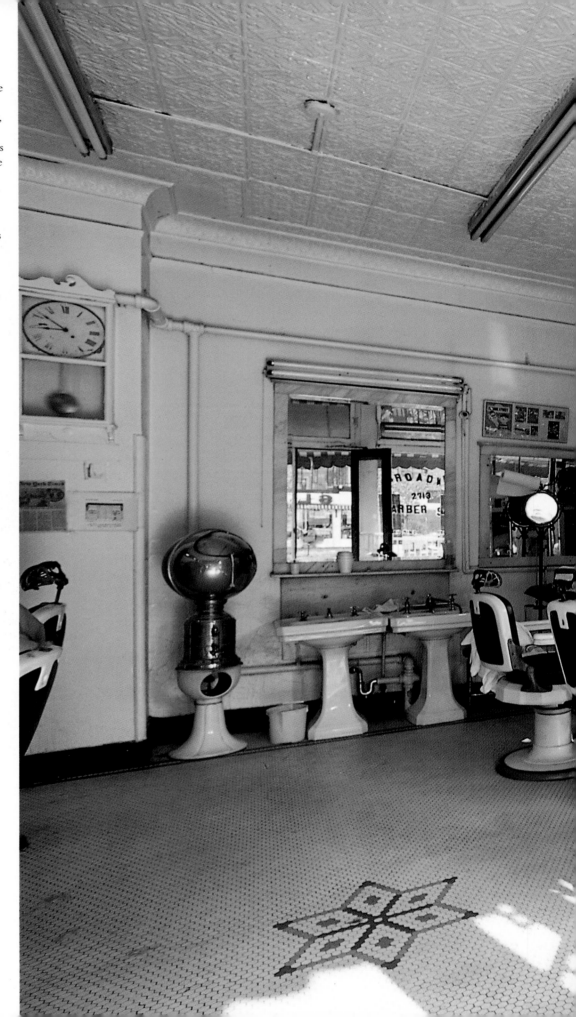

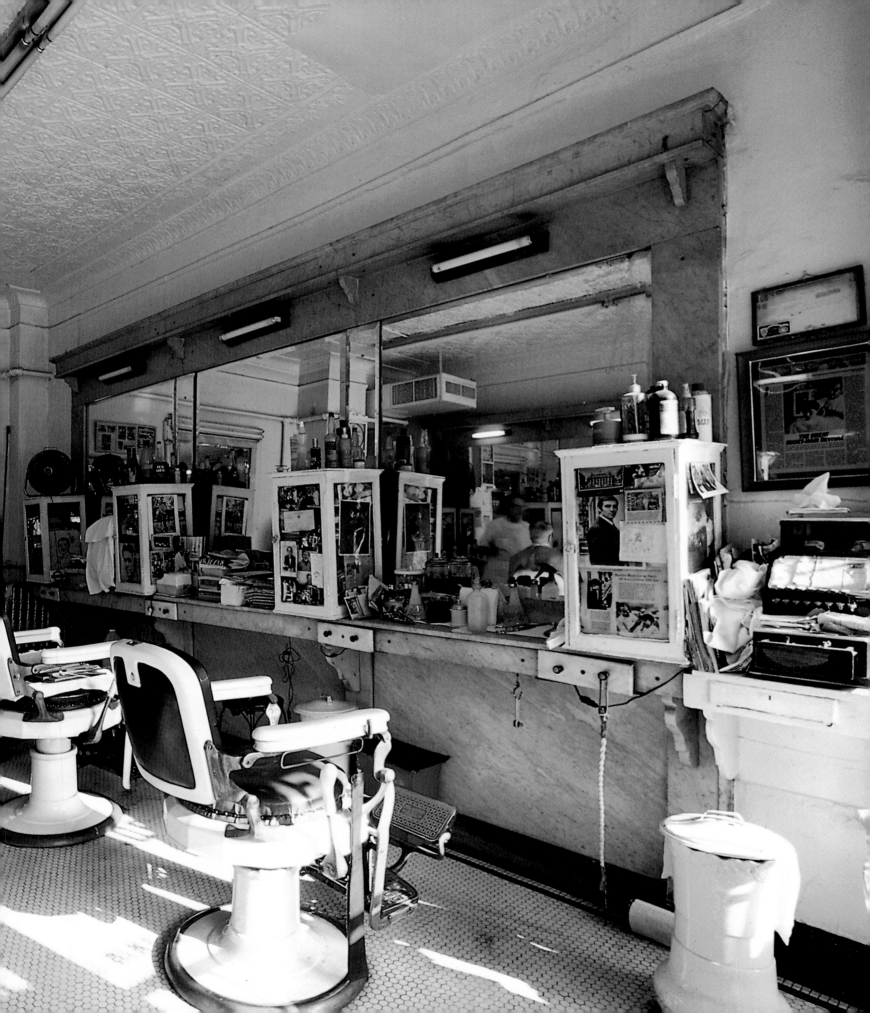

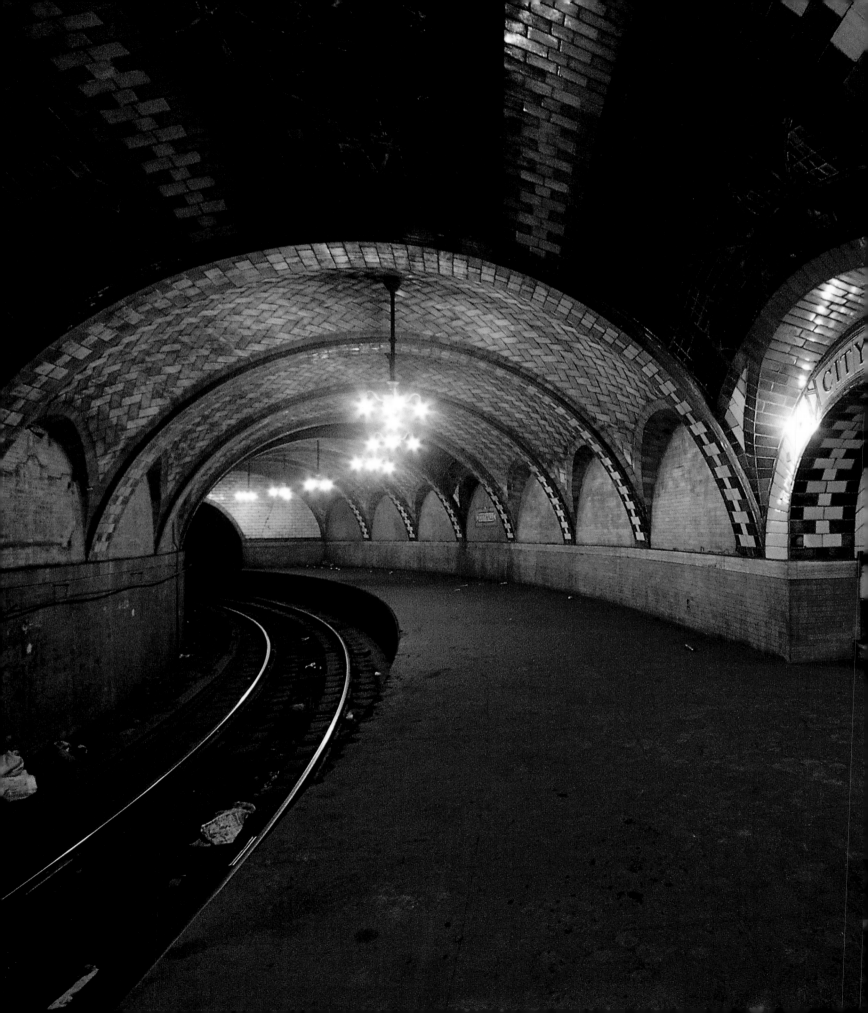

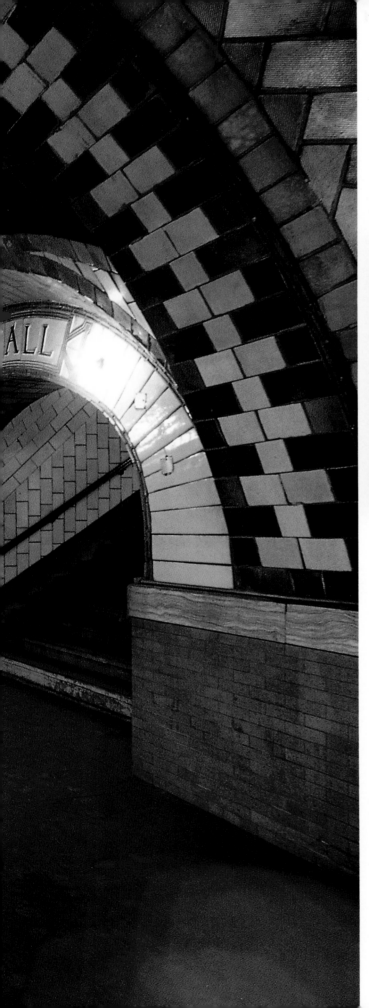

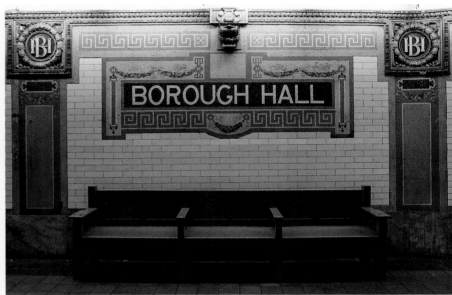

THE SUBWAY

The New York Subway is dirty and airless, a maze of iron girders and sporadic, half-hearted signage; but it can also be a beautiful, colorful museum of twentieth-century mosaics and ceramics. The restoration that is currently underway promises, and has already delivered, spectacular results. Virtually every station has something to offer. The best perhaps is the old station under City Hall in Manhattan *(left)*, closed for almost half a century but little changed since its construction in 1904, with a lavish glazed ceramic interior that comes close to the spirit of the Moscow Underground. At Borough Hall *(above)*, commuters are greeted by festoons and garlands; *(overleaf)* a steam ship hoists the star-spangled banner and sails from New York Harbor at Fulton Street *(top)*; a Baroque cartouche in cobalt blue marks the spot at Bleecker Street *(center)*; and Mother Columbia gathers together her alumni at West 116th Street *(bottom)*.

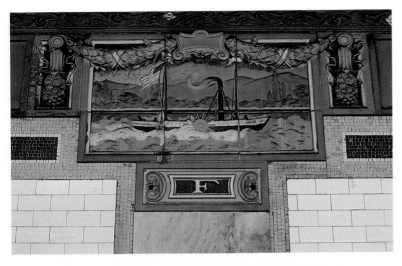

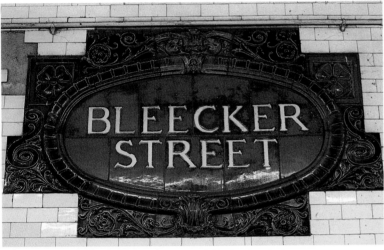

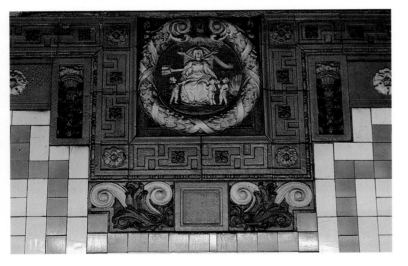

GRAND CENTRAL STATION
Midtown, Manhattan

Orphaned by the demolition of Pennsylvania Station, New Yorkers cling to Grand Central as if the life of the city depended on it, and recent moves to erect a giant tower above the main concourse met with the resounding slap they deserved. Completed in 1913, the building looks back to the architecture of Ancient Rome by way of nineteenth-century Paris. The main concourse is justly famous for its heroic vaulted ceiling painted with the constellations of the Zodiac, and is currently the focus of an ambitious program of restoration which aims to return the station to its original turn-of-the-century splendor. But there are dramatic perspectives and details at every point, architecture and engineering enriched by sculpture and painting. The Graybar Passage *(right)* features elegant chandeliers and a ceiling painting by Edward Trumbull on the theme of modern travel, which narrowly escaped destruction during a disastrous refurbishment program in the 1950s.

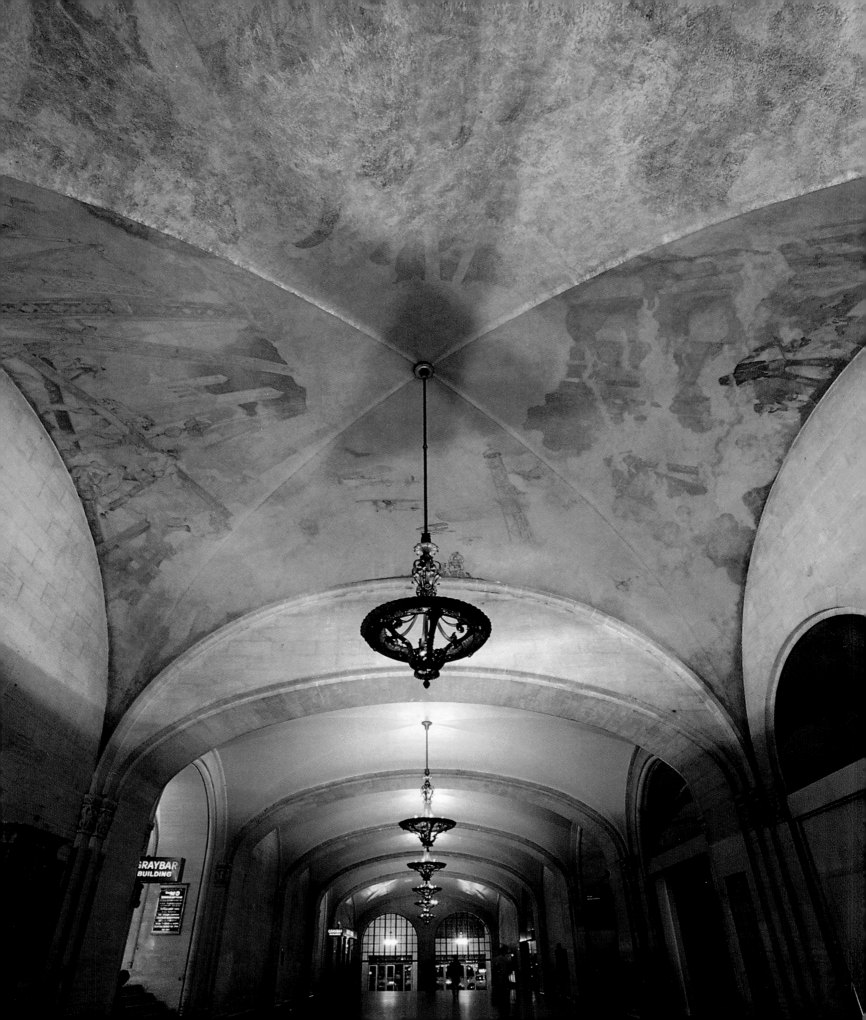

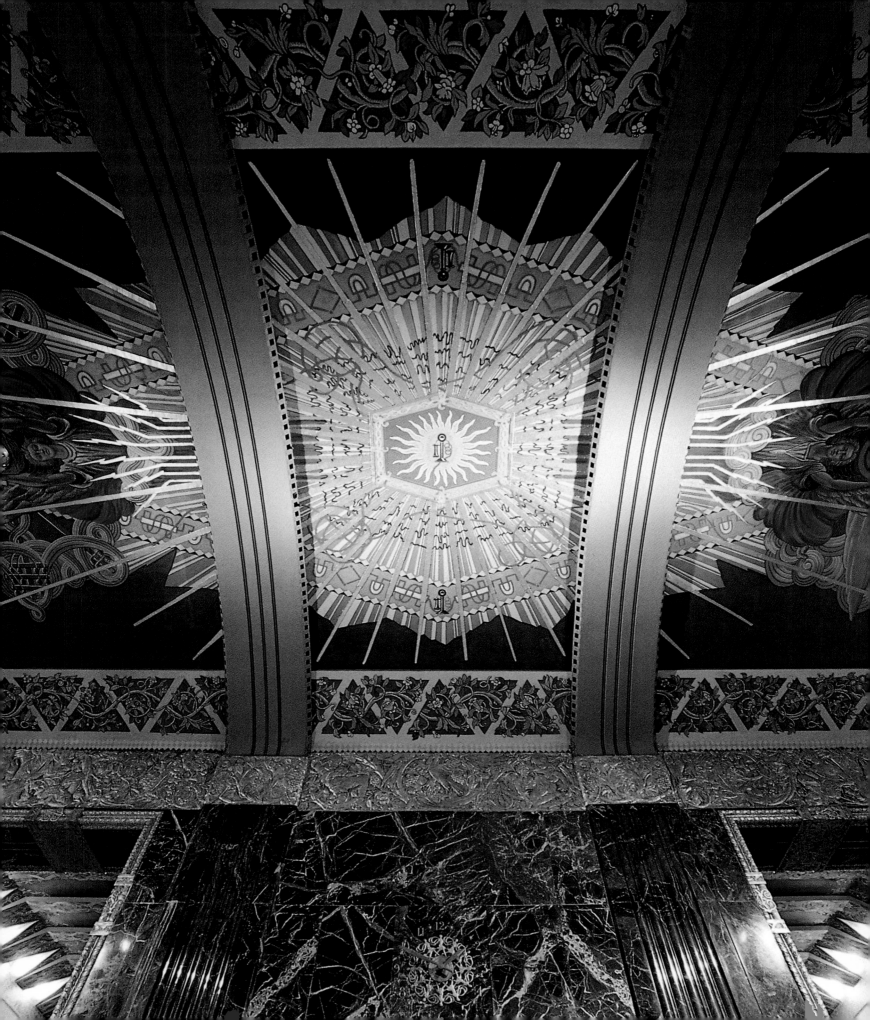

BARCLAY-VESEY BUILDING

The Barclay-Vesey Building is reputedly the earliest Art Deco skyscraper in New York, and since its construction in 1926 has served as the headquarters of the New York Telephone Company. The monolithic exterior eschews all reference to the architectural styles of the past, breaking decisively with the historicism of the Beaux-Arts tradition, and was chosen to illustrate the frontispiece of the first English language edition of Le Corbusier's *Towards a New Architecture.* The lobby is a riot of color and light that seems to express the excitement and dynamism of the dawn of modern telecommunications. The painted ceilings and elaborate metalwork are a reminder of the vital role played by traditional craftsmen in the construction of even the most forward-looking buildings of the period.

CORPORATE BUILDINGS

SEAGRAM BUILDING

Midtown, Manhattan

The lobby of the Seagram Building is interior design reduced to the bare architectural essentials of space, line and perspective; no interior ever came closer to achieving the dream of perfect abstraction which lay at the root of the International Style. The lobby dates from 1958 and was designed by Philip Johnson in association with Mies Van der Rohe. At the top of the stairs a theater curtain by Picasso hangs like some ancestral portrait, marking the commencement of the Modern Movement, of which the Seagram can be seen as the climax.

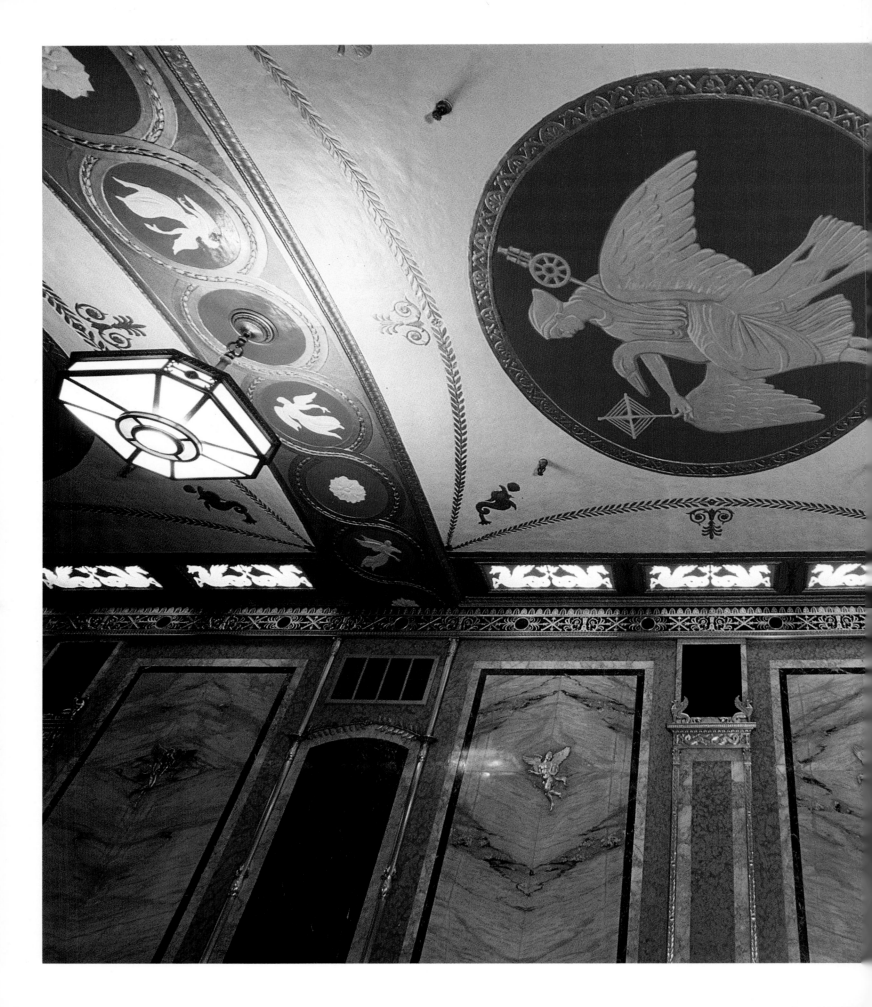

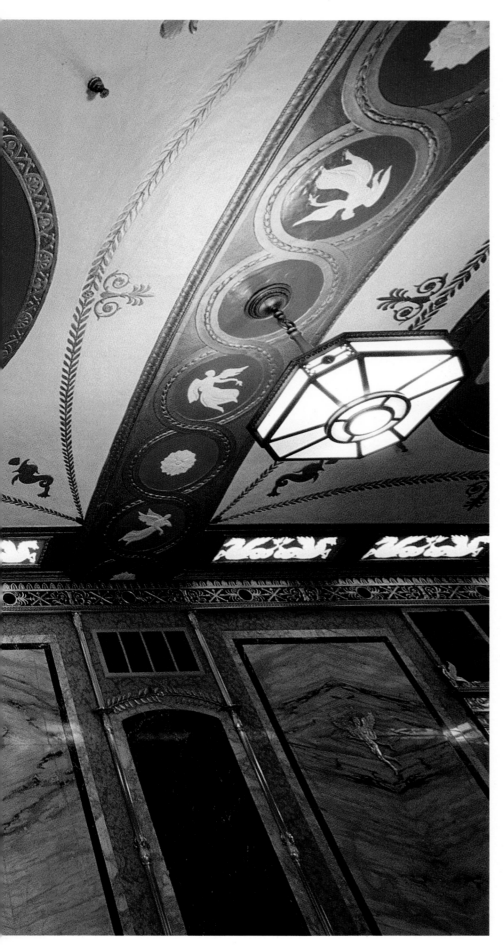

BELMONT MADISON BUILDING

Gramercy, Manhattan

The lobby of the Belmont Madison Building is a rare example of 1920s Napoleonica, one of only a handful of Empire Revival interiors in the city, designed by Warren & Wetmore, architects of Grand Central Station. The walls are panelled in marble, with gilt bronze mounts representing griffins and winged mythological figures, while the ceiling appears to have strayed from the ruins of some ancient Roman building in Pompeii or Herculaneum.

overleaf

SWISS CENTER BUILDING

Midtown, Manhattan

Small in scale but exquisitely tailored, this dapper 1930s office building easily holds its own against its towering neighbor, Rockefeller Center. The jewel-box interior epitomises the Art Deco style at its most opulent. The elevator doors are especially impressive, with contrasting silver and gilt reliefs representing flowers, foliage and nymphs, the whole framed by banded marble walls in shades of sienna and chestnut.

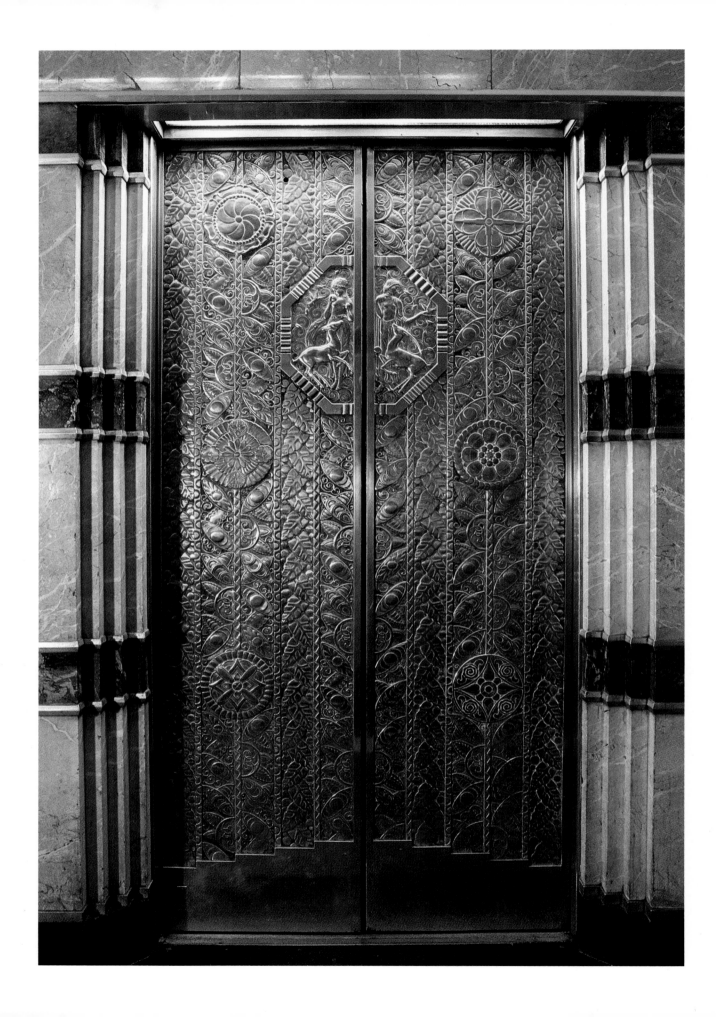

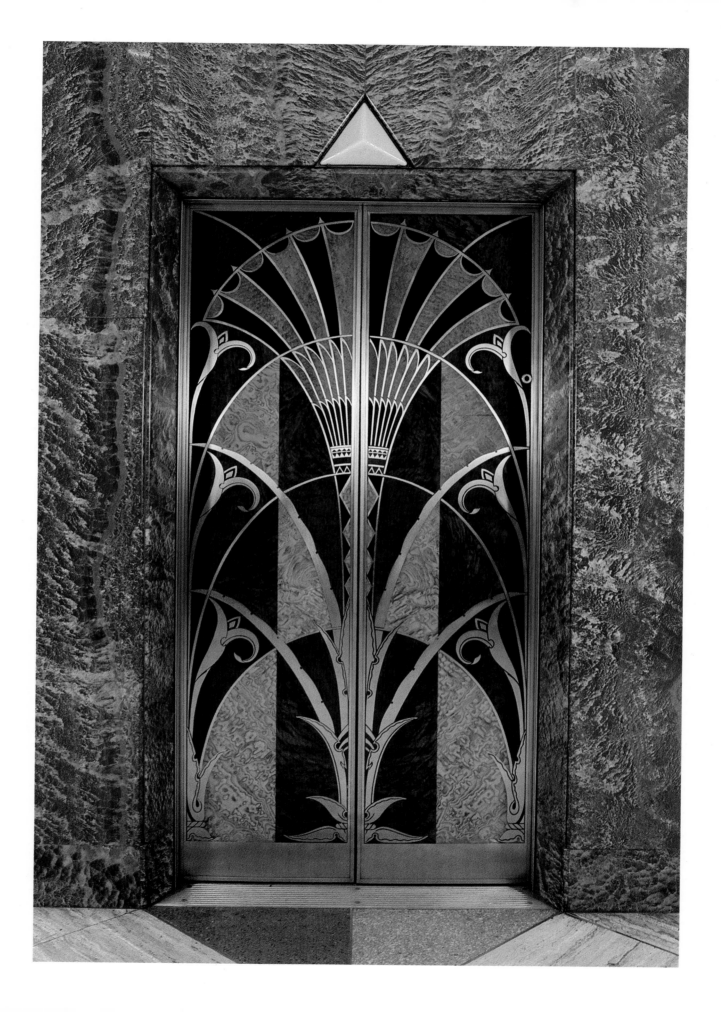

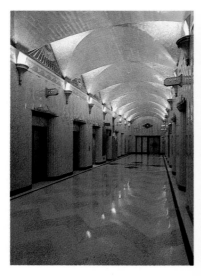

GENERAL ELECTRIC BUILDING
Midtown, Manhattan

This soaring fifty-storey office building dates from 1931 and was originally occupied by the radio and communications giant RCA. Since 1932 it has been the headquarters of the General Electric Company, who could hardly have found a more appropriate home. The exterior crosses Art Deco and Gothic, and is crowned by a storm of lightning bolts and sparks in bronze. The lobby *(above and right)* follows suit, crackling with energy in every detail, from the vaulted, aluminium-leaf ceiling to the streamlined grilles and vibrant painted sunbursts.

previous page

CHRYSLER BUILDING
Midtown, Manhattan

There is a whole book to be written on the elevators of New York, and those of the Chrysler Building would occupy a chapter to themselves. The Chrysler was built in 1928-30 for automobile tycoon Walter P Chrysler, and was designed by William Van Alen. With its distinctive chevron helmet and aluminium gargoyles, it is one of the cheekiest and most joyous Art Deco skyscrapers in New York, a masterpiece of massing and engineering which, at just over 1,000 feet, was for a short time the tallest building in the world. The walls of the lobby are faced with African marble, on a symmetrical butterfly pattern, but it is the elevators, with their marquetry doors and panelling, that steal the show.

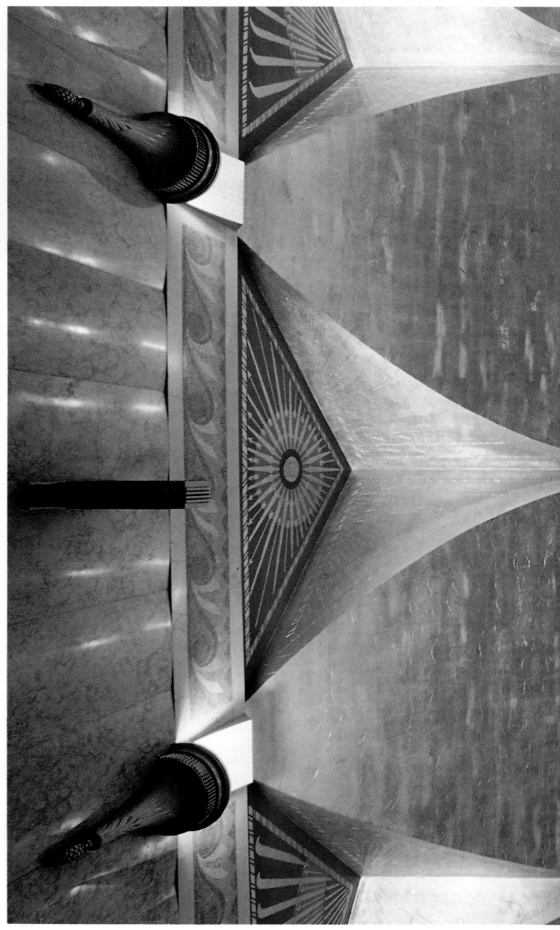

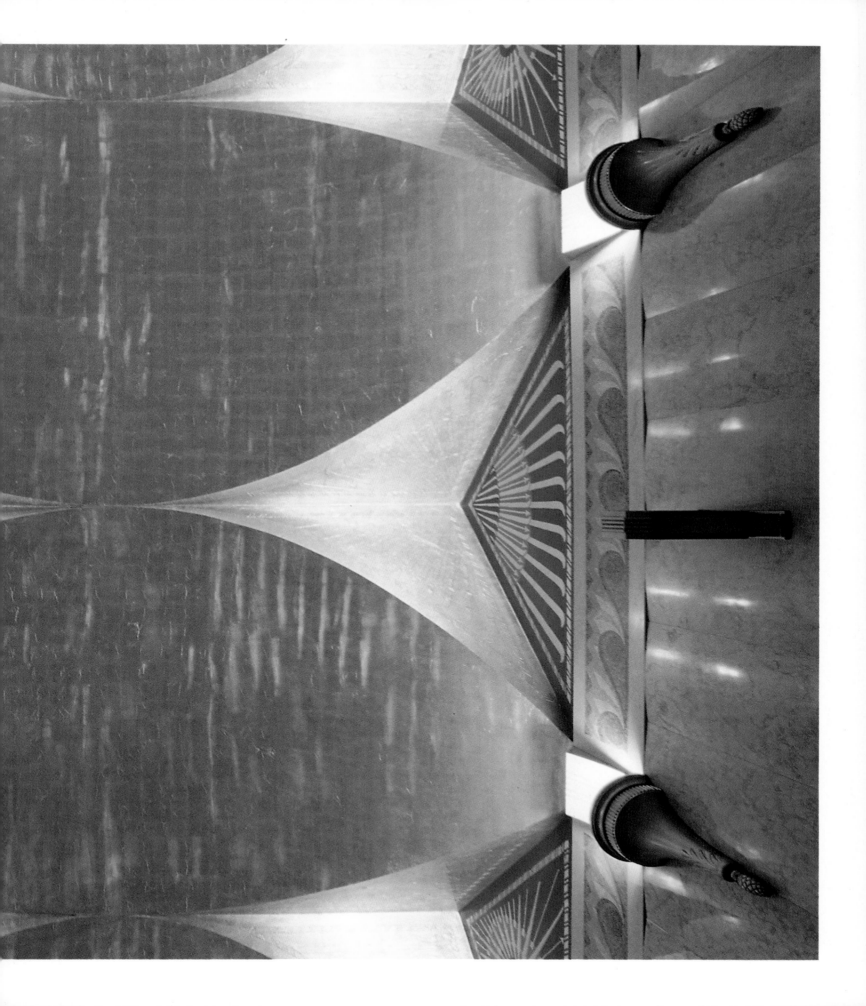

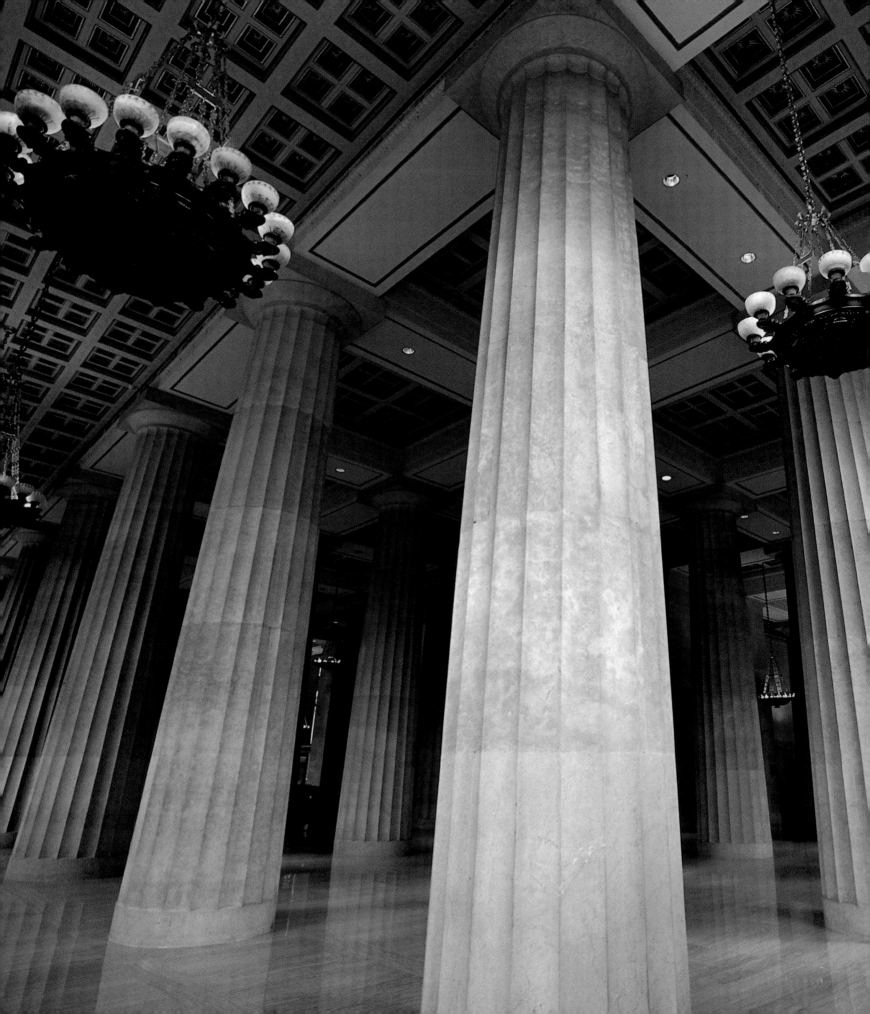

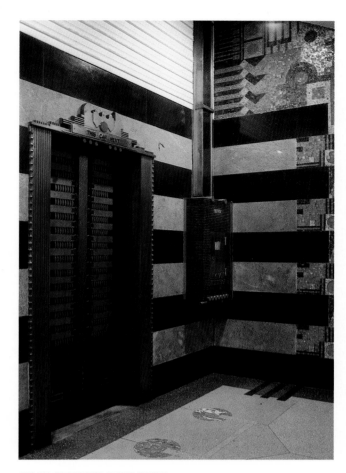

FILM CENTER BUILDING
Midtown, Manhattan

The Film Center Building is a reminder
of the days when New York rivalled
Hollywood as a center of the movie
industry. Completed in 1929, it was
designed to meet the needs of film-
makers at every stage in the production
process, and although most of the New
York studios have since shut down or
moved elsewhere, it continues to serve its
original purpose. The lobby reflects the
influence of 1920s textile design; the
mosaic panel between the elevators and
the geometric patterning of the walls and
floor were intended by architect Ely
Jacques Kahn to simulate the printed and
woven fabrics of the period. On another
level the interior epitomises the machine
aesthetic, its parts assembled like those of
a high-powered engine which at the flick
of a switch might suddenly spring into
action.

195 BROADWAY
Formerly the AT&T Building
Financial District, Manhattan

Densely planted with baseless Greek
Doric columns, the lobby of the old
AT&T Building on Broadway is a kind
of corporate Paestum. But for all the
archaeology the effect is anything but
archaeological. The columns may be
faithful copies but no such interior ever
existed in Antiquity, and while the detail-
ing is Classical the mood is Romantic,
with dramatic perspectives enhanced by
the atmospheric use of light and shadow.

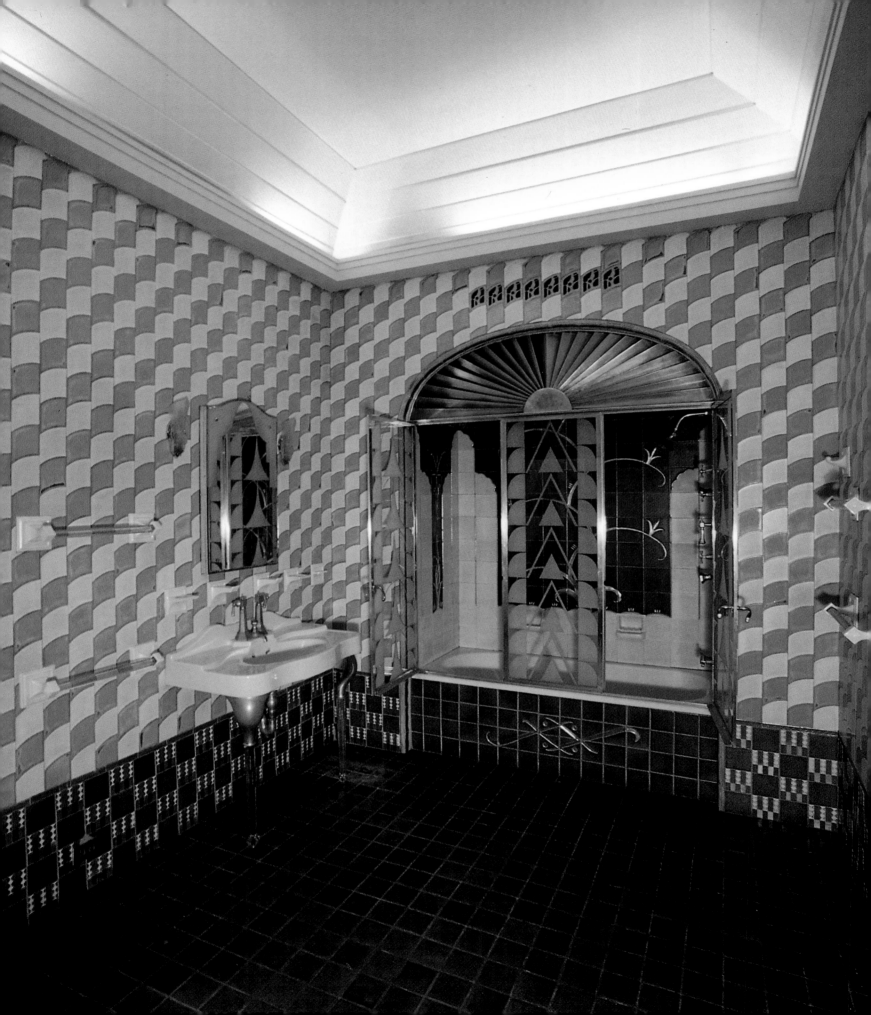

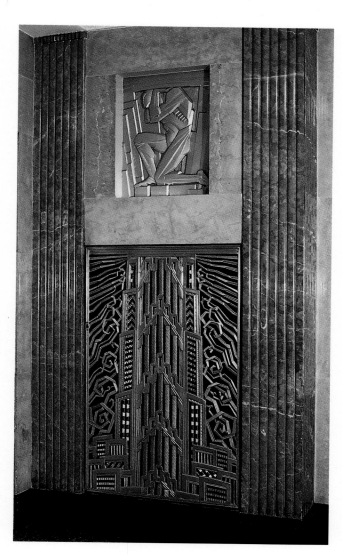

CHANIN BUILDING
Midtown, Manhattan

Monolithic in its massing, exquisite in its detail, the Chanin was the first of the great skyscrapers to be built in the area around Grand Central Station. It rises to fifty-six storeys, and near the summit is a stylish Art Deco bathroom *(far left)* which won a prize for design when it was first unveiled in 1929. The bathroom originally formed part of the private suite of Irwin Chanin, head of the giant real estate company which erected the building and which was also responsible for the development of Central Park West and the area around Times Square. At street level, the side entrances feature arresting bronze reliefs and convector grilles that are among the best examples of Art Deco metalwork in the city *(left)*. These were designed by Jacques Delamarre, head of the Chanin architecture department, and executed by sculptor and fellow Frenchman, René Chambellan. However, it was Chanin himself who determined the theme. On one level the work of Delamarre and Chambellan illustrates the importance of Franco-American exchange in the growth of the Art Deco style, and the vital contribution made by French and other foreign designers and artists to the architectural development of New York during this period. But its primary purpose is to express Chanin's own vision of New York as the city of opportunity, where through hard work and dynamism a man could rise, as he had done, from humble beginnings to the peak of wealth and power.

overleaf

AT&T BUILDING
Midtown, Manhattan

The new AT&T Building, designed by Philip Johnson and completed in 1984, is capped by a Chippendale pediment, but there is nothing eighteenth-century about the lobby, which is closer in style to the Romanesque, although with heavy Post-Modern overtones. The interior derives most of its drama from a colossal gilded statue of Commerce, which formerly stood on the roof of the old AT&T Building on Broadway *(page 52)*.

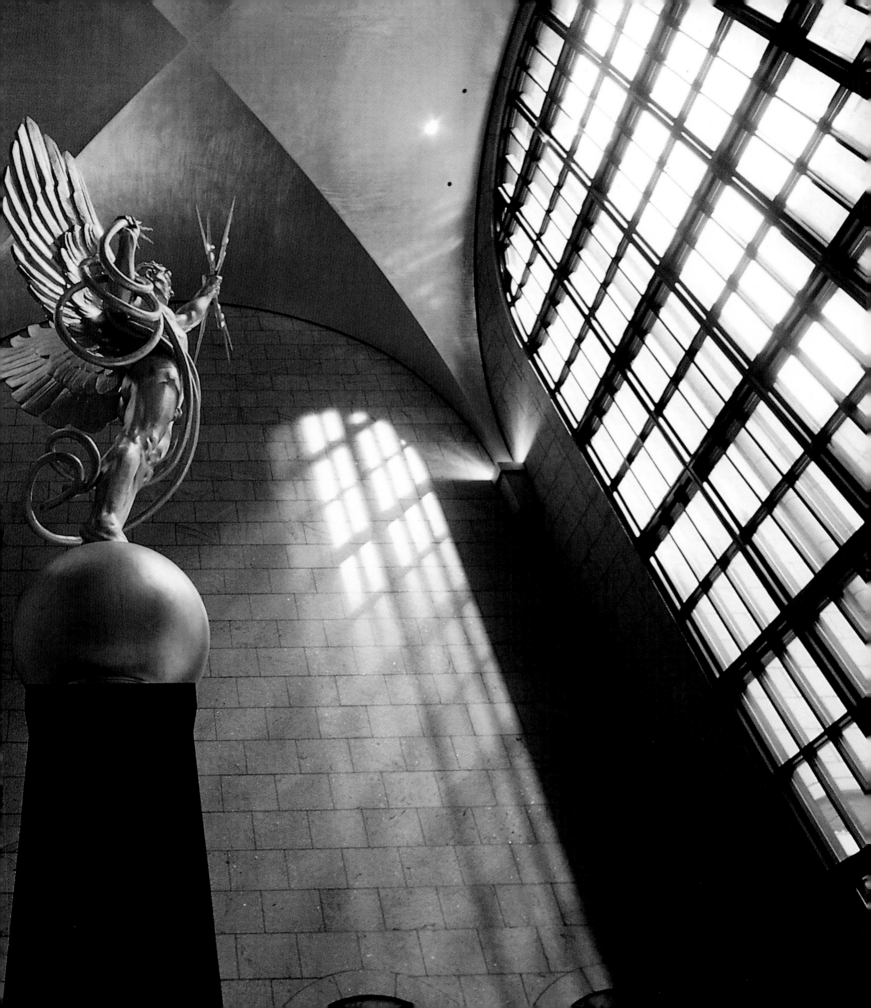

WOOLWORTH BUILDING
Civic Center, Manhattan

The Woolworth Building was erected in 1911-13 as the headquarters of the international chain of cut-price variety stores founded by Frank Winfield Woolworth. At 800 feet it was the tallest building in the world until the construction of the Chrysler Building in 1929. Both in its massing and in the theatricality of its detailing it set the pattern for many of the great skyscrapers of the 1920s and early 1930s. The structure of the building embodied the latest advances in engineering technology, but the style of Woolworth's 'Cathedral of Commerce' was Gothic: the lobby *(right)* consciously evokes the interior of a medieval church. The central axis forms a kind of nave, with elevator lobbies taking the place of side chapels, and the marble walls, mosaic ceiling and allegorical murals *(left)* are set off by a wealth of crockets, tracery and other Gothic details culled from the great ecclesiastical buildings of medieval Europe.

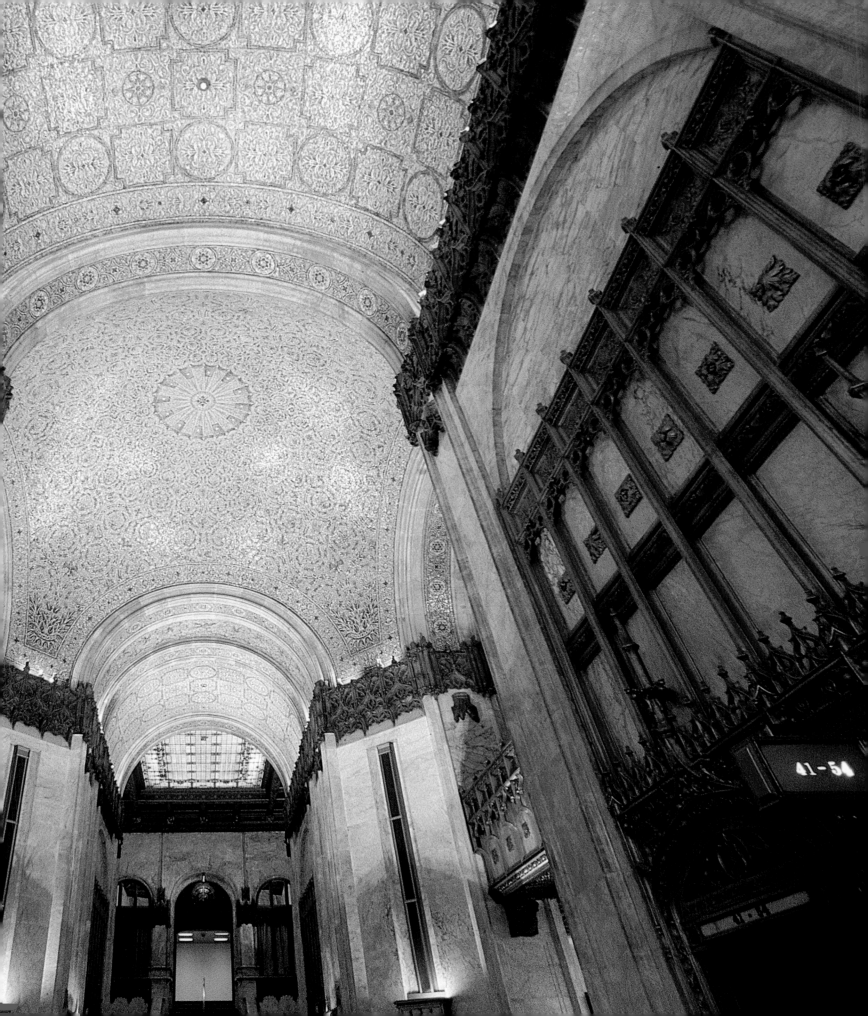

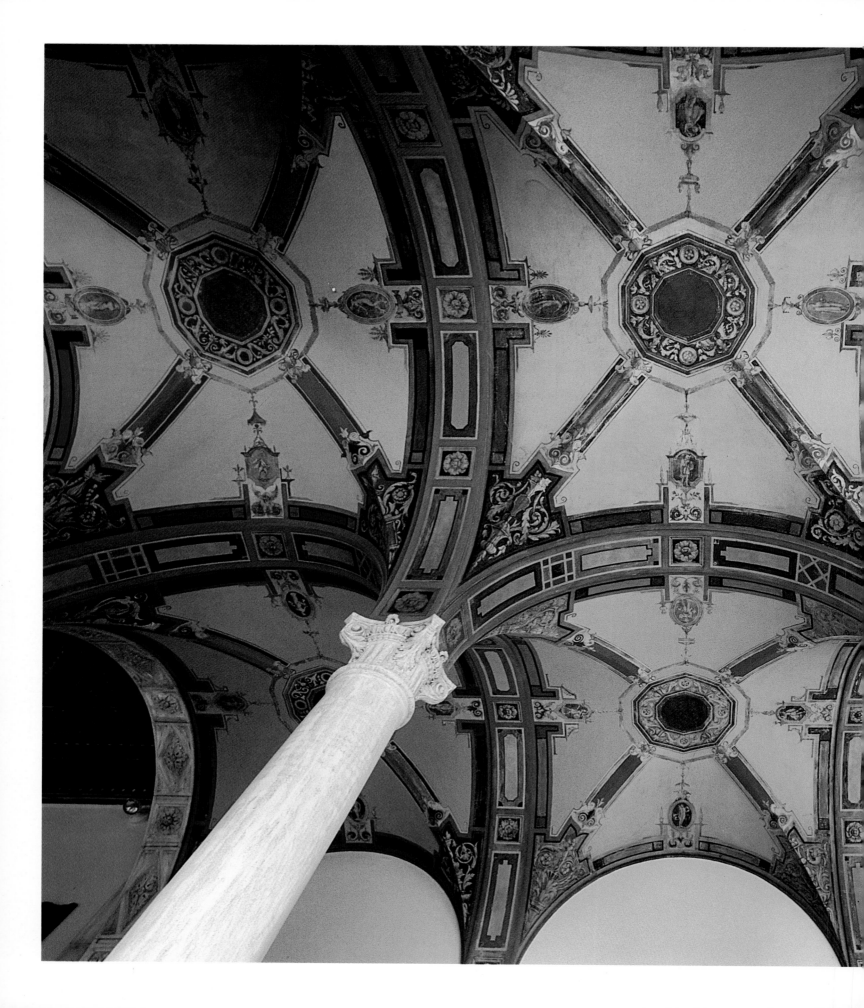

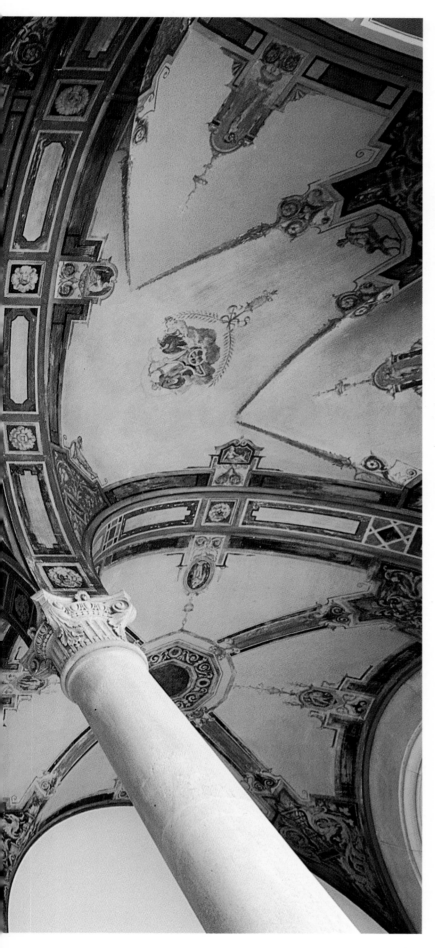

SCHOOLS AND COLLEGES

CONVENT OF THE SACRED HEART

Formerly the Otto Kahn Mansion
Upper East Side, Manhattan

Modelled on the Cancelleria in Rome, the Kahn Mansion occupies a vast site on the corner of Fifth Avenue and East 91st Street and was reputedly the largest private residence ever built in New York. Designed by C P H Gilbert and the English-born architect Alfred J Stenhouse for the millionaire financier and philanthropist Otto Kahn, it operates today as a convent, like its neighbor, the Burden Mansion *(page 66)*. The plan incorporates an internal carriage drive as well as courtyards and external staircases; the interior is inspired by the architecture of the early Renaissance. A vaulted ceiling with painted decoration, supported by slender Corinthian columns, is one of its many treasures.

overleaf

GOULD MEMORIAL LIBRARY

Bronx Community College.
University Heights, The Bronx

The Gould Memorial Library is the centerpiece of a grandiose Beaux-Arts complex of buildings erected in 1900 to provide an alternative campus for New York University. It takes its name from the railroad tycoon and financier Jay Gould, whose daughter financed the construction, and was designed by Stanford White. In siting the building on the highest spot in New York, White may have been thinking of the Acropolis in Athens; but the design of the library clearly looks back to the Pantheon in Rome. The vast scale of the interior is matched by immaculate detailing, including stained glass panels by Tiffany. The figures gazing down from the gallery below the cupola are the Muses, not the mere nine of ancient mythology but a splendid sixteen.

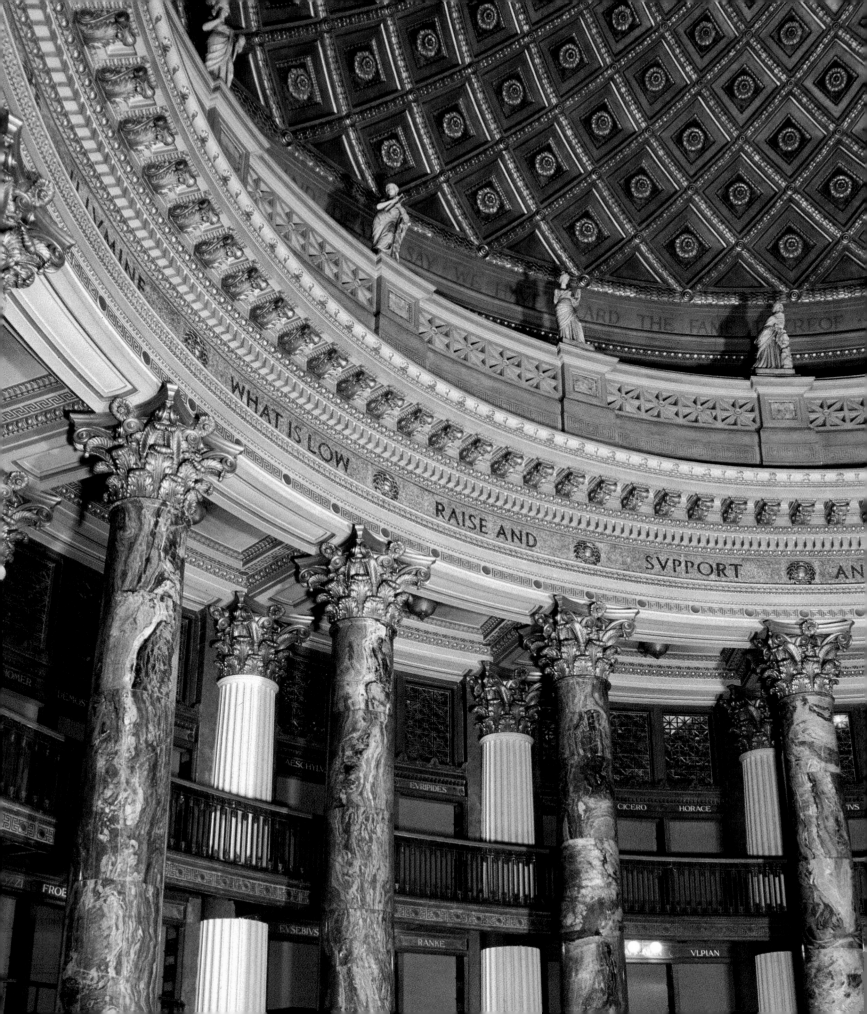

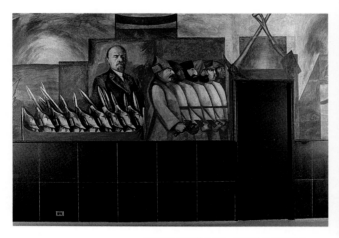

NEW SCHOOL FOR SOCIAL RESEARCH

Greenwich Village, Manhattan

Founded as an education center for working men and women, the New School for Social Research was built in 1930 to the designs of visionary Austrian architect, Joseph Urban. The remarkable egg-shaped auditorium *(right)* has a stage designed in imitation of the human ear, while the adjoining lobby, austere yet sensual, clearly reflects the influence of the Modern Movement in Urban's native Austria *(previous page)*. In a room which once served as a canteen, the walls are painted with frescoes by the Mexican artist, José Clemente Orozco, glorifying the Communist Revolution in Russia *(above)*. During the McCarthy period these would almost certainly have been defaced, but the school trustees cunningly draped them with curtains and they escaped unscathed. Ironically, perhaps, they have recently been restored with a grant from one of the giants of American capitalism, the Equitable Life Assurance Company.

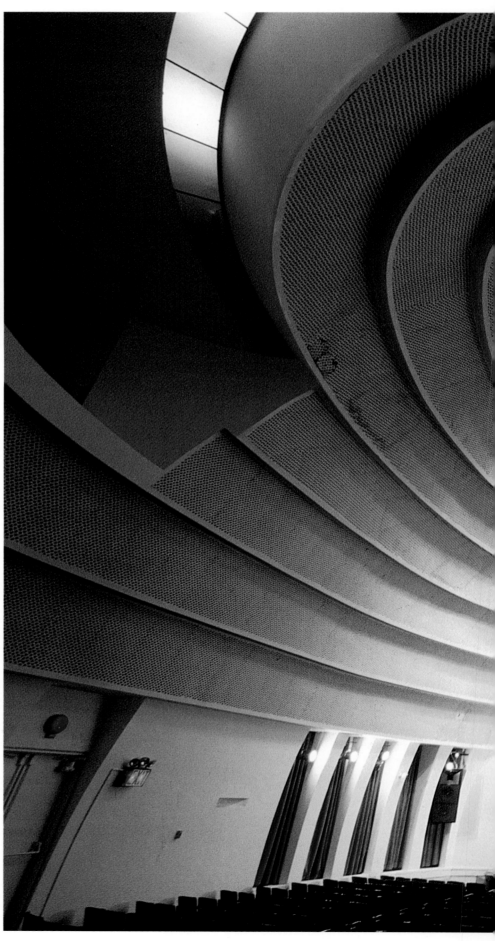

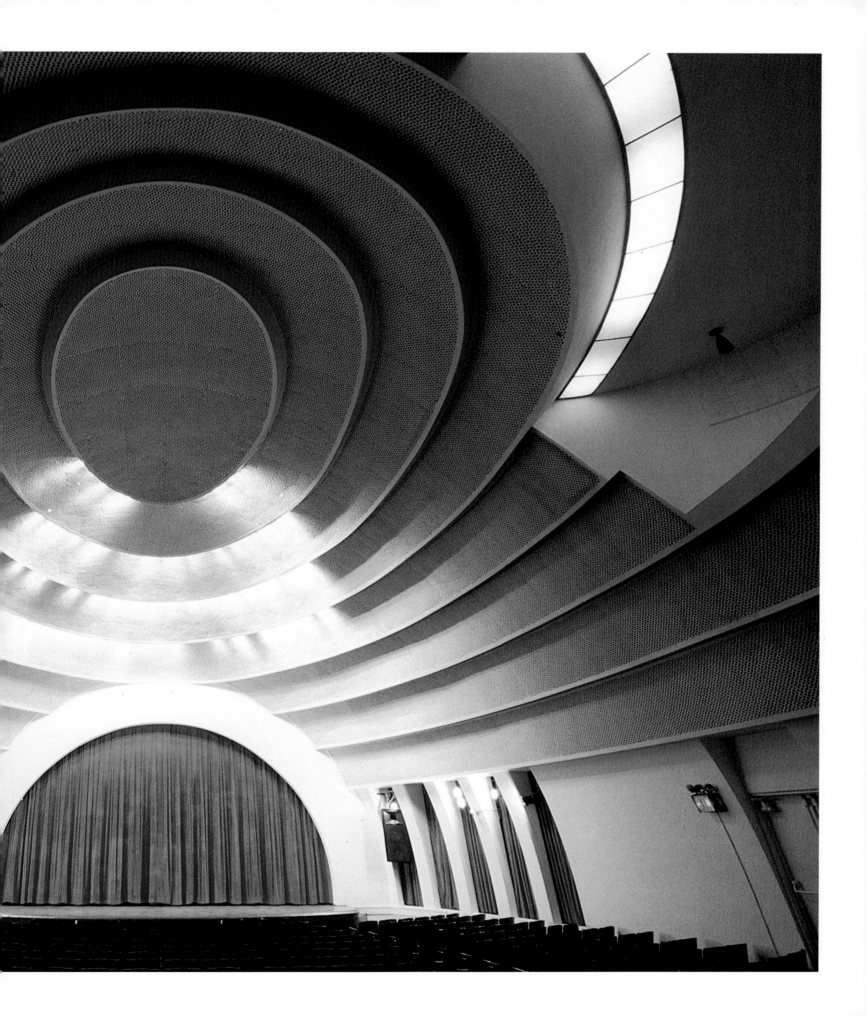

CONVENT OF THE SACRED HEART

Formerly James A Burden Mansion
Upper East Side, Manhattan

The Burden Mansion, built in the image of Versailles for steel-king James A Burden, was designed as a setting for lavish receptions. It comes as no surprise to discover that the architect, Whitney Warren, had studied in Paris and was assisted by French artists and craftsmen. A voluptuous eliptical staircase *(overleaf)* unfolds to reveal a stained glass cupola framed by paintings executed by Hector d'Espony. The Music Room, an eclectic yet harmonious composition in marble, gilt-bronze, carved wood and stucco *(right)*, provides an exuberant climax to the magnificent suite of reception rooms.

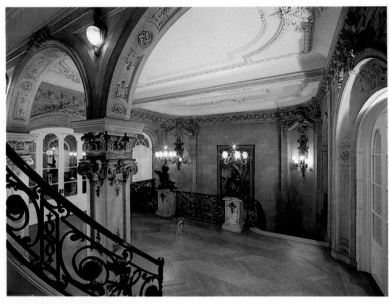

JOHNSON O'CONNOR RESEARCH FOUNDATION

Formerly the Fabbri Mansion
Upper East Side, Manhattan

The Johnson O'Connor Research Foundation occupies the old Fabbri Mansion, a palatial turn-of-the-century town house built as a wedding present from Margaret Vanderbilt Shepard to her daughter and son-in-law, Mr & Mrs Ernesto Fabbri, who lived here until 1916. Designed by the partnership of Haydel and Shepard (the latter a relation), two American architects who had studied in Europe, the interior is an eclectic synthesis of diverse styles. The staircase hall is broadly Louis XV, although with elements from other sources, and features lifesize figures in bronze of children bearing horns of plenty and torchères.

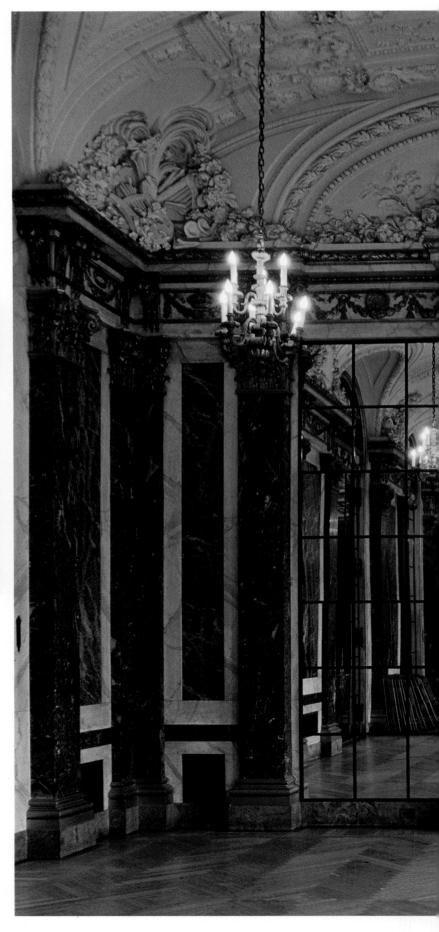

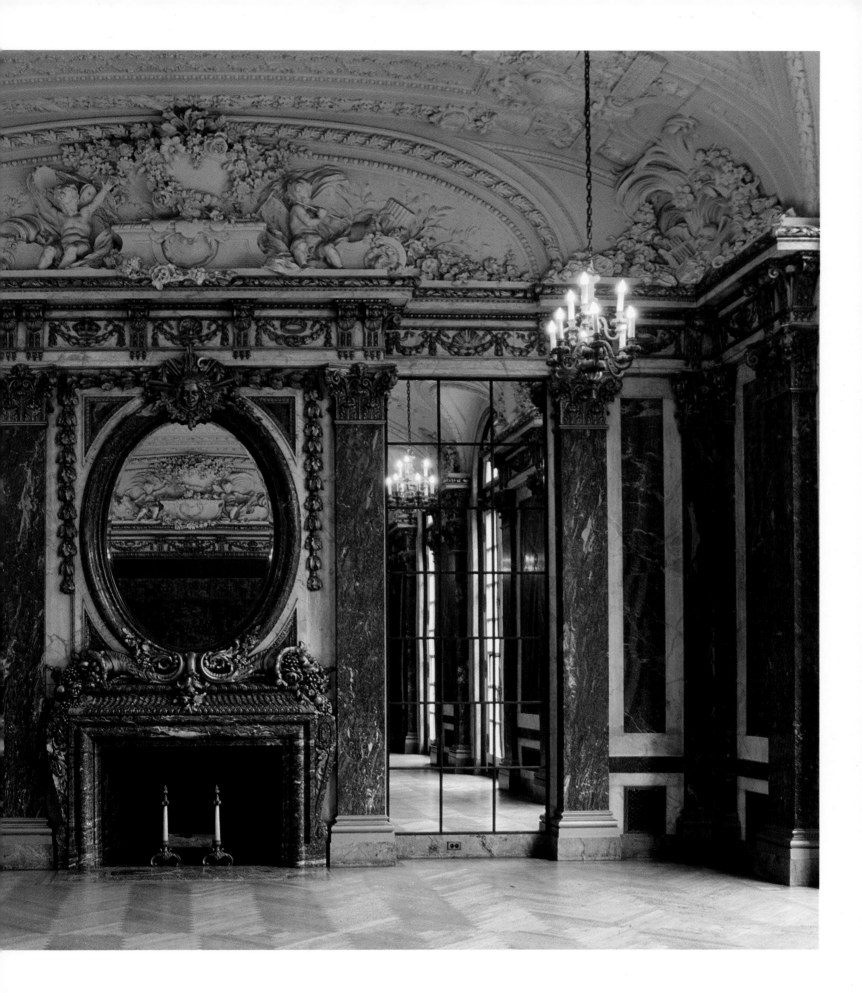

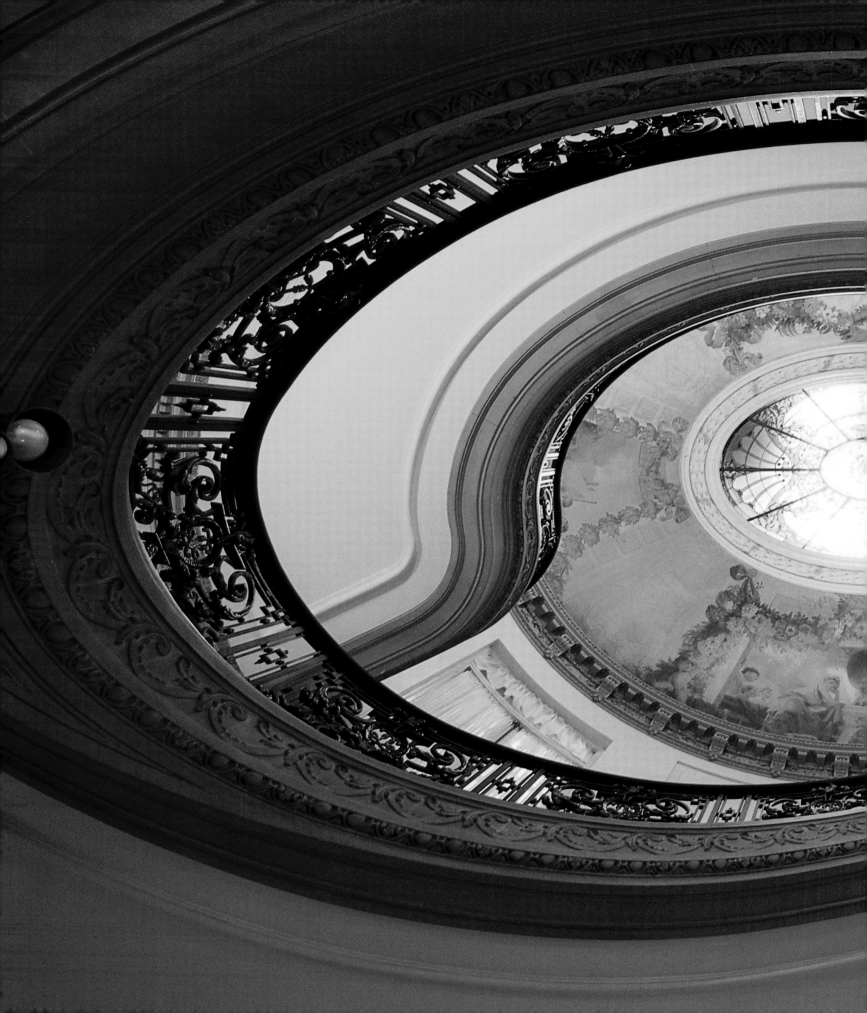

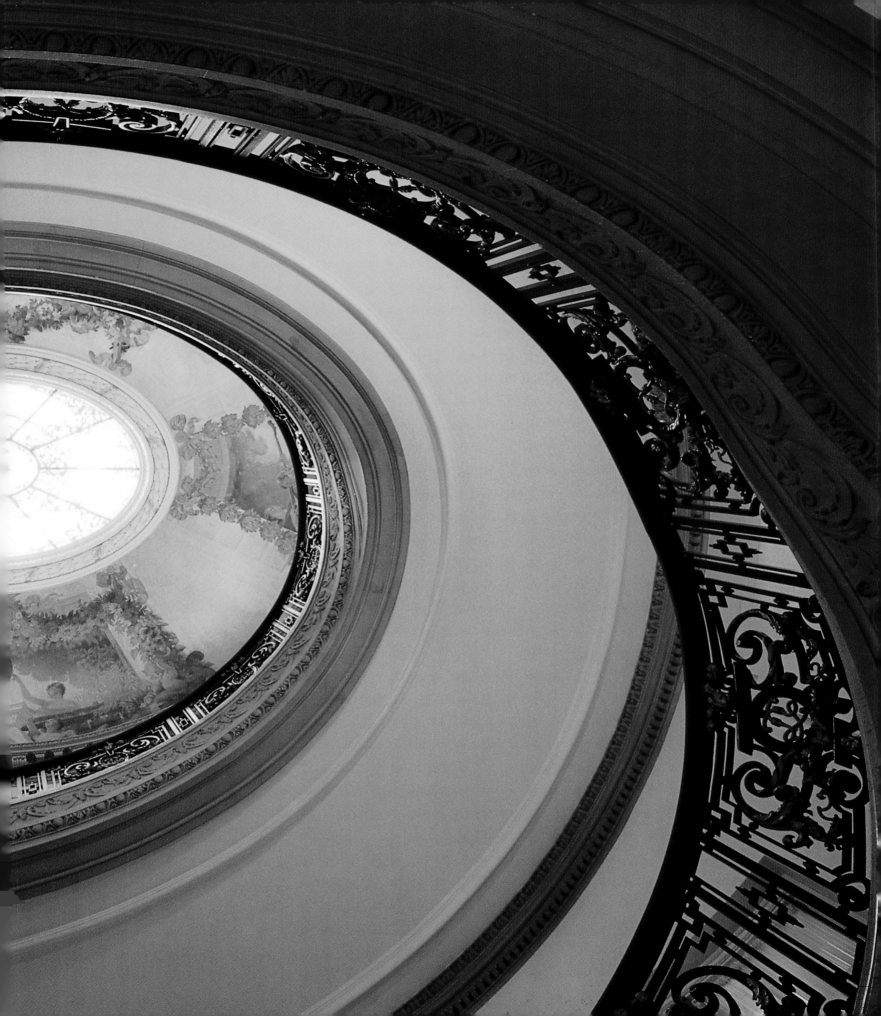

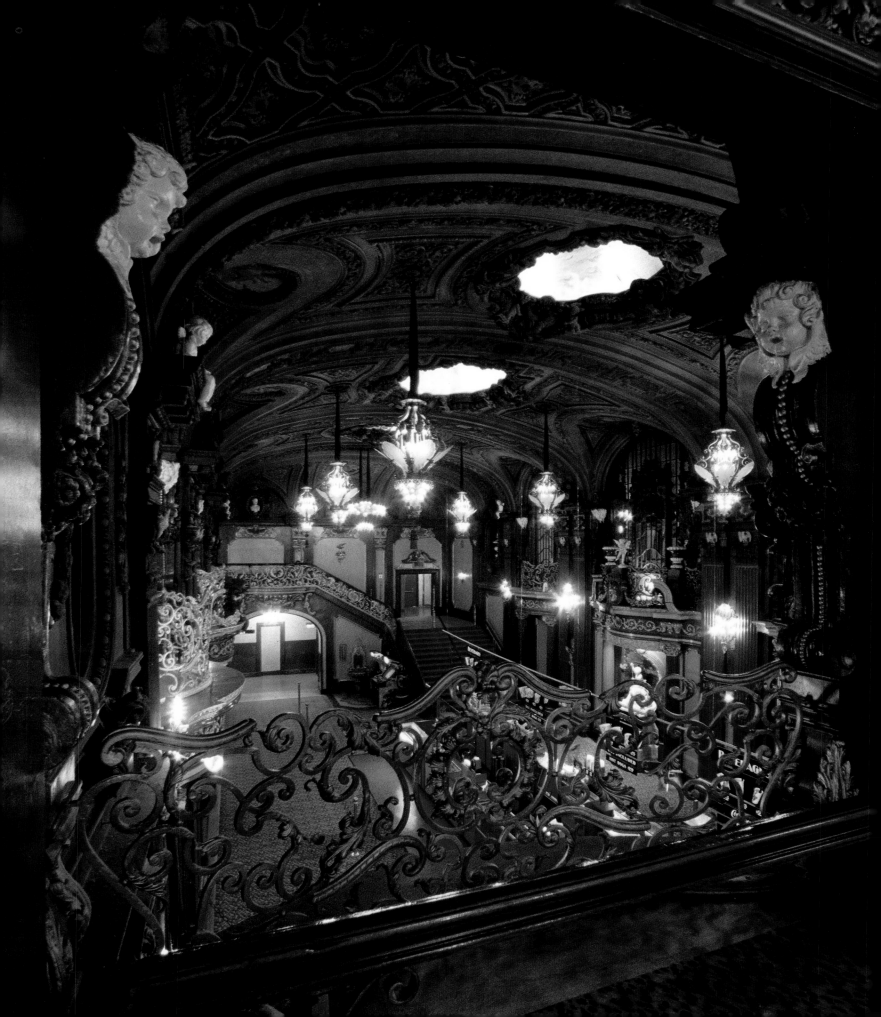

LOEW'S PARADISE THEATER

Fordham Heights, The Bronx

Where they have not been demolished or defaced, the old movie palaces of New York have generally been converted into evangelical churches, rock venues, furniture warehouses, even grocery stores. The Paradise, however, is still used as a cinema, and although the auditorium itself has been partitioned and the lobby is given over to popcorn and soda stands, much of the original decoration remains intact, including a heavenly host of angels illuminated by Chinese lanterns.

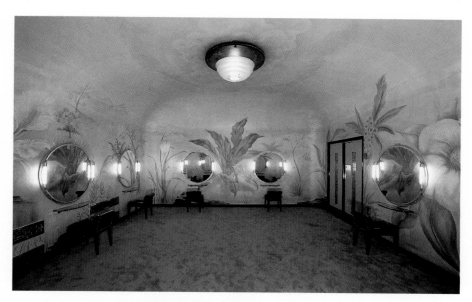

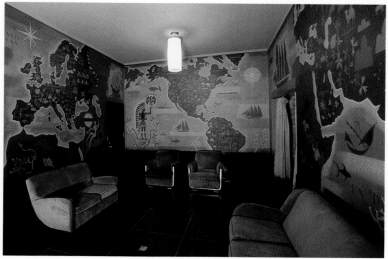

RADIO CITY MUSIC HALL

Rockefeller Center, Manhattan

Radio City Music Hall is a shrine to popular American culture, a fantastical Art Deco playground, where architecture, painting and sculpture come together to celebrate the values of mass entertainment. Designed by Donald Deskey, the interiors were completed in 1932 and are among the best preserved examples of their kind in New York, retaining practically all their original furnishings. They not only provide the background to the show; to a large extent they are the show. The Ladies' Powder Room *(above)* has exotic floral murals in the style of Georgia O'Keefe, while the walls of the Gentlemen's Smoking Room are painted with maps of the world symbolising man's dominion over the earth *(left)*.

SAILORS' SNUG HARBOR MUSIC HALL

Staten Island

Founded in 1801, Sailors' Snug Harbor was New York's answer to London's Greenwich Hospital, a retirement home for veteran seamen which has recently beenconverted for use as a cultural center. The old Music Hall *(right)* is long disused and badly scarred but sublime in the manner of all great ruins, with crumbling Ionic pilasters and a spirited allegorical relief above the proscenium arch. The lobby *(above)* is equally atmospheric, retaining its original painted frieze of theatrical masks and festoons. A cast-iron statue of Neptune has been brought in from a broken-down fountain in the grounds. This is one of the oldest surviving theaters in New York, built in 1892; it has been designated a landmark, but for lack of funds, and perhaps political will, restoration has been delayed and it is now considered a dangerous structure, barred to the public.

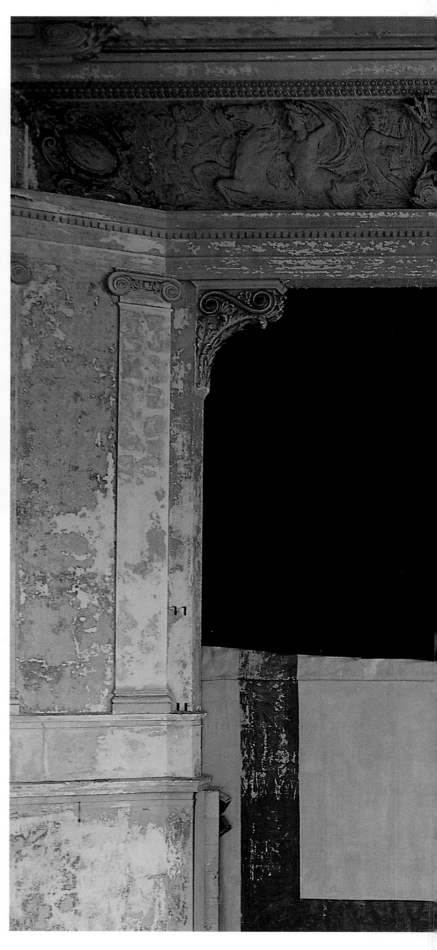

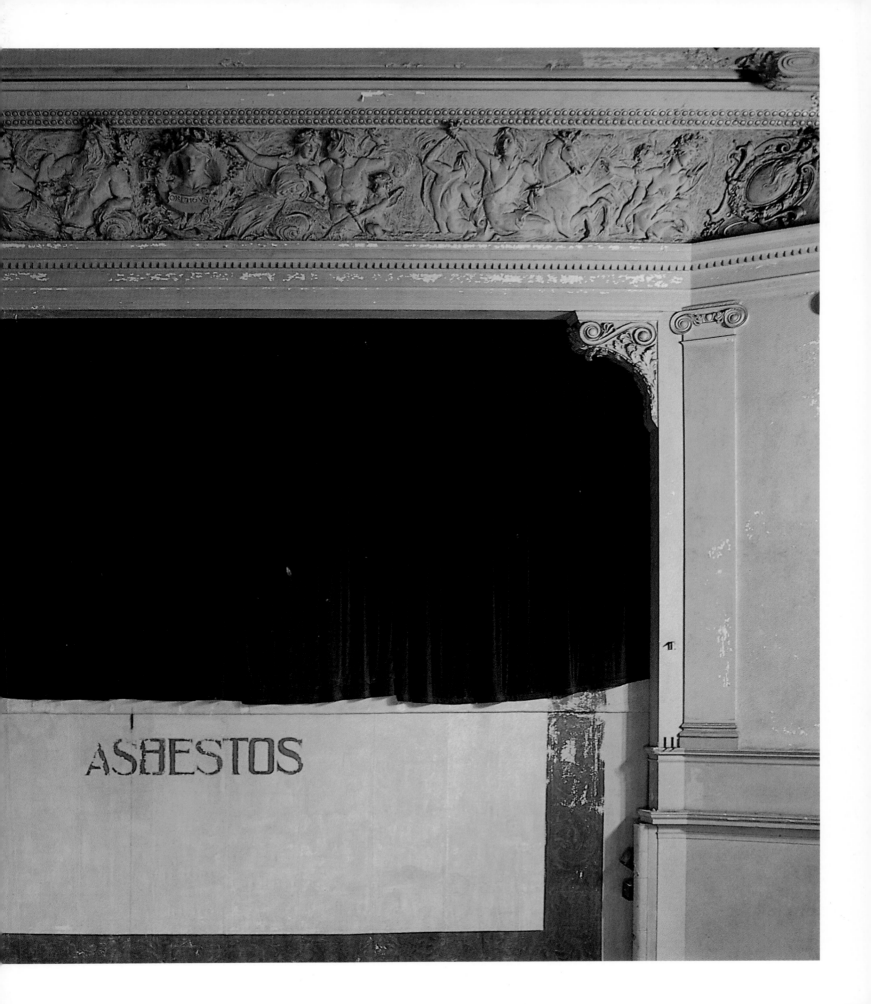

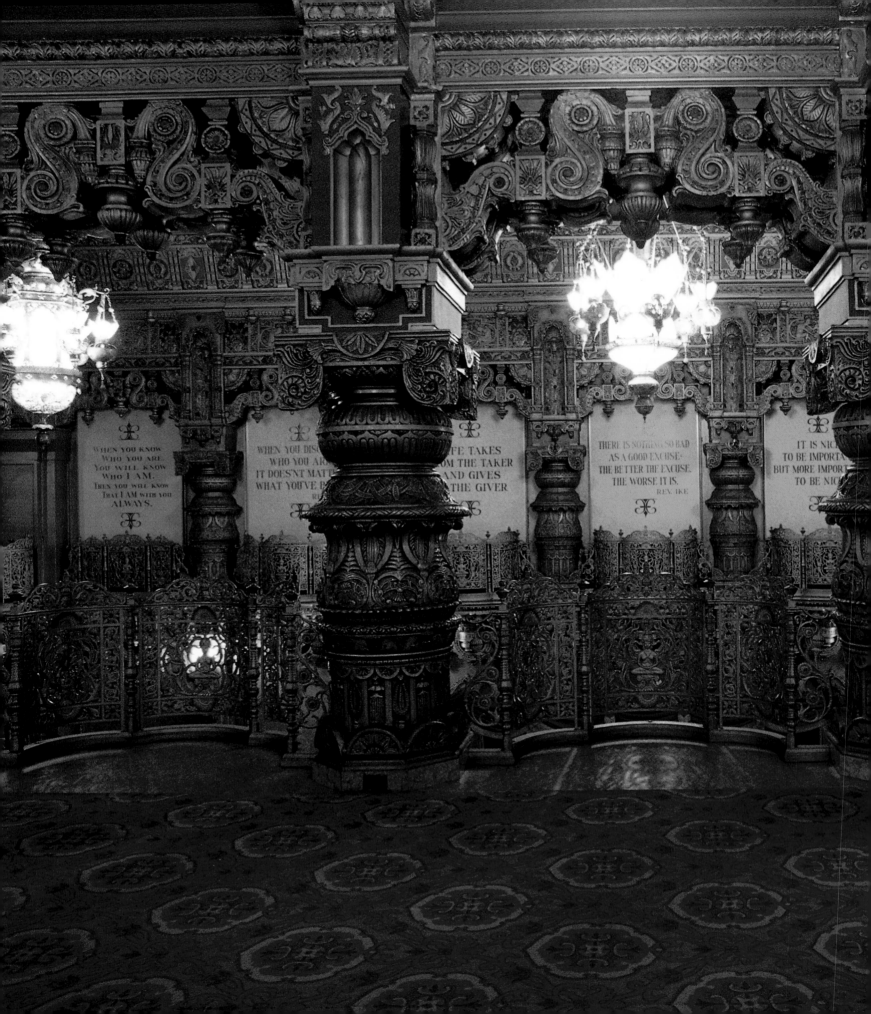

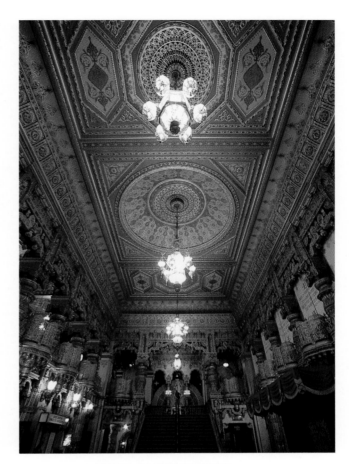

LOEW'S 175TH STREET THEATER

United Church
Washington Heights, Manhattan

The old Loew's Theater on West 175th
Street is by far the most spectacular
surviving movie palace in New York.
Designed by Thomas Lamb, architect of
the Mark Hellinger Theater *(frontispiece)*,
it was built in 1930 as part of a vast chain
of cinemas operated by visionary
impresario Marcus Loew. 'We sell tickets
to theaters, not movies,' Loew once
boasted, and here on 175th Street it is
hard to imagine any movie living up to
the thrill of the theater itself. The lobby
(above and left) is an Indo-Moorish fantasy,
a stylistic head-on collision between the
Brighton Pavilion, Kajirao and the
Alhambra Palace. It may seem extraor-
dinary now, but how much more
extraordinary at the time it was built,
when few Americans had ever travelled
abroad and the country was in the
depths of the Great Depression. Today
the building serves as an evangelical
church. In this gilded Shangri-la, says the
resident preacher, 'You can feel the
richness of God.'

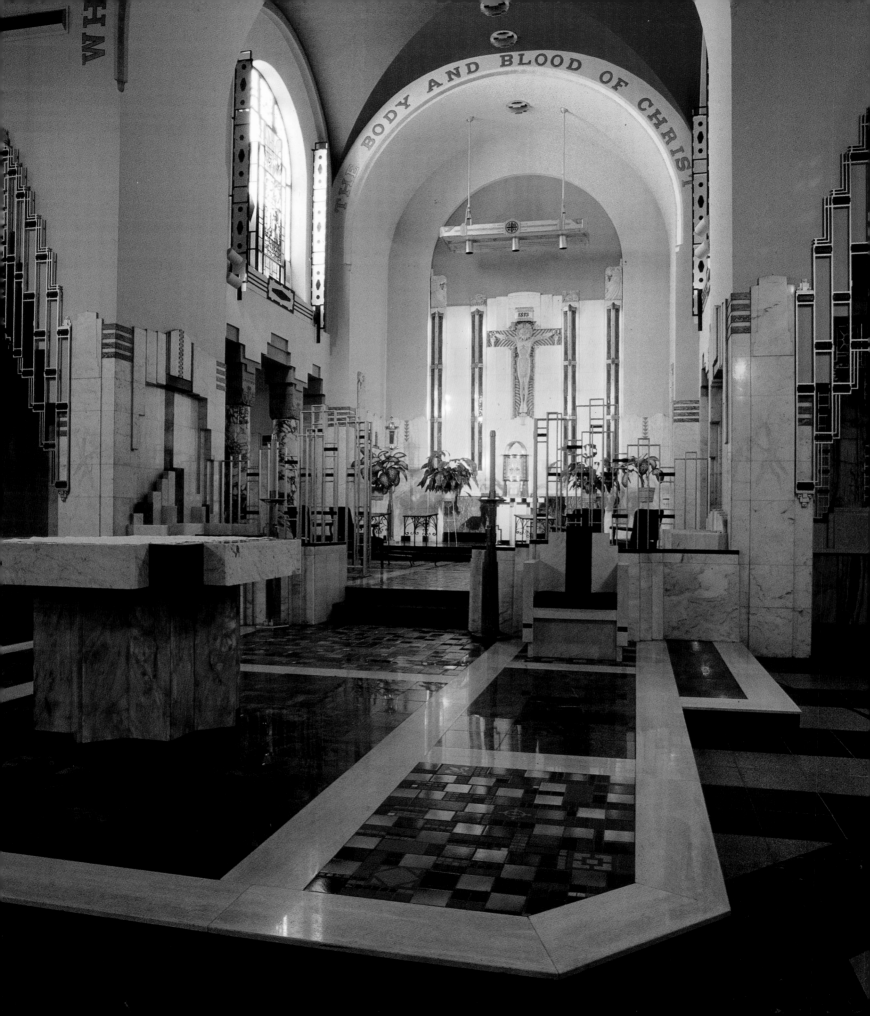

CHURCH OF THE MOST PRECIOUS BLOOD

Long Island City, Queens

The plan of the church is perfectly traditional, conforming to every requirement of the Catholic liturgy. The detailing, however, is unashamedly Art Deco, and taken as a whole the interior constitutes one of the most thorough-going statements in that style anywhere in New York. It is unusual to find Art Deco applied to the design of places of worship; the style was essentially profane, associated with secular buildings, such as corporate headquarters, hotels, cinemas, night clubs and apartment blocks, and thus with fashion, big business, entertainment and fast living. Here, however, it is used to sanctify a sacred space. Certain elements are derived from the mission churches of New Mexico, such as the terracotta tiles and whitewashed plaster walls. Another striking feature is the use of stepped pyramidal forms to represent the Stations of the Cross, while on either side of the Crucifix above the altar the blood of Christ is symbolised by illuminated red panels trimmed in aluminium.

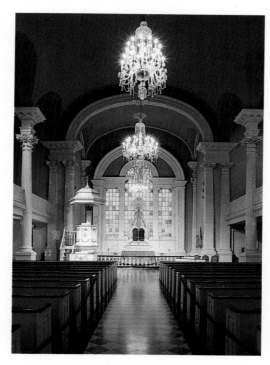

ST PAUL'S CHAPEL

Civic Center, Manhattan

St Paul's is the only surviving pre-Revolutionary church in Manhattan and the island's oldest public building to have remained in continuous use. The church dates from the 1760s and was originally built in open fields outside the city boundaries. Now it stands in the thick of the Financial District, dwarfed but not diminished by the high-rise buildings that surround it on all sides. The interior clearly shows the influence of eighteenth-century English church design, especially St Martin-in-the-Fields by James Gibbs. The arms of George III appear on the gallery, the coronet and feathers of an English nobleman are found on the pulpit, and the cut-glass chandeliers are of Irish manufacture. In recent years attempts have been made to restore the original paintwork: eighteenth-century architects were not afraid to use bright colors, but this confection of bourbon pink and peppermint green may be going too far.

overleaf

ELDRIDGE STREET SYNAGOGUE

Lower East Side, Manhattan

In 1886 work began on the construction of a large neighborhood synagogue in Eldridge Street, which was for many years the center of a poor but thriving community of Jewish refugees from Eastern Europe. In time the community prospered and its members gradually moved away to more affluent areas. By the 1930s few remained and the Eldridge Street Synagogue virtually shut down. The magnificent sanctuary was sealed, and services were held for a dwindling number of worshippers in a make-shift prayer-hall in the basement, until a short time ago when this dilapidated interior was rediscovered. Architecturally it represents a fascinating blend of Moorish, Gothic and Romanesque, highlighting the dilemma faced by synagogue architects in their search for an appropriate style.

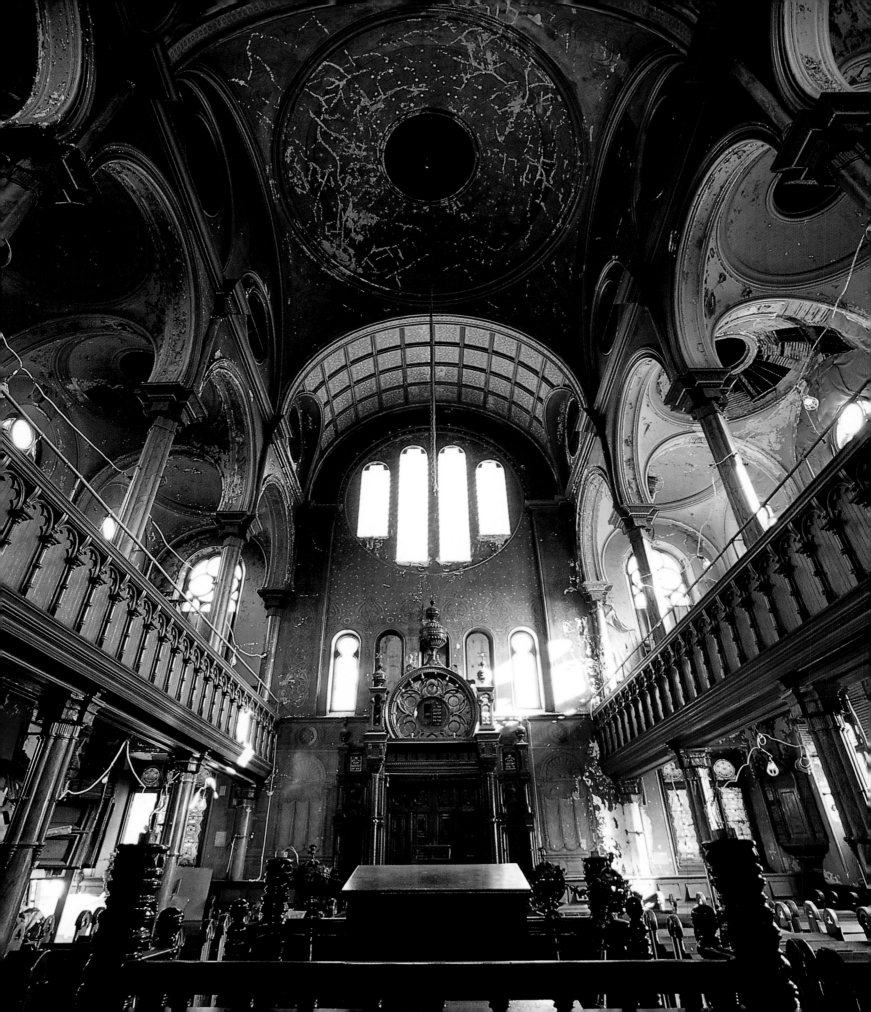

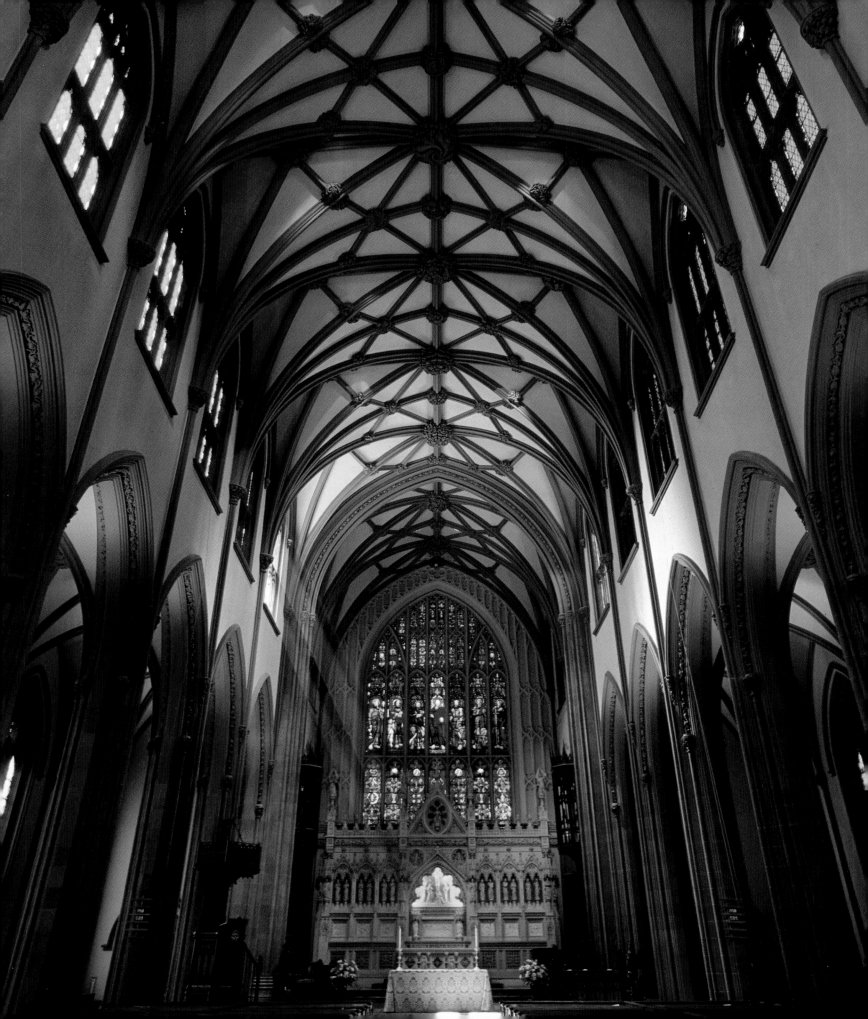

previous page

TRINITY CHURCH
Wall Street, Manhattan

St John the Divine may be the largest
Gothic Rivival church in New York (the
largest in the world, in fact) but Trinity is
surely the most beautiful. The building
was completed in 1846 to the designs of
Richard Upjohn, an English-born
architect who had settled in Boston; it is
the third church on this site, the first
having been erected in 1698. Located at
the juncture of Broadway and Wall
Street, in a neighborhood devoted to
material gain, it stands conspicuous as a
symbol of the survival of religious faith
and spiritual values.

FRIENDS MEETING HOUSE
Flushing, Queens

Set back from Northern Boulevard, a
ten-lane freeway that cuts a swathe of
noise and pollution through the heart of
modern Queens, the Friends Meeting
House is New York's oldest place of
worship. This modest, late seventeenth-
century timber structure originally stood
in open country and has been in
continuous use for almost three hundred
years, except for the period 1776-83
when it was occupied by the British,
who used it successively as a jail, a
hayloft and a field hospital. Simple yet
sturdy in its architecture, the building is
a metaphor for the religious feelings of
the community that built it: humble
before God, pure and strong in its faith,
austere in its devotion.

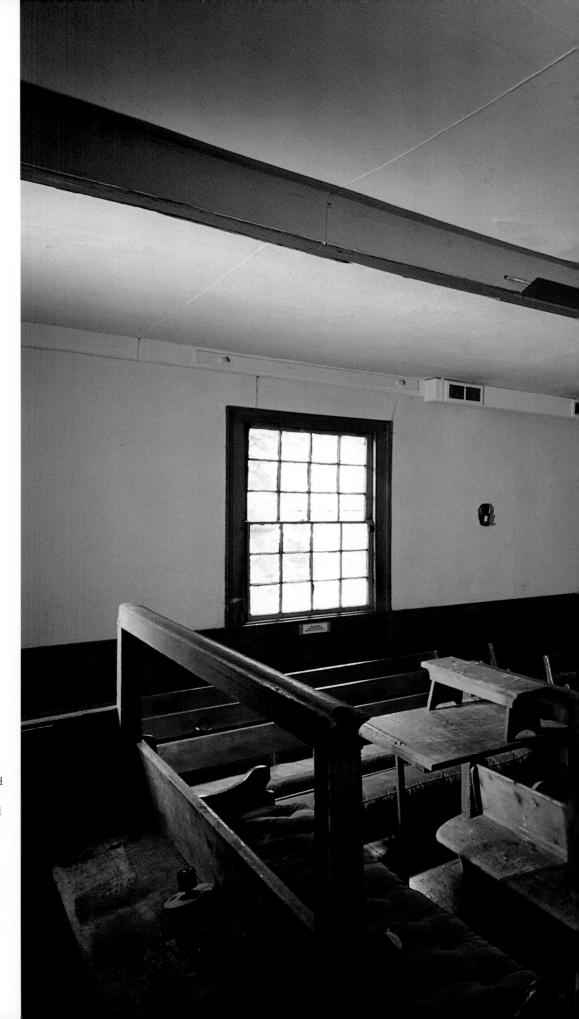

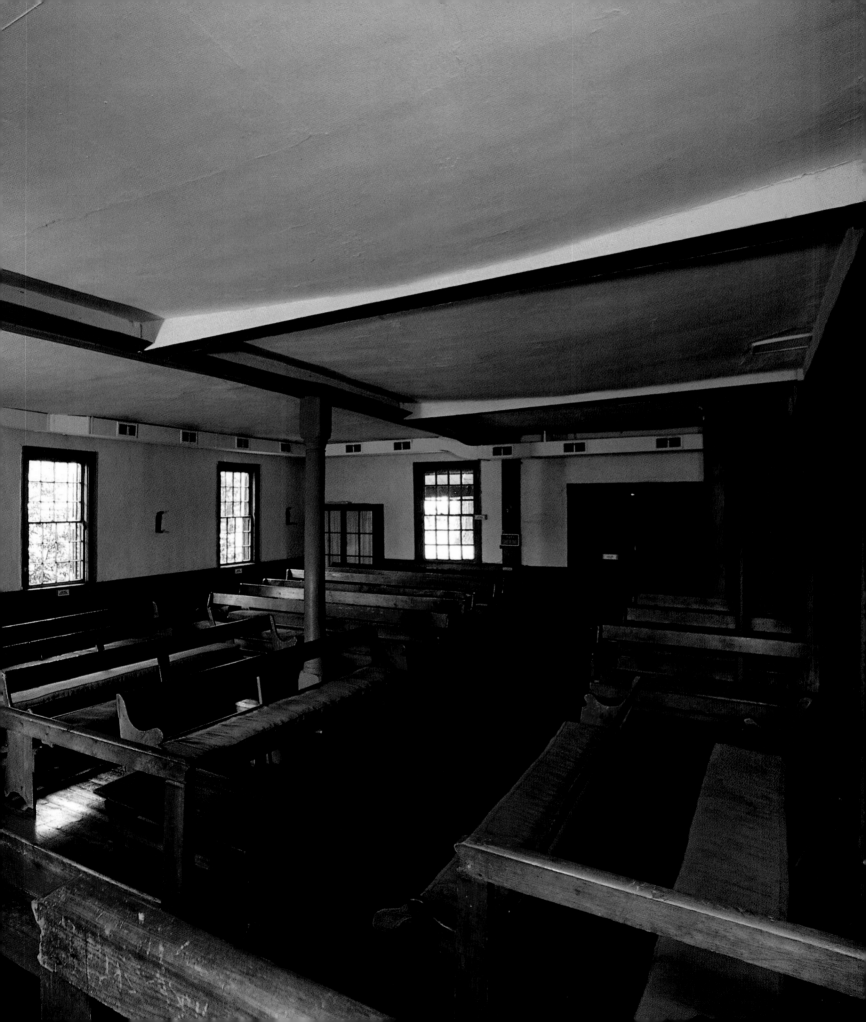

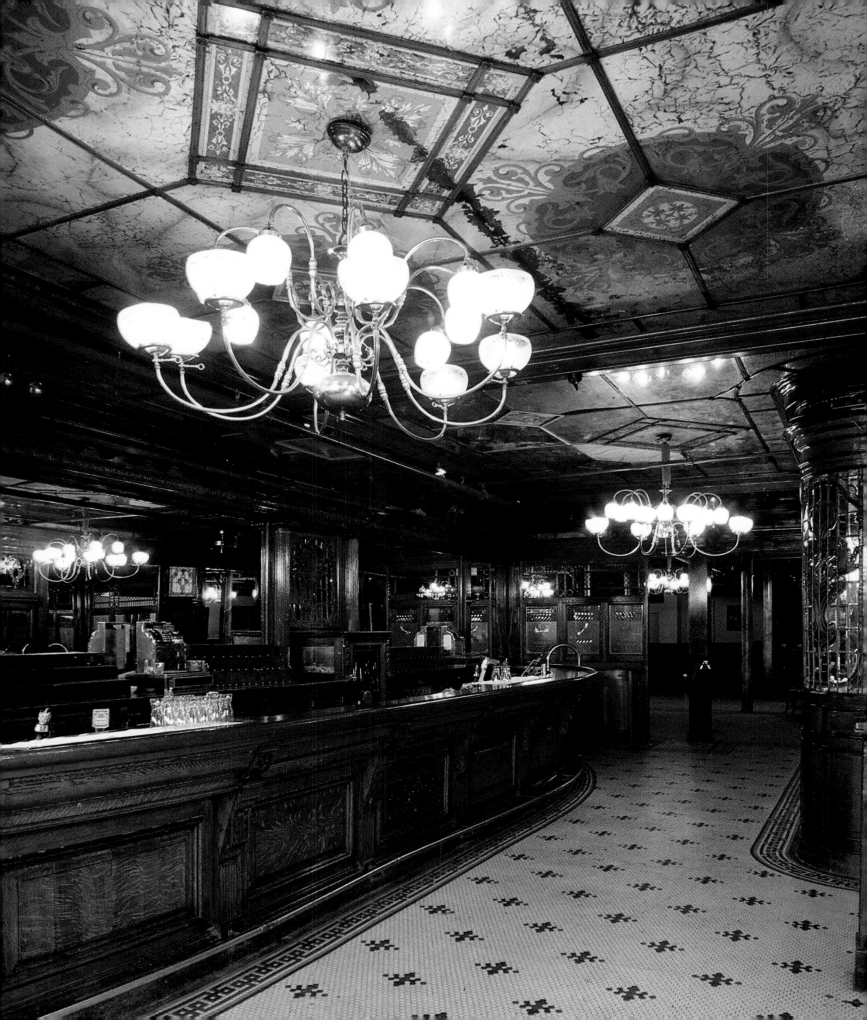

EXSPO
Chelsea, Manhattan

This former working men's club, which has served in its time as a restaurant, a public bar and a venue for rock concerts, is one of the forgotten wonders of New York. The interior dates from the nineteenth century and features a unique painted glass ceiling, complemented by mahogany panelling, etched glass panels and a terrazzo floor. It has changed hands so many times and catered to such a wide variety of people, in such differing circumstances, it is hard to believe that so much of the original decoration survives, and the current owners are to be commended for the trouble they have taken in preserving this precious relic of the past.

P J CLARKE'S BAR
Midtown, Manhattan

Few New York bars survive from the days before Prohibition, fewer still from the late-nineteenth century, and the number which have retained their original decoration can be counted on the fingers of one hand, which is why P J Clarke's is so special, its diminutive red brick facade gloriously incongruous amid the high-rise blocks and roaring traffic of Third Avenue. The men's room *(above)*, which occupies the greater part of the bar area, is indisputably the best in the city. Can there be another with the same domed stained-glass ceiling and mirror-plated mahogany walls?

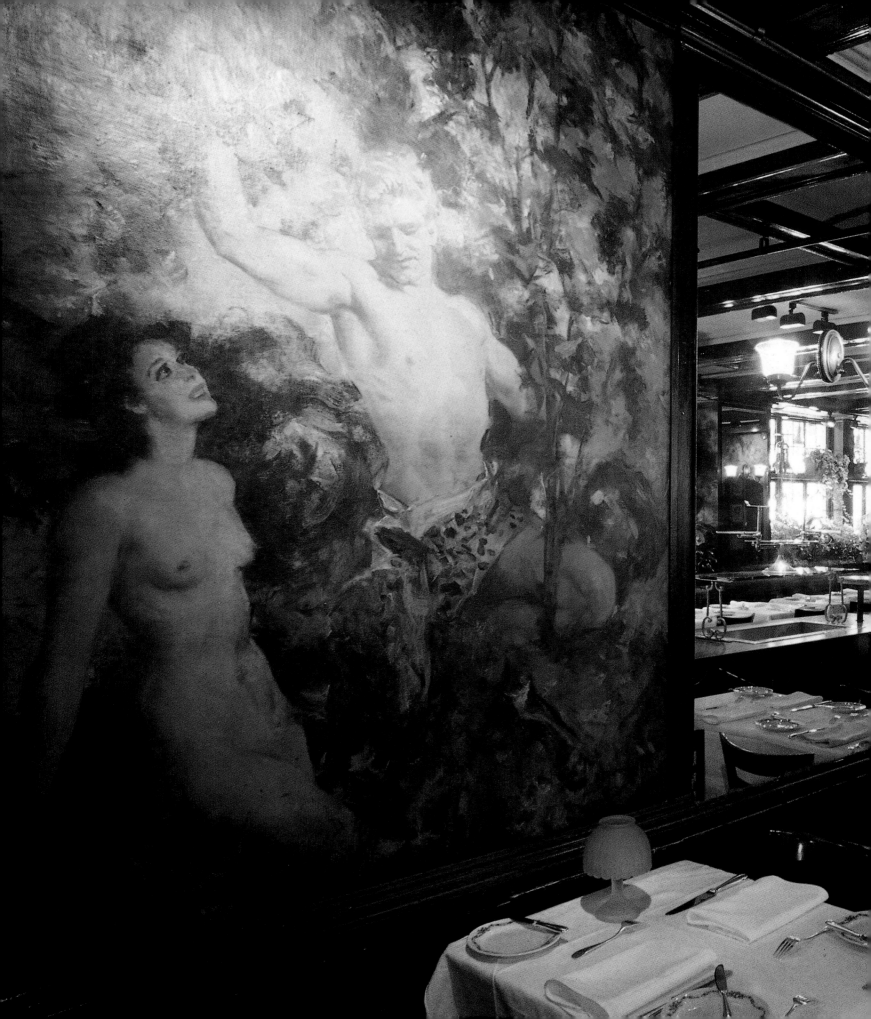

CAFÉ DES ARTISTES
Central Park West, Manhattan

The Café des Artistes is part of the famous Hotel des Artistes, an Elizabethan-style apartment building erected in 1915-17, which was originally designed for the use of artists and performers, among them Isadora Duncan, Noel Coward, Al Jolson, Rudolph Valentino, Marcel Duchamp, Robert Lowell and Norman Rockwell. The restaurant originally functioned as a central canteen for residents, since the apartments were not then provided with kitchens. Today it is a fashionable bistro, frequented by some of the famous musicians and dancers who regularly perform at nearby Lincoln Center. The walls are decorated with murals *(below)* executed in 1933 by Howard Chandler Christy, a commercial artist and society portrait painter who at the time was a resident of the hotel. His subject is a chorus of naked American showgirls, magically transported to a tropical paradise – noble savages indeed.

GAGE & TOLLNER

Downtown Brooklyn, Brooklyn

It would be surprising anywhere, but in New York it is astonishing, and on Fulton Street bewildering, to come across an unspoilt late nineteenth-century chop house with functioning gas lamps. The restaurant opened in 1892 and is named after the original owners, Charles M Gage and Eugene Tollner. When the partners sold out in 1911 they made it a condition that nothing be changed, and their wishes have largely been respected. Lincrusta paper still lines the walls; the original arched mirrors, which greatly increase the room's apparent size, are still in place; even the tables and chairs are said to date from the 1890s.

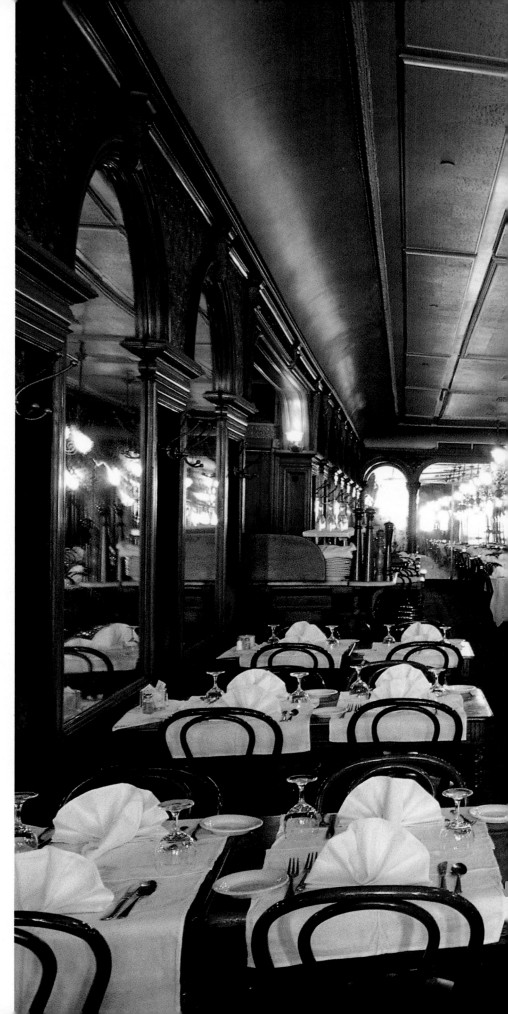

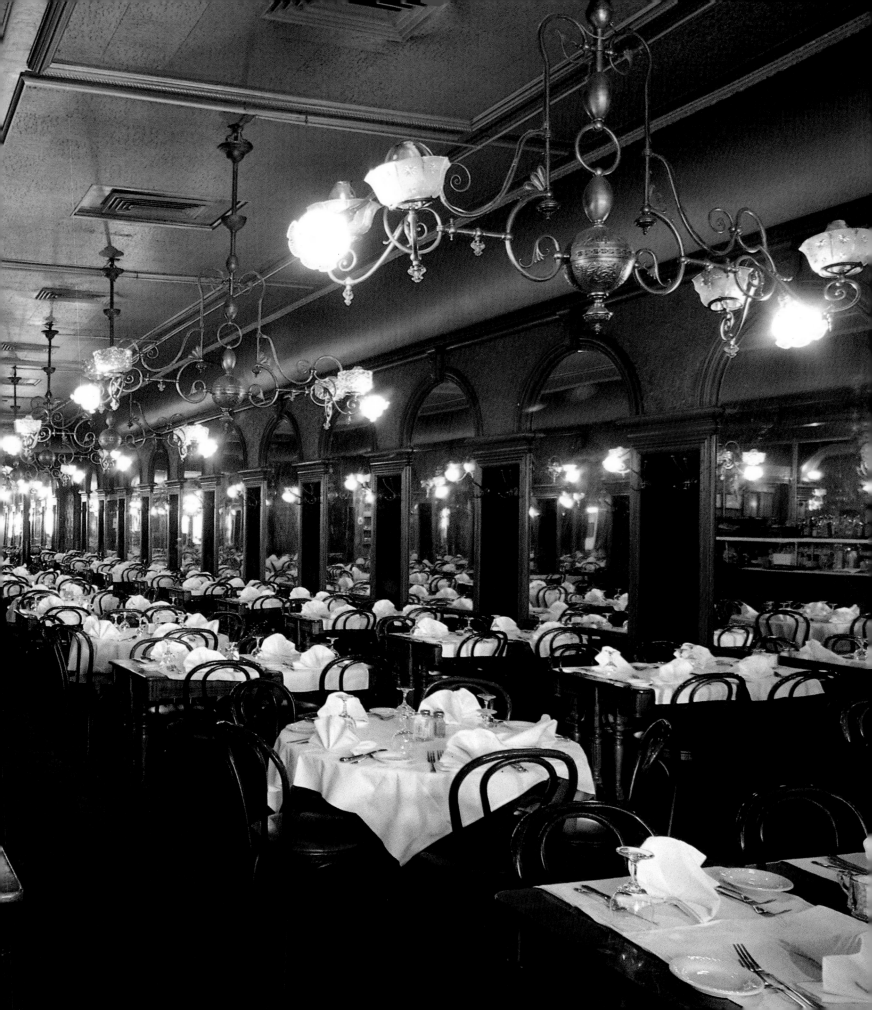

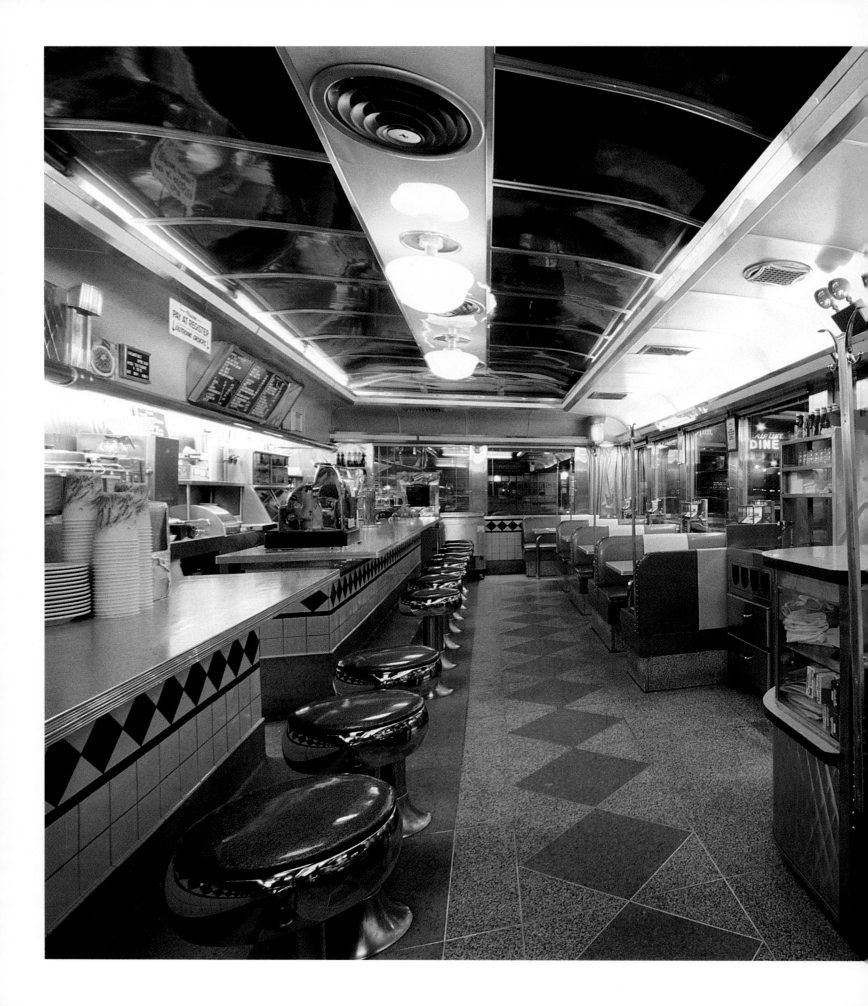

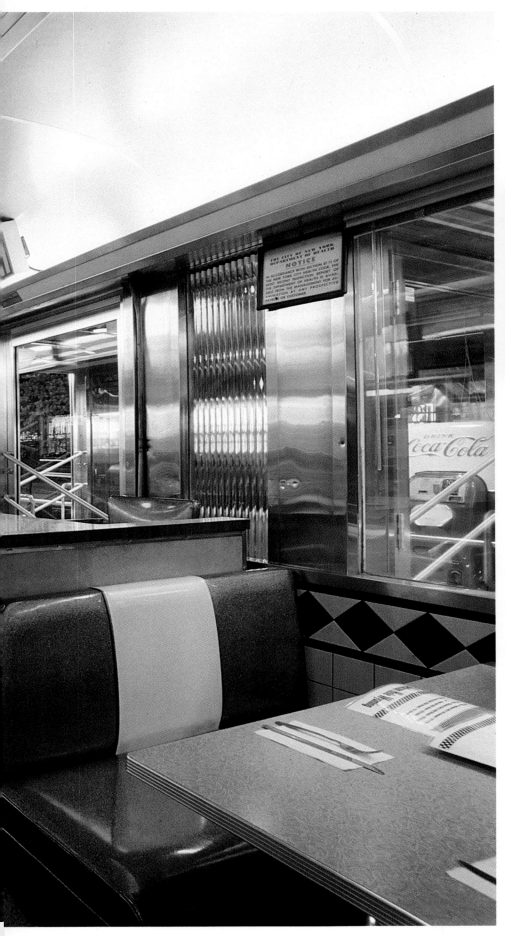

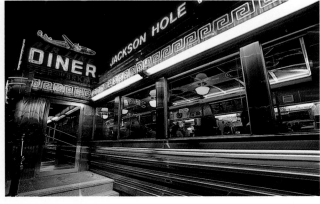

THE AIRLINE DINER

Now called Jackson Hole Wyoming
Astoria, Queens

Once a common sight on the streets of
New York, the traditional American
diner is now an endangered species,
hounded into extinction by the fast-food
chains. A long hard search through all
five boroughs revealed only one that
retained its original decor and had not
been restored beyond recognition: the
Airline Diner, a perfectly-preserved
1950s eatery on the road from La Guardia
Airport. Built in 1954 by the Mountain
View Diner Company in New Jersey, it
features all the classic essentials, including
quilted metalwork, neon signs, formica-
topped tables and vinyl-covered benches
and stools.

McSORLEY'S OLD ALE HOUSE

East Village, Manhattan

'Good Ale, Raw Onions, No Ladies'. This was the sign that hung outside the McSorley Saloon when it opened in 1854. It was true then, and it is largely true today, although since 1970 the management has been forced to tolerate the presence of women. Humphrey Bogart was a regular, as were Henry Fonda, Laurel and Hardy and virtually every American President since Abraham Lincoln, not to mention the British Prime Minister, Lloyd George. The bar remained open throughout Prohibition. By means of a hidden footpump, barmen were able to serve regular customers with the famous McSorley brew, while newcomers and suspected informers received a legal low-alcohol substitute known as 'near beer'. On the walls hang leather fire helmets, shillelaghs and Fenian bonds from the 1830s (the bar is still Irish-run), while the well-worn bar keeps company with an original pot-bellied stove that once warmed a free supply of soup and chowder.

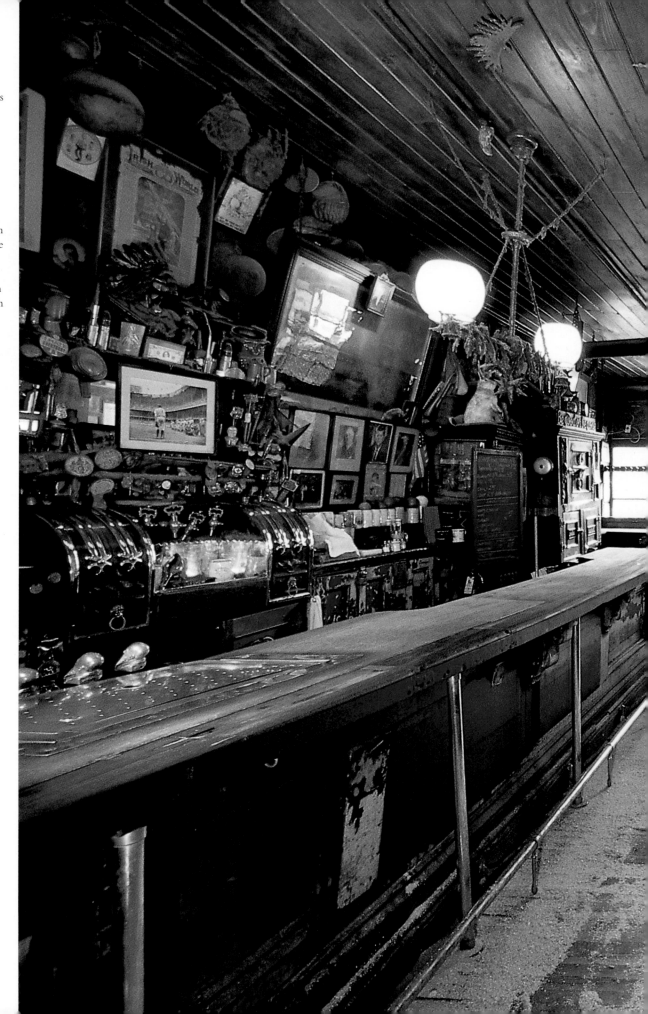

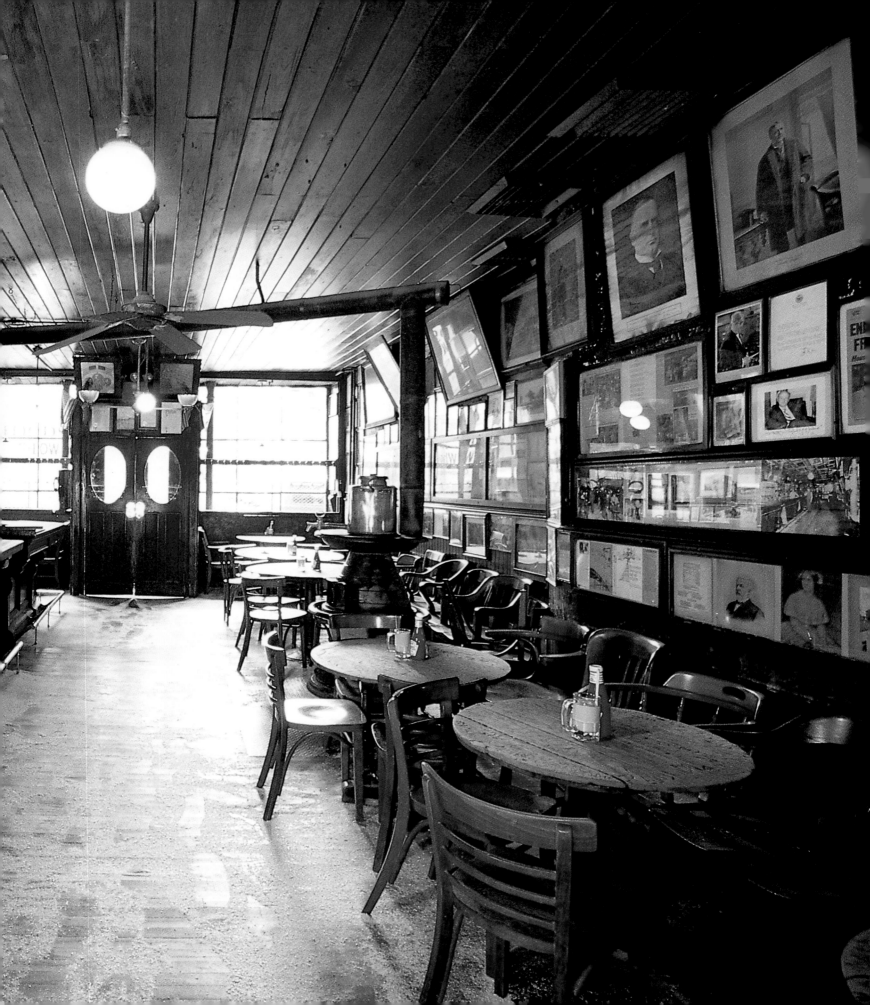

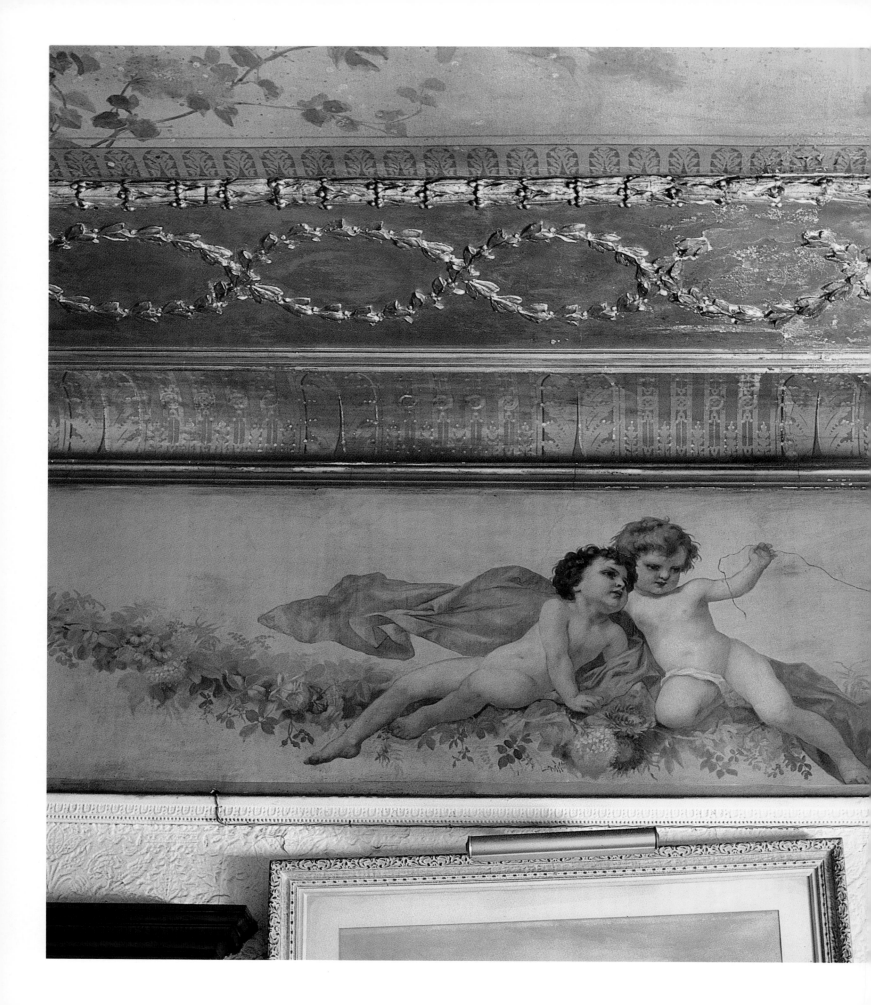

THE CHELSEA HOTEL
Chelsea, Manhattan

The Chelsea Hotel is part of the mythology of New York; not so much a hotel, more a rite of passage, a fixture in the itinerary of any remotely ambitious artist. The guest list reads like a *Who's Who* of music, painting, literature and the performing arts. Sarah Bernhardt was here, Bette Davis, Dylan Thomas, Jasper Johns, Andy Warhol and Bob Dylan, to name but a few. The building dates from 1884, and the exterior is hung with some of the finest wrought-iron balconies outside New Orleans (matched, if not surpassed, by the balustrade on the eleven-storey staircase inside). Less well known is the manager's office *(left)*, which retains virtually all its original fittings, together with a whimsical painted ceiling and frieze ornamented with cherubs and festoons.

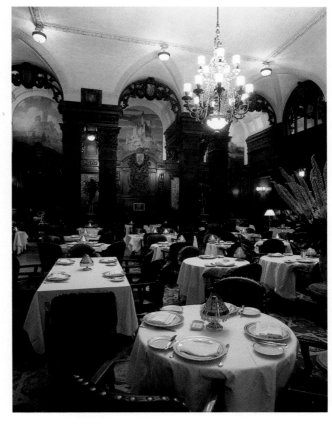

THE PLAZA
Midtown, Manhattan

The Oak Room at the Plaza epitomises the sophistication and wealth of turn-of-the-century New York. The style, however, and even some of the materials, are European. The panelling, for instance, from which the room derives its name, was imported from England, while the wall paintings offer views of romantic German castles on the Rhine.

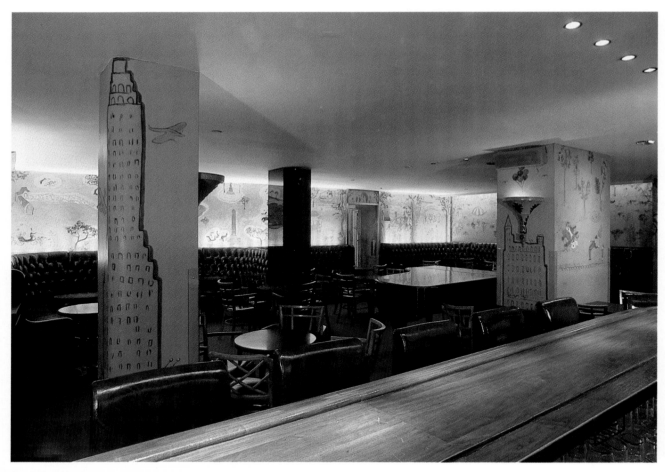

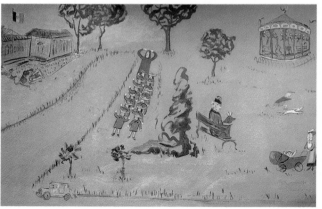

THE CARLYLE
Upper East Side, Manhattan
The highlight of the Carlyle Hotel is Bemelman's Bar. The architecture is unexceptional perhaps, but the murals and ceiling paintings are a delight, executed by the caricaturist Ludwig Bemelmans, from whom the bar derives its name.

ST REGIS-SHERATON HOTEL
Fifth Avenue, Manhattan

The wraps are finally off, and after a three-year restoration program costing an estimated $100 million, visitors can experience once more the spectacular Beaux-Arts interiors of the old St Regis Hotel. The hotel was built in 1904 by John Jacob Astor, and it was Astor's granddaughter Jacqueline Astor Drexel who cut the ribbon at its official reopening. Continuity was the key, and by and large the restoration has been a success, despite the fact that more gold leaf was expended than on any other building in the United States, with the sole exception of the Mormon Tabernacle in Utah. The lobby features scrolling, gilt-bronze balustrades, illuminated fairy lights, and what must surely be the finest revolving doors in New York City.

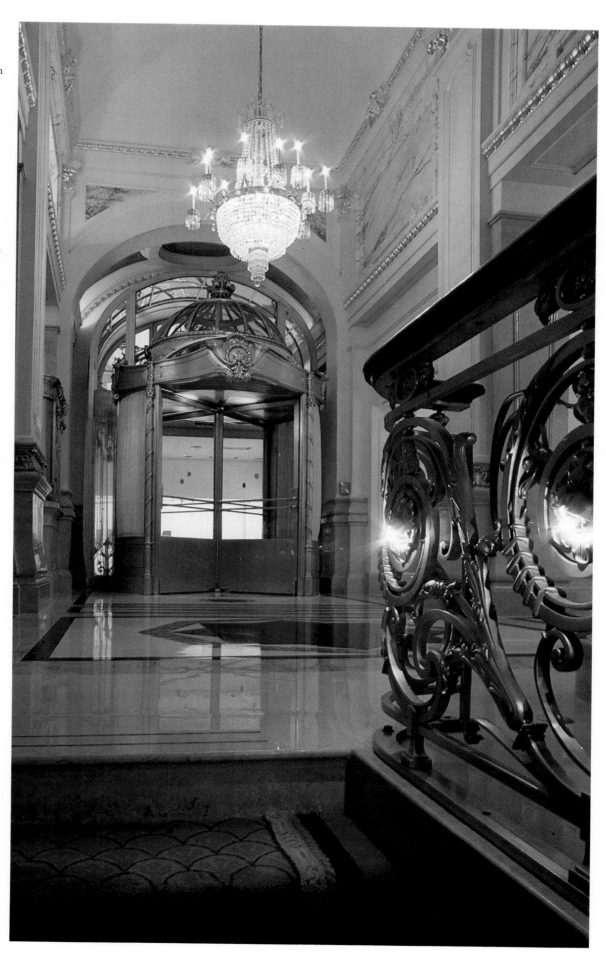

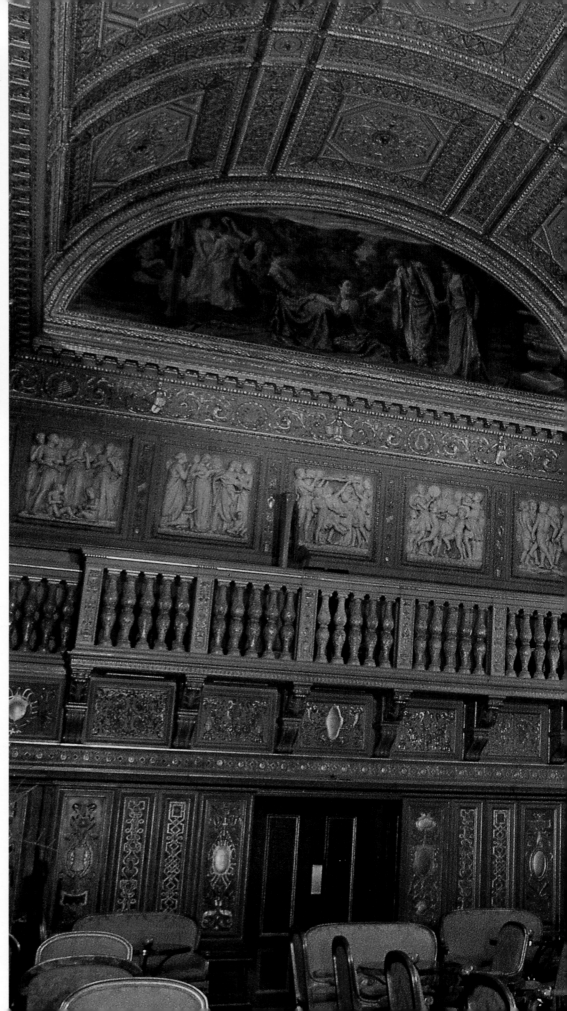

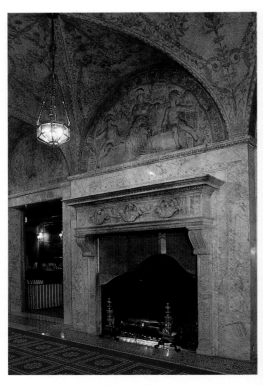

HELMSLEY PALACE HOTEL

Formerly the Henry Villard Mansion
Madison Avenue, Manhattan

Few interiors in New York give a better idea of the style in which the millionaire class lived towards the end of the nineteenth century than those of the old Villard Mansion on Madison Avenue, recently acquired and impeccably restored by the Helmsley Palace Hotel. The mansion was built in 1883-6 for Bavarian-born railroad tycoon Henry Villard, and was designed by Charles McKim, architect of both the Morgan Library *(pages 34-5)* and the University Club *(pages 106-7)*. The exterior was inspired by the Cancelleria in Rome and heralded the Renaissance Revival. The interior featured a vaulted two-storey music room *(right)*, with a minstrels' gallery surmounted by a mural by John La Farge. In the marble and mosaic staircase hall the sculptor Augustus Saint-Gaudens carved a magnificent chimney-piece of Renaissance inspiration with figures symbolic of peace *(above)*.

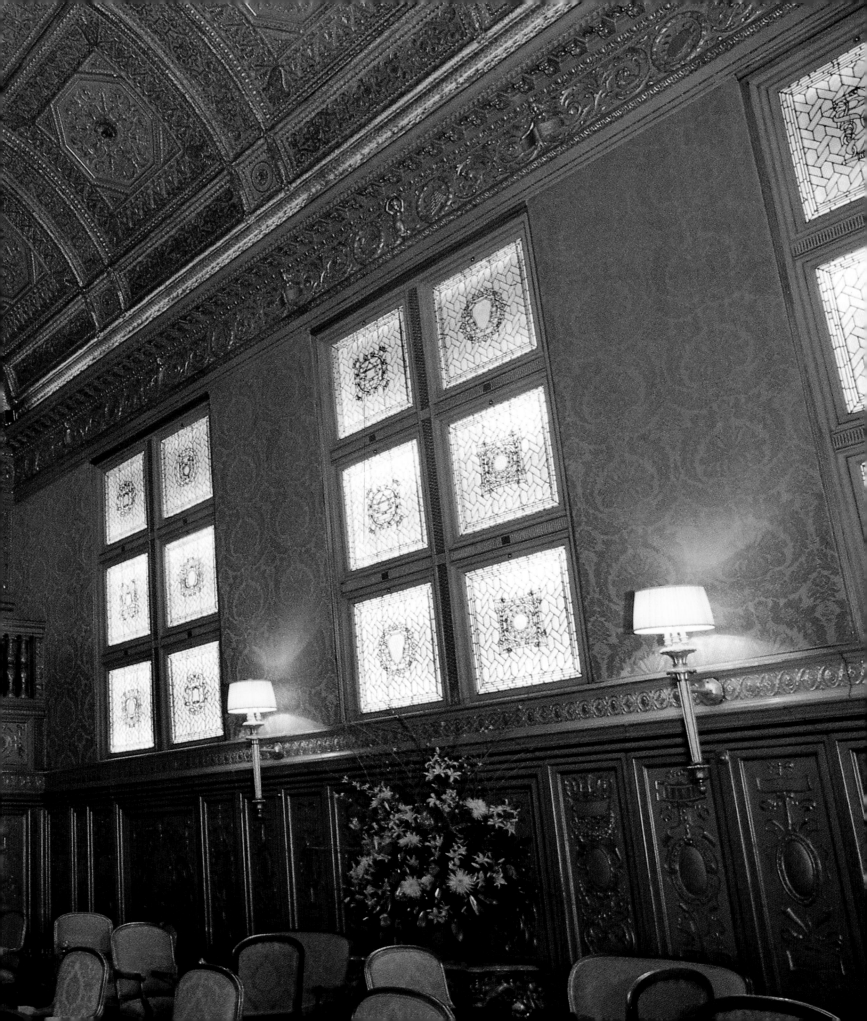

THE ROYALTON AND
THE PARAMOUNT
Theater District, Manhattan

The Royalton and the Paramount are
among the most exciting hotels to be built
in New York since the War. The interiors
were conceived by Philippe Starck, one
of the most innovative and versatile
designers of recent times, able to turn
his hand to architecture, interior design,
furniture, fabrics, even toothbrushes.
Nothing is standard; everything is
individually designed, reinvented as if
from scratch. At the same time there are
oblique and sometimes direct references
to the past. Starck is clearly working in
the tradition of the 1920s and 30s; he
makes no secret of the fact that his designs
are influenced by the great transatlantic
liners, and there are distinct echoes of
Ruhlmann and Printz. His work can be
provocative and challenging: it sometimes
takes guests a full five minutes to discover
how the bathroom taps are operated,
but this is just gentle teasing, designed to
make an event out of even the most
ordinary function. Each of Starck's
interiors provides a different experience,
but the padded bar at the Royalton *(left)*
and the lobby of the Paramount *(right)* are
typical of the special quality he brings to
all his work.

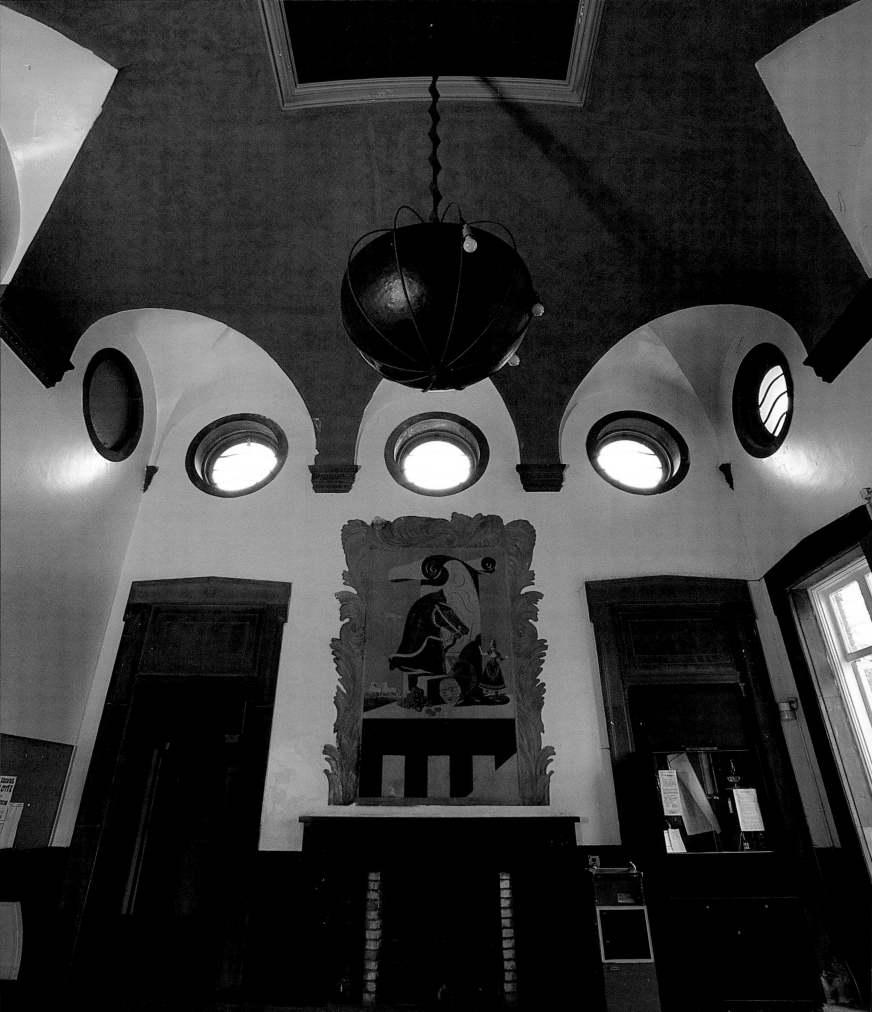

PELHAM-SPLIT ROCK GOLF CLUB

Pelham Bay Park, The Bronx

The exterior of the Pelham-Split Rock Golf Club is a stylistic *ménage-à-trois* of Art Deco, Greek Revival and American Vernacular, the roof capped by a balustrade composed of machine-age palmettes and antlers. The interior is another marriage of styles: the vaulted ceiling is Late Medieval going on Early Renaissance; the liner-style windows and doorcases are clearly Art Deco; and the chimney-piece is surmounted by a Surrealist mural, executed by WPA artist Allan Saalburg. Despite the introduction of water-coolers and other modern appliances, the interior has changed very little and deserves to be better known.

CLUBS AND INSTITUTIONS

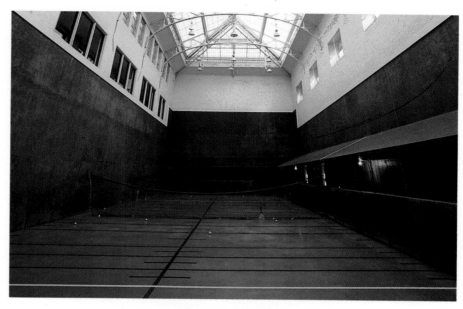

RACQUET AND TENNIS CLUB

Park Avenue, Manhattan

The Racquet and Tennis Club was built in 1916-18, at the height of the First World War, and the interiors, grand yet sober, reflect both the austerity of the period and the resolutely masculine character of this gathering-place for gentlemen athletes. The exterior presents the appearance of a fortified Florentine *palazzo*, with a solid brick wall at fourth-floor level relieved by rusticated arches. Behind this blind arcade lies a Real Tennis Court, two to be precise, replicas of that original courtyard in France where the game of tennis was born, complete with sloping roofs, irregular walls, multiple nets, and bells.

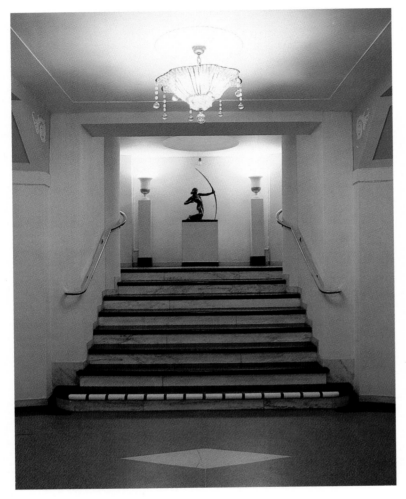

Upper East Side, Manhattan
The Lotos was originally founded in
1870 by a group of young writers and
journalists including Mark Twain, and
takes its name from Tennyson's *The
Lotos-Eaters.* Since 1946 it has occupied a
turn-of-the-century mansion, built by the
architect Richard Howland-Hunt for
society matriarch Margaret Vanderbilt
Shepard, who afterwards presented it to
her daughter and son-in-law, Mr & Mrs
William J Schiefflin. Most of the original
architectural decoration survives intact,
including a magnificent chimney-piece
carved by sculptor Karl Bitter, but
the hub of the house, and the most
spectacular single feature, is the staircase,
which consciously evokes the interior of
a sea-shell.

COSMOPOLITAN CLUB
Upper East Side, Manhattan
The Cosmopolitan was founded as a club
for ladies distinguished in the field of art
and literature and occupies an exquisite
purpose-built clubhouse off Park Avenue
designed in imitation of a Regency
mansion. The architect was Thomas
Harlan Ellett, who completed the
building in 1932, but the interiors, which
include a Napoleonic library and some
rare surviving examples of Vogue
Regency decoration, were conceived by
the members, notably Eleanor Brown
McMillen, Clare Kennard and
Constance Ripley. Adjoining the
ballroom is a small yet beautifully
proportioned and detailed lobby *(above),*
which typifies the refinement and
elegance of this most restrained example
of 1930s design.

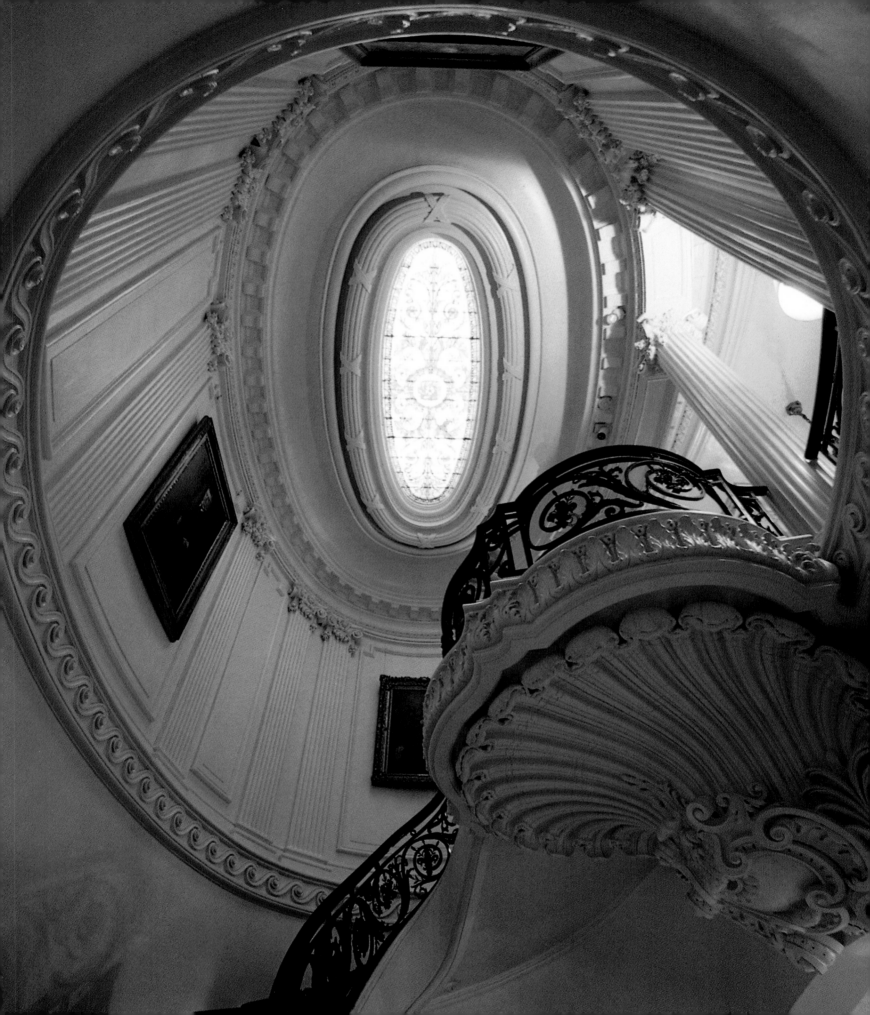

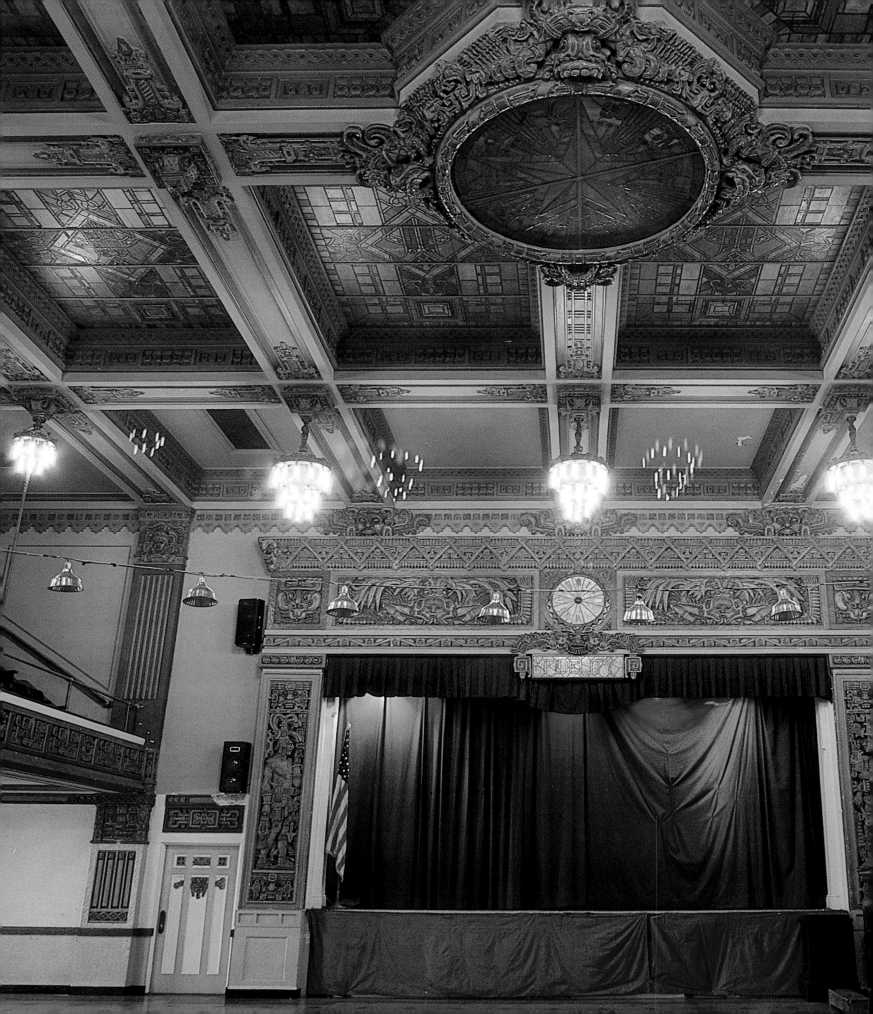

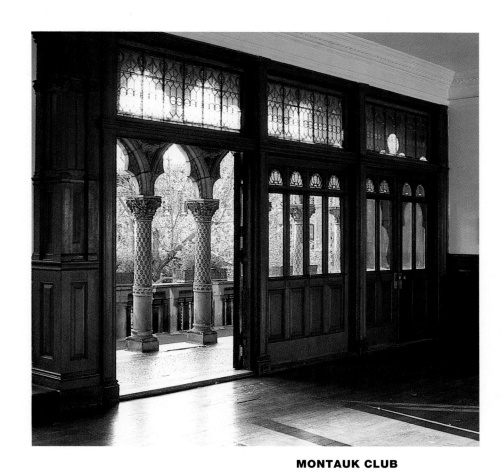

MONTAUK CLUB
Park Slope, Brooklyn

The Montauk Club must surely be the only building in the world to cross Venetian Gothic with Native American. Built in 1891 on land formerly settled by the Montauk Indians, the clubhouse was modelled on the Ca d'Oro on the Grand Canal in Venice, and from the first-floor drawing room the eye instinctively searches for waterside palaces and gondolas. Instead the view is of neat Victorian brownstones, glimpsed through a screen of Venetian Gothic columns with capitals enriched with the masks of Montauk Indians.

ELKS LODGE
Astoria, Queens

The assembly hall at the Elks Lodge in Queens is one of the few interiors of its kind in New York, a bizarre concoction of the Inca and Mayan styles. The room dates from 1923 and is used for the initiation of new members and as an occasional boxing-hall. Anyone who is twenty years old or more, an American patriot and a religious believer, can join the Elks, a foundation that dates back to 1868, with some 2500 lodges across the United States administered from a grandiose headquarters in Washington DC. Do not imagine, however, that the clothes live up to the architecture. Even the Grand Exalted Leader, head of the Elks, wears a regular coat and trousers.

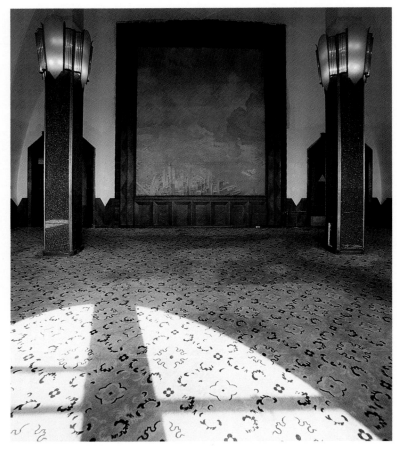

UNIVERSITY CLUB

Fifth Avenue, Manhatttan

The University Club was built in the last years of the nineteenth century by the architects McKim, Mead & White. The pink granite exterior, conspicuously sited at the northwest corner of Fifth Avenue and Fifty-fourth Street, is a typical example of Renaissance Revival confectionery, with architectural elements that have been traced to the Medici and Strozzi palaces in Florence, the Spanocchi palace in Siena, and the Bocchi and Albergati palaces in Bologna. The decoration of the interior is equally eclectic and equally Italianate. The Library *(right)* looks back to Antiquity by way of Raphael's *Loggie* at the Vatican and the frescoes of Pinturicchio in the Borgia apartments in Rome. The painted decoration was executed by H Siddons Mowbray and prefigures his performance at the Morgan Library a few years later.

CLOUD CLUB

Chrysler Building
Midtown, Manhattan

The Cloud Club is aptly named, situated as it is at the top of the Chrysler Building, once the tallest building in New York. The club was originally a gathering-place for executives of the oil, aviation, automobile and steel industries, and the interiors, which originally included a Georgian lobby, a Tudor lounge and a Breton taproom, were designed by William Van Alen. The club has long since closed, and the rooms stand empty and abandoned, stripped of most of their decoration; but the former dining room retains its original Art Deco piers and light fittings, together with a mural of Manhattan that echoes the view from the window opposite.

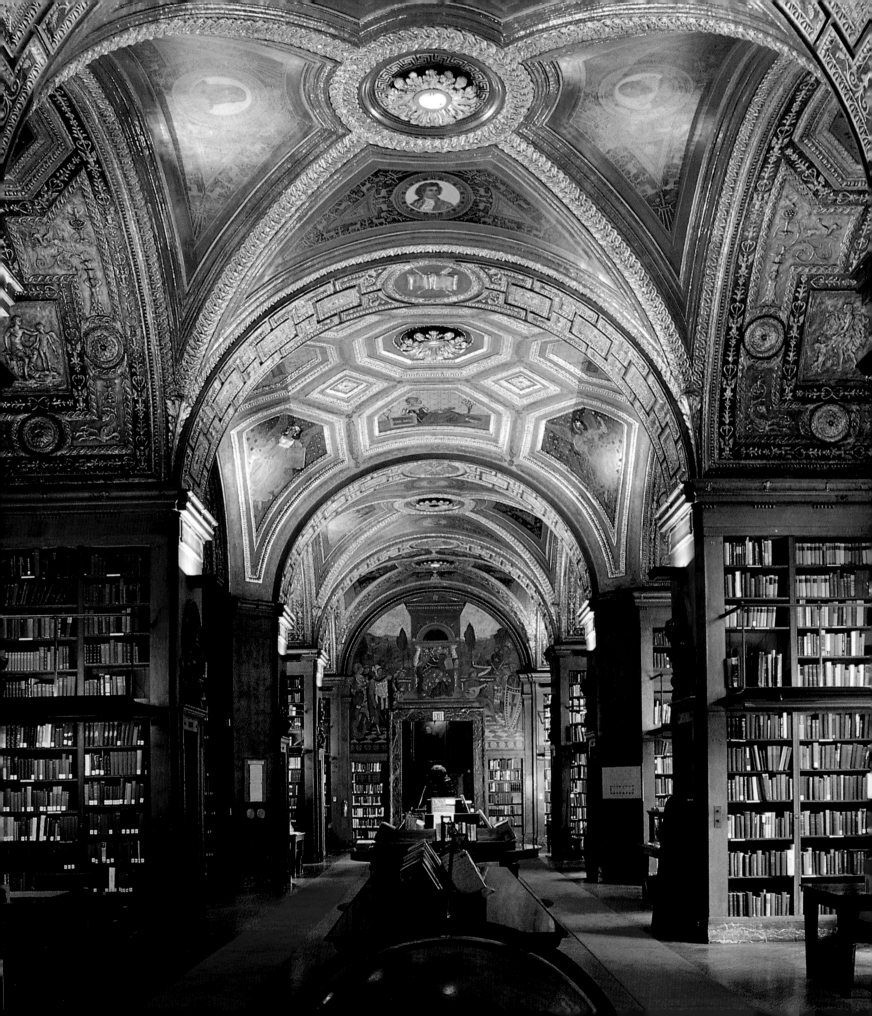

CLUB EL MOROCCO
Midtown, Manhattan

The interior of Club El Morocco is 30s going on 40s, a faux North African fantasy that was once a playground for the rich and famous; where old money mixed with new money, show business with big business, against a theatrical backdrop of artificial palm trees and cactus, zebra-stripe upholstery, Moorish tracery and tented ceilings. There were regular visits from Eva Gardner, Cecil Beaton, the Duke and Duchess of Windsor, the Astors and the Hearsts, and for a time Errol Flynn lived in an apartment on the upper floors. The crowd has since moved on, but the decor is still intact, no less outrageous and delightful than before.

NATIONAL ARTS CLUB

Gramercy Park, Manhattan

The National Arts Club was established in 1898 and was the first association of its kind to admit both men and women members. Some of the great names in American art have been members, along with senior politicians such as Theodore Roosevelt and Woodrow Wilson. Since 1906 the club has occupied the former town house of Samuel J Tilden, lawyer, bibliophile, political reformer and Governor of New York in 1875-6. The building dates originally from 1845 and was among the first to be built in Gramercy Park, but in the early 1880s, following its acquisition by Tilden, it was substantially enlarged and remodelled under the direction of Calvert Vaux, architect of Central Park, and the artist John La Farge. The building was altered again in 1906 when the club took possession, but much of the decoration carried out by Vaux and La Farge survives. The bar room *(right),* which in Tilden's day was the library, housing a part of his vast collection of books (now in the New York Public Library), is distinguished by a magnificent stained-glass ceiling *(left),* which is one of the finest examples of its kind in the city.

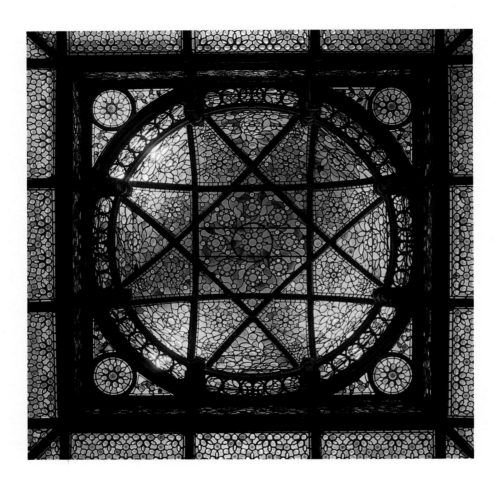

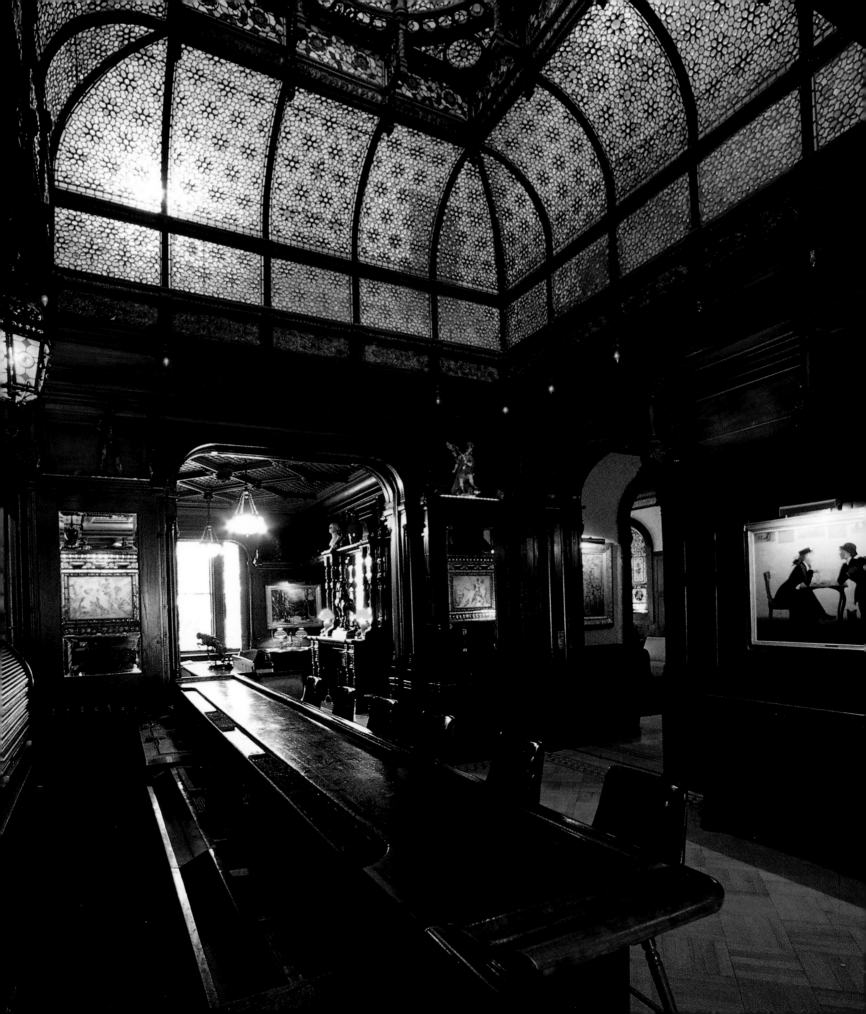

THE SAN REMO
Central Park West, Manhattan
Honey-colored walls and Pueblo Deco detailing give the lobby of the San Remo apartment building a warm, balmy atmosphere. The name alone suggests some luxury beach-side resort in Florida or Mexico, and on exiting from the building one half expects a view of the ocean with white sand and palms, rather than the trees of Central Park and the roar of yellow cabs on asphalt. And yet with the nonchalant eclecticism of the period, architect Emery Roth has worked in Neo-Classical motifs that might have come from some eighteenth-century English country house. The result is something both typically New York and utterly alien, the kind of architectural paradox with which the city abounds.

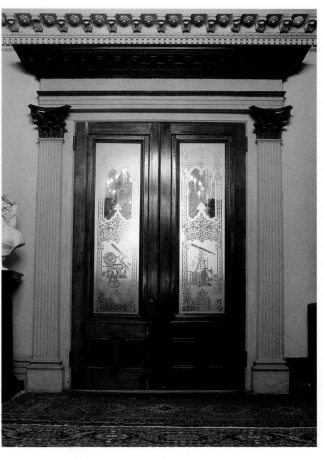

STEINWAY MANSION
Steinway, Queens
Originally built around 1850 for Benjamin T Pike, a manufacturer of scientific instruments, this handsome Italianate villa takes its name from the celebrated piano-maker William Steinway, who moved here in 1870. Although a designated landmark, the exterior, with its ornate cast-iron porches, is in an advanced state of decay, while the grounds have shrunk to a fraction of their original size, hemmed in by factories and warehouses. By a miracle, however, the interior has survived in near-perfect condition, displaying a wealth of mid-nineteenth-century decoration. The staircase hall *(above)* features a remarkable pair of doors with etched glass panels representing scientific instruments, a reminder of the original owner.

PARK PLAZA APARTMENTS
The Bronx

The Bronx is filled with outstanding Art Deco apartment buildings that rival and often surpass the more famous examples in Manhattan. The finest perhaps is the Park Plaza, completed in 1931. The lobby has the unusual feature of etched looking-glass panels, decorated with trees and birds, as well as a striking inlaid floor and gilt metal reliefs that echo those at the Chanin Building *(page 55)*. The quality of the materials and craftsmanship seem all the more remarkable when one considers that the building was erected in the midst of the Great Depression. The lobby surely deserves the same landmark status as the exterior.

THE ELDORADO
Central Park West, Manhattan

This is a building which took apartment living to a new level of luxury and sophistication, following in the tradition of the famous Dakota, a few blocks further south. With its fairytale towers rising above the trees of Central Park, and a name that conjures up visions of some elusive, opulent Utopia, the Eldorado has a theatrical quality that has long made it a favorite with the show-business community. Occupants have included Groucho Marx, Marilyn Monroe and, more recently, Richard Dreyfuss and Faye Dunaway. Whereas the apartments themselves have largely been altered, usually several times over, in accordance with changing fashion, the lobby has recently been restored and features sybaritic *fêtes galantes* by Willy Pogany, a leading muralist of the period.

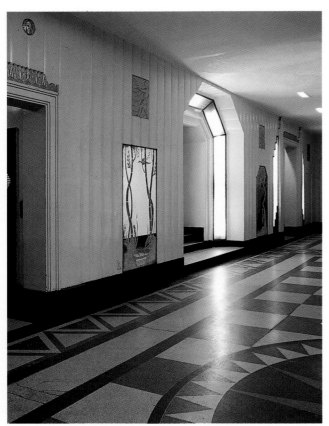

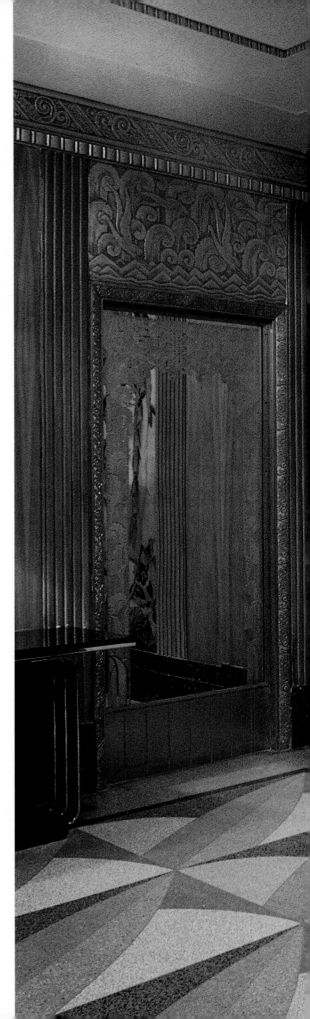

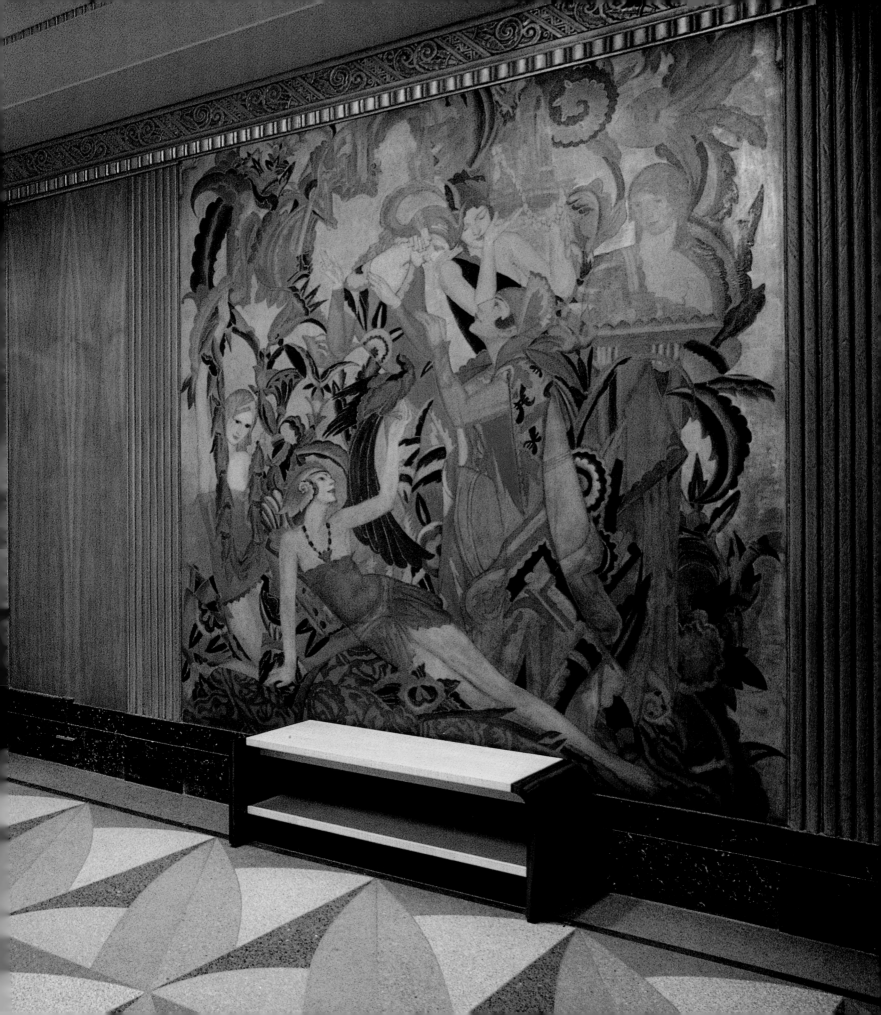

ROCKEFELLER RESIDENCE

Philip Johnson House
Upper East Side, Manhattan

The stripped-down interior of the old Rockefeller Residence in mid-town Manhattan was designed by Philip Johnson as long ago as 1949, anticipating many of the developments associated with the minimalism of the 1980s. The building clearly reflects the influence of Japan, especially in the use of glass partitions, which follow the Japanese tradition of translucent paper screens, and in the plan, which incorporates an inner courtyard with a shallow pool crossed by stepping stones leading from the drawing room to the bedroom. The house occupies the site of an old carriage house erected in the 1860s, and parts of the original brick shell have been retained and brought into play, providing a tangible, almost archaeological link with the past. The house was built in 1949 for Blanchette Rockefeller, and it is interesting to see an old New York family still at the forefront of architectural patronage in the years immediately following the Second World War. Rockefeller gave the building to the Museum of Modern Art in 1958 for use as a guest house; despite several changes of ownership, it continues to serve as a private residence.

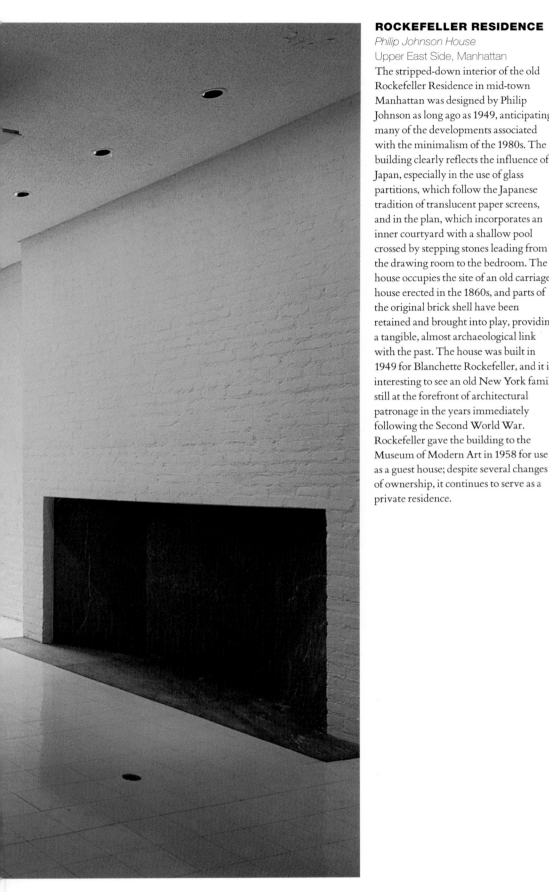

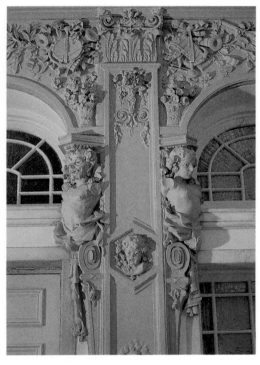

43 FIFTH AVENUE

Greenwich Village, Manhattan
The date of construction is 1905, but the style suggests 1705 or even 1305; if, that is, the lobby of 43 Fifth Avenue can be said to conform to the style of any one period. The architect, Henry Andersen, well known for the design of luxury apartment buildings such as the Semiramis, mixes Gothic with Rococo, and France with Northern Europe, to produce an eclectic amalgam that typifies the greedy antiquarianism of the period.

The lobby of this little-known apartment building in Gracie Square, near the residence of the Mayor of New York, is an Art Deco gem that any passer-by can admire with none of the usual genuflexions to doormen and superintendents. The aluminium leaf doors are a rare treat, especially for those with a weakness for elephants, and it is remarkable how many decorative effects have been achieved in so tiny a space. Especially striking are the polished brass kicking-boards on the internal swing-doors, which follow the same wave-scroll pattern as the inlaid marble floor. The interior dates from 1929 and is believed to have been designed by the muralist Arthur Crisp, who also worked on the decoration of Radio City Music Hall *(page 71).*

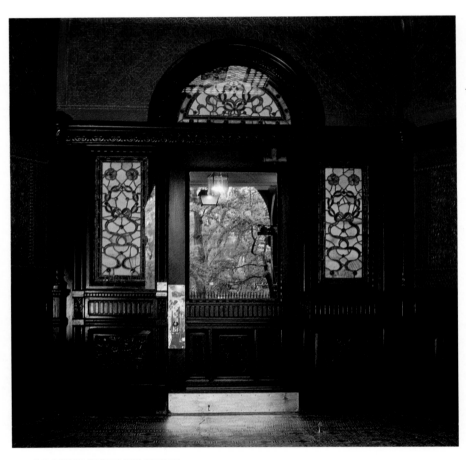

34 GRAMERCY PARK EAST
Gramercy Park, Manhattan

Gramercy Park is a tranquil garden square, originally laid out in the 1830s; nowhere in Manhattan does the Londoner feel more at home: the apartment building at No 34, originally the Gramercy Park Hotel, is an addition of the 1880s, but the red brick and terracotta facade somehow preserves that Kensington and Belgravia illusion. It is the lobby that comes as a surprise, with polychrome decoration that evokes Byzantium and the Orient rather than Eaton Square, and which looks forward to the exotic atmospherics of the Osborne *(page 120),* completed two years later.

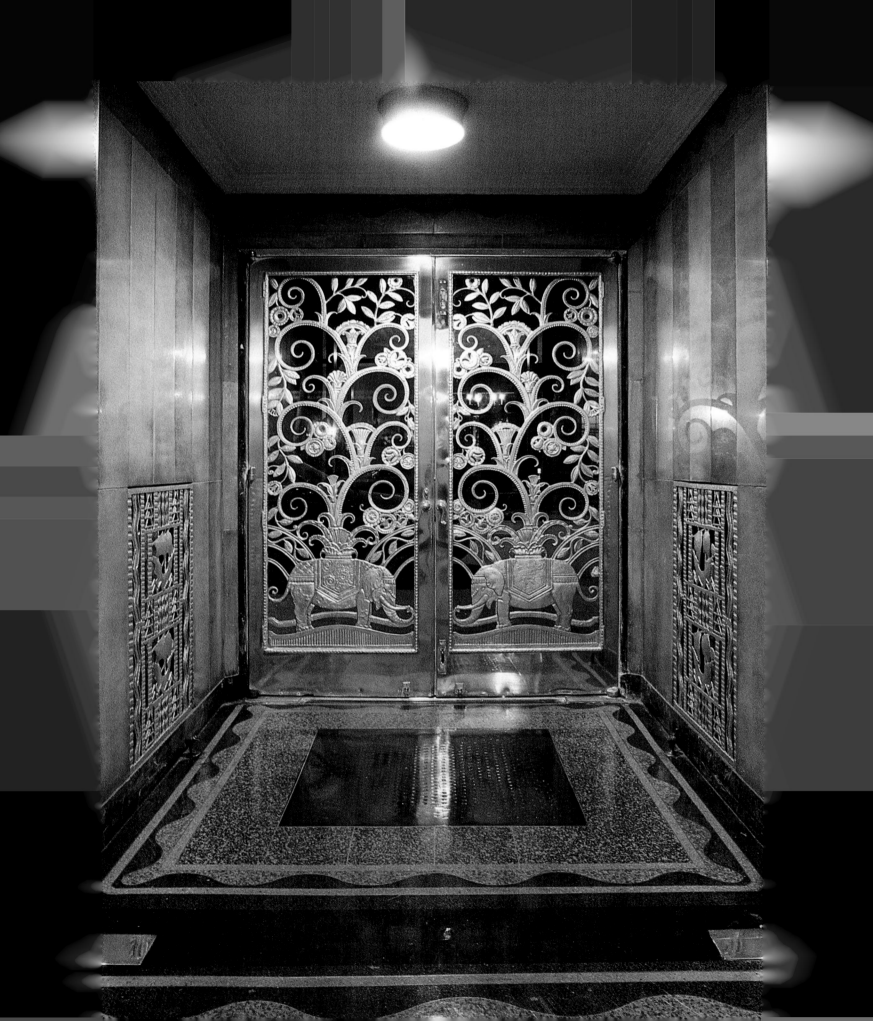

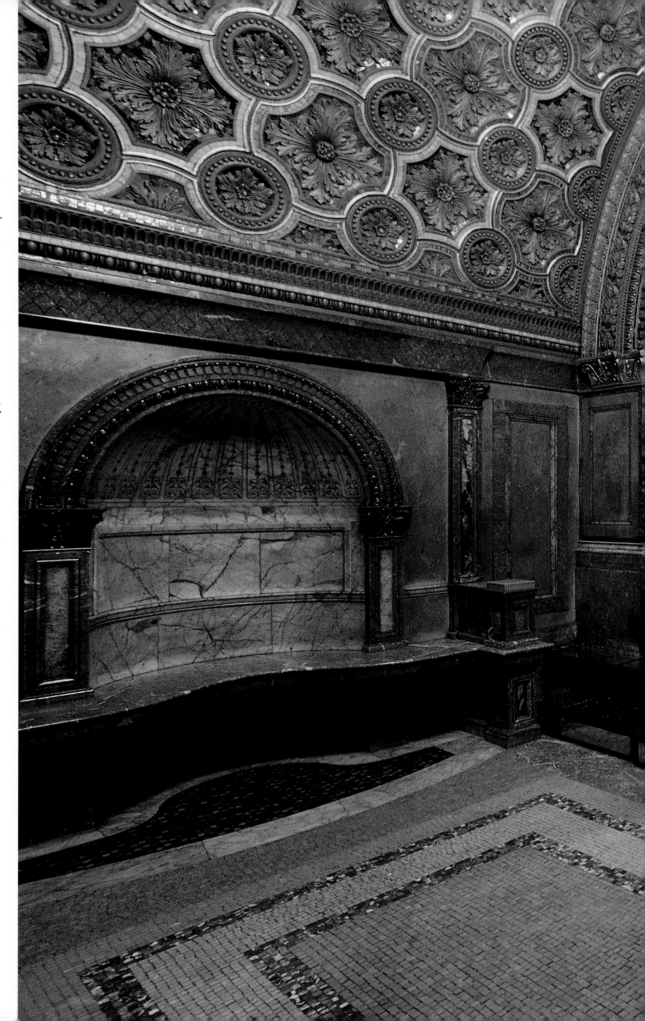

THE OSBORNE

Central Park South, Manhattan

To the street the Osborne presents the appearance of a Romanesque fortress, its looming ten-storey facade clad in rough-hewn sandstone; but one step through the door and another world is revealed, far removed in time and space from the modern chaos of midtown Manhattan, a new Byzantium in vibrant shades of red, blue and gold, with painted and gilded plasterwork, opalescent stained glass, foil-backed mosaics, polished brass, marble, ceramics and mahogany. At the time of its construction in 1885, when purpose-built apartment buildings were still a relative novelty, the Osborne was advertised as the 'most magnificently finished and decorated apartment house in the United States'. According to *The New York Times,* it was the tallest building in the city and possibly the whole country; and it must surely have been the only apartment building in America with a croquet lawn on the roof. The architect was James E Ware, but the decoration of the interior was entrusted to the Swiss-born sculptor and painter Adolphus Holzer, an associate of Louis Comfort Tiffany, who is thought to have supplied the stained glass and mosaics here. The outer lobby is remarkable for its barrel-vaulted coffered ceiling, inspired perhaps by the ancient Roman ruins at Palmyra and Baalbec. Other striking features are the use of embossed brass stair-treads and the rich Aegean-blue floor-tiles. The inner lobby, glimpsed through a glass and mahogany partition, retains its original Byzantine Revival ceiling lights and circular plaster reliefs representing allegories of music and literature.

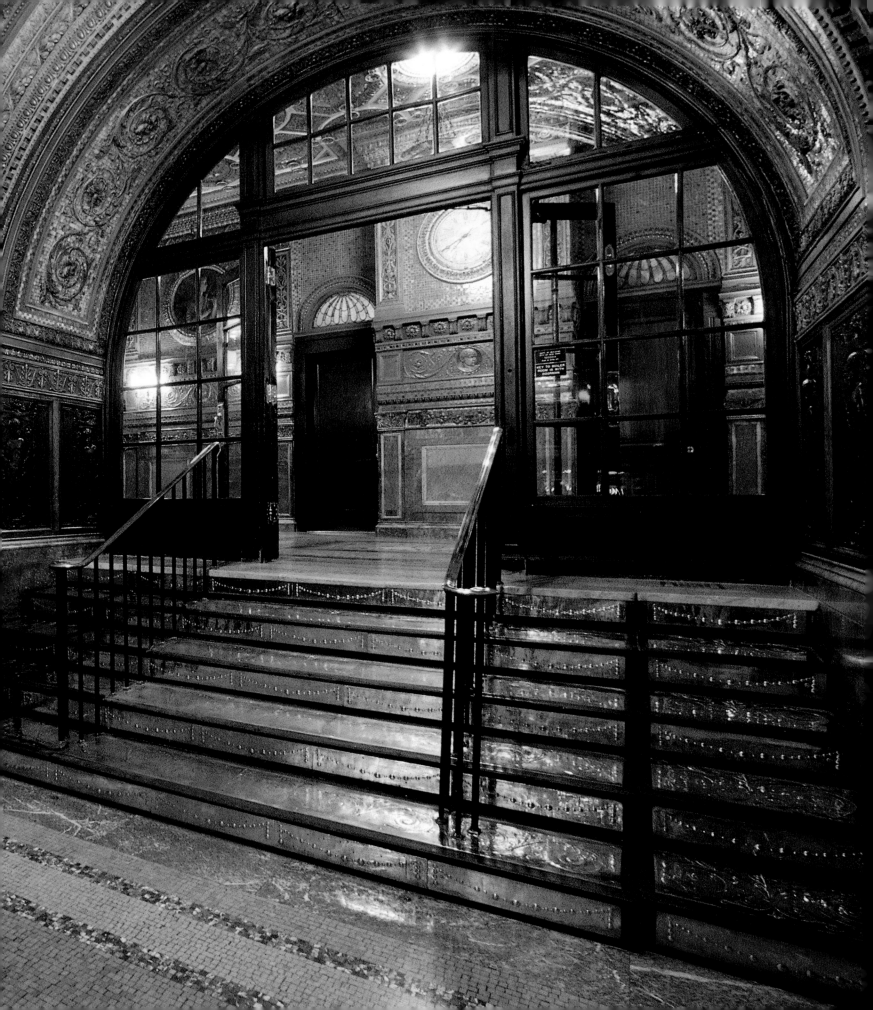

ACKNOWLEDGEMENTS

In the first place, I must thank Richard Berenholtz, who has produced the outstanding photographs in this book. I must also make special thanks to all those people, too many to list individually, who allowed me to include the interiors which are featured. Without their cooperation, and the care with which they and their predecessors have maintained these precious elements of our architectural heritage, *Inside New York* would not have been possible. I am grateful also to those, more numerous still, who allowed me to visit, and in some cases to photograph, the many interiors which regrettably could not be included. In the course of my researches I have consulted a great many experts. For giving so generously of their time and knowledge I should like to thank the following: Michael Adams, Brendan Gill, Kent Barwick, David Dunlap, John Tauranac, Barry Bergdoll, Christopher London, Pauline Metcalfe, Byron Saunders, Tom Mellings, Lloyd Ultan. I owe an enormous debt to Jonathon Morse, whose advice and support were invaluable, and to James Ivory, who took such an interest in the project and supplied so many useful ideas and suggestions. I am likewise indebted to Davida Deutsch, Adolf Pietersen, Mrs John P McGrath, Kitty Carey, Adrian Zuckerman, Huyler Held, Mrs London and Sean Flaherty; also to Bill Griswold, Alexander Tsiaras, Henriette Lubard, Hans and Judy Noë, Irene Worth, Elaine Malsin, Ellen Levine, Barbara Bray and Jane Press. I have received every assistance from my publishers, Phaidon Press, especially Roger Sears, and from Julie Fitzpatrick and Marianne Ryan. But my deepest thanks are to my assistant, Liz Corcoran, whose commitment and enthusiasm were an inspiration, and to whose tact, patience and organisational powers this book is largely due.

BIBLIOGRAPHY

Andrew Alpern, *New York's Fabulous Luxury Apartments,* Dover Publications, New York, 1975

New York Art Deco Skyscrapers, Architecture and Urbanism Magazine (extra edition), Tokyo, 1987

Barbaralee Diamonstein, *The Landmarks of New York,* Harry N Abrams, Inc., New York, 1988

Paul Goldberger, *The City Observed: New York, A Guide to the Architecture of Manhattan,* Vintage Books, New York, 1979

Gary Hermalyn and Robert Kornfeld, *Landmarks of the Bronx,* The Bronx Historical Society, New York, 1989

Henry Hope Reed, *Beaux-Arts Architecture in New York,* Dover Publications, New York, 1988

Donald Martin Reynolds, *The Architecture of New York City,* Macmillan, New York, 1984

Cervin Robinson and Rosemarie Haag Bletter, *Skyscraper Style: Art Deco New York,* Oxford University Press, 1975

Nathan Silver, *Lost New York,* Legacy Press, New York, 1967

Robert A M Stern, Gregory Gilmartin, John Montague Massengale, *New York 1900: Metropolitan Architecture and Urbanism 1890-1915,* Rizzoli, New York, 1983

Robert A M Stern, Gregory Gilmartin, Thomas Mellins, *New York 1930: Architecture and Urbanism between the Two World Wars,* Rizzoli, New York, 1987

John Tauranac, *Elegant New York, the Builders and the Buildings 1885-1915,* Abbeville Press, New York, 1985

Elliot Willensky and Norval White, *AIA Guide to New York City,* 3rd edition, Harcourt Brace Jovanovich, New York, 1988

GAZETTEER

Every effort has been made to ensure the accuracy of the information given below. Telephone numbers and opening hours are included where possible. Details of bus services are only provided if there is no subway service.

front cover
RCA BUILDING
Now the GE Building
30 Rockefeller Plaza
New York, NY 10112
Subway: B/D/F/Q trains to Rockefeller Center
Lobby open to the public during business hours
Built 1931-3 as centerpiece of Rockefeller Center; design team led by Raymond Hood; murals by José María Sert and Frank Brangwyn; exterior and ground-floor interior designated 1985.

frontispiece
MARK HELLINGER THEATER
Times Square Church
217-239 West 51st Street
New York, NY 10019
Tel: 212 769 2000
Subway: 1/9 trains to 50th Street
Services: Sun 10am and 6pm
Tue 7pm
Fri 7pm
Originally the Hollywood movie theater, built 1929 by architect Thomas Lamb for Warner Brothers; converted for stage as well as cinema 1934; renamed Mark Hellinger Theater 1949 in honour of columnist, playwright and former Warner Brothers producer; exterior designated 1988; interior designated 1987.

GOVERNMENT AND CIVIC BUILDINGS

SURROGATE'S COURT
Formerly the Hall of Records
31 Chambers Street
New York, NY 10007
Tel: 212 374 4500
Subway: 4/5/6 trains to City Hall, Brooklyn Bridge, J/M/Z trains to Chambers Street
Main lobby and Court Rooms: Mon-Fri: 9.30am-5pm
Formerly the Hall of Records, built 1899-

1907 by John R Thomas (1899-1901) and Horgan & Slattery (1901-11); exterior designated 1966; interior designated 1976; in addition to main concourse, see entrance foyer with mosaics by William de Leftwich Dodge and allegorical statues by Albert Winert.

CONSULATE GENERAL OF THE POLISH PEOPLE'S REPUBLIC
233 Madison Avenue
New York, NY 10016
Tel: 212 889 8360
Subway: 6 train to 33rd Street
No public access
Originally Joseph R DeLamar Mansion, built 1902-06 by C P H Gilbert; bequeathed by DeLamar to medical schools of Harvard, Johns Hopkins, and Columbia; sold on to National Democratic Club; acquired by Polish Consulate 1973; exterior designated 1975; restoration imminent; magnificent, if overblown, Louis XV/Louis XVI-style interiors, plus Pompeian Gallery.

US BANKRUPTCY COURT
Formerly US Custom House
Bowling Green
New York, NY 10004
Tel: 212 264 2600
Subway: 4/5 trains to Bowling Green
No public access
Completed 1907 to designs of Cass Gilbert as headquarters of New York customs service; vacated by customs service 1973; occupied by Federal Government; exterior designated 1965; interior designated 1979; first-floor interiors retaining original architectural decoration, embellished in 1930s.

CITY HALL
Broadway at City Hall Park
New York 10007
Tel: 212 788 3200
Subway: N train to City Hall, 4/5/6 trains to

City Hall/Brooklyn Bridge
Open: Mon-Fri 10am-4pm
Built 1803-12 by Joseph F Mangin and John McComb Jr; alterations by Leopold Eidlitz 1860, John Duncan 1898, William Martin Aiken 1903, Grosvenor Atterbury 1907, 1915, 1917, Shreve, Lamb and Harmon 1956; exterior designated 1966; interior designated 1976; see in particular Rotunda, Governor's Room and City Council Chamber.

TWEED COURTHOUSE
Office of the Mayor
52 Chambers Street
New York, NY 10007
Tel: 212 788 2495
Subway: 4/5/6 trains to City Hall/Brooklyn Bridge
Open: by appointment
Formerly New York County Courthouse built 1861-81 to designs of John Kellum and Leopold Eidlitz; Classical exterior encasing Romanesque Revival interiors in picturesque decay; interesting rotunda; exterior and staircase hall designated 1984.

SEVENTH REGIMENT ARMORY
643 Park Avenue
New York, NY 10021
Tel: 212 744 2968
Subway: 6 train to 68th Street
Tours by appointment: ask for the Curator
Castellated red-brick fortress built 1878-80 by architect Charles W Clinton as headquarters of Seventh Regiment, founded 1806; lavish interiors on ground and first floors with decoration by among others Louis Comfort Tiffany, the Herter Brothers, Kimbel & Cabus, Marcotte & Co, Alexander Roux, Pottier & Stymus; alterations and additions 1909 and 1930; exterior designated 1967.

APPELLATE COURTHOUSE
27 Madison Avenue
New York, NY 10010
Tel: 212 340 0400
Subway: R or 6 trains to 23rd Street
Main lobby open: Mon-Fri 9am-5pm
Completed 1900 to designs drawn up in 1896 by James Brown Lord; exterior designated 1966; interior designated 1981; statuary and murals by leading

artists of the period, including H Siddons Mowbray, Chester French, and Karl Bitter; lobby, court room, and adjoining robing room all in excellent state of preservation.

BANKS

BOWERY SAVINGS BANK
110 East 42nd Street
New York, NY 10017
Tel: 212 953 8363
Subway: 4/5/6 trains and 7 train to Grand Central/42nd Street
Banking hours: Mon-Fri 8.25am-3pm except Thur, 8.25am-6pm
Built 1923 by York and Sawyer. Vast banking hall evoking Romanesque basilica, with original fittings and furniture.

WILLIAMSBURGH SAVINGS BANK
1 Hanson Place
Brooklyn, NY 11243
Tel: 212 270 4242
Subway: D/Q, 2/3, 4/5 trains to Atlantic Avenue
Banking hours: Mon-Sat 9.30am-3pm
Built 1927-29 to designs of Halsey, McCormick & Helmer; exterior designated 1977.

IRVING TRUST BUILDING
No 1 Wall Street
New York, NY 10005
Tel: 212 635 6747
Subway: 4/5 trains to Wall Street
No public access
Completed 1932 to designs of Voorhees, Gmelin & Walker; extension added 1965 by Smith, Smith, Haines, Lundberg & Waehler; banking hall of particular note, likewise the penthouse board room.

DIME SAVINGS BANK
9 DeKalb Avenue
Brooklyn, NY 11201
Tel: 718 403 9600
Subway: D/Q, R/N and M trains to DeKalb Avenue, 2/3, 4/5 trains to Nevins Street
Banking hours: Mon, Thur, Fri 9am-6pm
Tue, Wed 9am-3pm, Sat 10am-3pm
Built 1907 by Mowbray and Uffinger; enlarged 1932 by Halsey, McCormack and Helmer.

KING'S COUNTY SAVINGS BANK

The Cottage
135 Broadway
Brooklyn, NY 11211
Tel: 718 384 8064
Subway: J/M/Z trains to Marcy Avenue
No public access
Noble Second Empire structure, built
1868 to designs of King & Wilcox;
the exterior was designated 1966 and
the interior is currently under
restoration.

MUSEUMS AND LIBRARIES

THE NEW YORK PUBLIC LIBRARY

455 5th Ave
New York, NY 10018
Tel: 212 869 8089
Subway: 4/5/6 trains or 7 train to Grand
Central/42nd Street
Open: Tue-Wed 11am-6pm
Thur-Sat 10am-6pm. Closed: Sun, Mon
Built 1898-1911 by Carrere and
Hastings; exterior and interior designated
1967; restoration program initiated
1985; superb Beaux-Arts fusion of
architecture, painting and sculpture;
principal interiors include Astor Hall,
Main Reading Room, Trustees' Room,
3rd Floor landing.

VAN CORTLANDT MANSION

Van Cortlandt Park
Broadway at 242nd Street
Bronx, NY 10471
Tel: 212 543 3344
Subway: 1/9 trains to Van Cortlandt
Park/242nd Street
Open: Tue-Fri 11am-3pm
Sun 1pm-5pm
Built 1748 for descendants of Dutch
immigrant Oloff Van Cortlandt;
architect unknown; run as museum by
New York chapter of National Society of
Colonial Dames since 1897; exterior
designated 1966; interior designated
1975.

THE MOORISH ROOM

The Brooklyn Museum
200 Eastern Parkway
Brooklyn, NY 11238
Tel: 718 638 5000
Subway: 2/3 trains to Eastern
Parkway/Brooklyn Museum
Open: Wed-Sun 10am-5pm
Closed: Mon, Tue
Designed c.1877 by George A Schastey;
formerly located in John D Rockefeller
Residence, West 54th Street, Manhattan;
dismantled and presented to Brooklyn
Museum.

SOLOMON R GUGGENHEIM MUSEUM

1071 Fifth Avenue
New York, NY 10128
Tel: 212 727 6200
Subway: 4/5/6 trains (Lexington Avenue
line)-86th Street
Closed for alteration at time of writing
Completed 1959 to designs of Frank
Lloyd Wright; extension added 1968 by
Taliesin Associated Architects; Aye
Simon Reading Room added 1978 by
Richard Meier & Associates.

THE PIERPONT MORGAN LIBRARY

29 East 36th Street
New York, NY 10016
Tel: 212 685 0610
Subway: 6 train to 33rd Street
Open: Tue-Sat 10.30am-5pm
Sun 1pm-5pm
Closed: Mon, public holidays
Built 1903-06 by McKim, Mead &
White; annex added 1928 by Benjamin
W Morris; former J P Morgan Jr mansion
at 231 Madison Avenue amalgamated
1990; exterior of main building
designated 1966; interior of same
designated 1982.

SHOPS

STEINWAY SHOWROOM

109 West 57th Street
New York, NY 10019
Tel: 212 246 1100
Subway: B/Q trains to 57th Street
Open: Mon-Fri 9am-6pm
Sat 9am-5pm
Sun 12pm-5pm
Originally Steinway Hall, built 1925 to
designs of Warren & Wetmore. Piano
showroom little altered since
construction, with exuberant
Adamesque decoration.

M MARSHALL BLAKE FUNERAL HOME

10 St Nicholas Place
New York, NY 10031
Tel: 212 926 1366
Subway: A/B trains to 150th Street
Open: by appointment only
Originally the Bailey Residence, built
1886-8 by architect Samuel B Reed for
James Anthony Bailey of the Barnum &
Bailey Circus Company; acquired by
present owners and converted for use as
funeral home 1950; exterior designated
1974; many surviving features
throughout.

BROADWAY BARBERSHOP

2713 Broadway
New York, NY 10025
Tel: 212 666 3042
Subway: 1/9 trains to 103rd Street
Open: daily except Sun 8am-7pm
Unspoilt interior with fittings dating
back to 1907; the oldest of its kind in
New York.

SUBWAYS

SUBWAY STATIONS

City Hall: No public access
Constructed 1904; closed 1945;
designated 1979; interior virtually
undisturbed retaining original vaulted
structure with Guastavino tiles and brass
light fittings.

Borough Hall: 2/3 or 4/5 trains
Original mosaics by American Encaustic
Tile company dating back to 1908.

Fulton Street: 4/5 trains
Original ceramics by Rockwood Pottery
Company dating back to construction,
1905; designated 1979.

Bleeker: 6 train
Original ceramic signs by Grueby
Faience Company dating back to
construction, 1904; designated 1979.

Columbia University: 1/9 trains
Original ceramic signs by Rockwood
Pottery dating back to c.1905.

GRAND CENTRAL STATION

75-105 East 42nd Street
New York, NY 10017
Subway: 4/5/6 trains, 7 train and S train to
Grand Central/42nd Street
Closed: 1.30am-5am
Built 1903-13 by Reed & Stern and
Warren & Wetmore; exterior designated
1967; interior designated 1980;
highlights include main concourse, main

waiting room, Graybar Passageway,
Hyatt Passageway, Whispering Gallery,
Oyster Bar.

CORPORATE BUILDINGS

BARCLAY-VESEY BUILDING

140 West Street
New York, NY, 10007
Subway: J/M/Z trains, 2/3 trains, 4/5 trains
to Fulton Street or R train to Park Place
Lobby open to the public during business
hours
Completed 1926 to designs of architects
McKenzie, Voorhees, Gmelin, and
Walker; headquarters of New York Tele-
phone Company; ornate Art Deco lobby.

SEAGRAM BUILDING

375 Park Avenue
New York, NY 10022
Subway: 6 train to 51st Street, E/F trains
to Lexington Avenue/3rd Avenue
Lobby open to the public during business
hours
Built 1958 by Ludwig Mies Van der
Rohe; interiors designed by Philip
Johnson, including Four Seasons
Restaurant; associate architects Kahn &
Jacobs .

BELMONT MADISON BUILDING

183 Madison Avenue
New York, NY 10036
Subway: 6 train 33rd Street
Lobby open to the public during business
hours
Built 1925 by Warren & Wetmore for
Robert M Catts; Napoleonic/Pompeian-
style lobby featuring marble-panelled
walls and painted ceiling.

SWISS CENTER BUILDING

608 Fifth Avenue
New York, NY 10020
Subway: B/D/F trains to Rockefeller
Center/47-50th Street
Lobby open to the public during business
hours
Originally Goelet Building, built 1932 by
architects E H Faile & Co with L Hafner;
surviving Art Deco decoration in lobby.

CHRYSLER BUILDING

405 Lexington Avenue
New York, NY 10174
Subway: 4/5/6 trains or 7 train to Grand
Central/42nd Street
Lobby open to the public during business
hours
Built 1928-30 by architect William Van
Alen for tycoon Walter P Chrysler;
restoration program begun 1975 under
then owners Massachusetts Mutual Life
Assurance Company and continued by

present owners Cooke Properties; exterior and interior designated 1978; interiors of greatest interest are the lobby and the former Cloud Club.

GENERAL ELECTRIC BUILDING

570 Lexington Avenue
New York, NY 10022-6853
Subway: 6 train to 51st Street
Lobby open to the public during business hours
Originally RCA Victor Building, built 1929-31 by Cross & Cross; occupied by General Electric since 1932; exterior designated 1985.

195 BROADWAY

195 Broadway
New York, NY 10007
Subway: J/M/Z, 2/3 or 4/5 trains to Fulton Street
Lobby open to the public during business hours
Formerly the AT&T Building, built 1914-17 by William Welles Bosworth.

FILM CENTER BUILDING

630 9th Avenue
New York, NY 10036
Subway: A/C/E trains to 50th Street
Lobby open to the public during business hours.
Built 1928-9 by Buchman and Kahn; interior (lobby) designated 1982.

CHANIN BUILDING

122 East 42nd Street
New York, NY 10168
Subway: 4/5/6 trains or 7 train to Grand Central/42nd Street
Lobby open to the public during business hours; no public access to apartment
Built 1927-9 by architects Sloan and Robertson, in consultation with Jacques Delamarre, as headquarters of Chanin Construction Company; exterior designated 1978; interiors of special interest include lobby and side entrances at street level, and the former suite of Irwin Chanin.

AT&T BUILDING

550 Madison Avenue
New York, NY 10022
Subway: 4/5/6 to 59th Street, N/R to Lexington Avenue

Lobby open to the public during business hours
Completed 1984 to designs of Philip Johnson in association with John Burgee; lobby contains statue of 'Spirit of Communication' transferred from cupola over old AT&T Building at 195 Broadway.

WOOLWORTH BUILDING

233 Broadway
New York, NY 10007
Subway: 2/3 trains to Park Place
Lobby open to the public during business hours
Gothic-style skyscraper commissioned 1910 by Frank Winfield Woolworth; built 1911-13 to designs of Cass Gilbert; exterior and interior designated 1983; remarkable triple-volume lobby with Gothic detailing, including caricatures of architect and patron; board room of particular note, formerly Woolworth's private office, with Empire-style furnishings now stored in museum room.

SCHOOLS AND COLLEGES

CONVENT OF THE SACRED HEART

Formerly the Kahn Mansion
1 East 91st Street
New York, NY 10128
Tel: 212 722 4745
No public access
Italian Renaissance-style mansion built for investment banker Otto Kahn by architect C P H Gilbert in association with J Armstrong Stenhouse, 1918; original decoration largely intact.

GOULD MEMORIAL LIBRARY

Bronx Community College
West 181st Street and University Avenue
Bronx, NY 10453
Tel: 212 220 6920
Subway: 4 train to Burnside Avenue
Hall of Fame open daily 10am-5pm.
Gould Memorial Library can be visited by arrangement only
Built 1897-9 by McKim, Mead & White; originally part of New York University; subsequently transferred to ownership of Bronx Community College; exterior designated 1966; interior designated 1987.

NEW SCHOOL FOR SOCIAL RESEARCH

66 West 12th Street
New York, NY 10011
Tel: 212 229 5600
Subway: F train or 2/3 trains to 14th Street
Limited public access: contact Dean's

office for information
Built 1930 to designs of Joseph Urban, with murals by Thomas Hart Benson, José Clemente Orozco and Camillo Egas; extended 1958 by Mayer, Whittlesey & Glass; highlights include lobby, auditorium, circular dance studio in basement, former cafeteria (room 712), interior court and adjoining spaces.

CONVENT OF THE SACRED HEART

Formerly the Burden Mansion
7 East 91st Street
New York, NY 10128
Tel: 212 722 4745
Subway: 4/5/6 trains to E 86th Street
No public access
Built 1902-05 by Warren & Wetmore for James A Burden Jr and his wife, Florence Adele Sloan; acquired by Society of the Sacred Heart 1940; exterior designated 1974; magnificent Beaux-Arts interiors, notably staircase and second-floor reception rooms.

JOHNSON O'CONNOR RESEARCH FOUNDATION

Formerly the Fabbri Mansion
11 East 62nd Street
New York, NY 10021
Subway: 4/5/6 trains to 59th Street, N/R trains to Lexington Avenue
No public access
Built 1900 by Haydel & Shepard; magnificent French-Italian Beaux-Arts interiors, notably on ground and first floors.

THEATERS

LOEW'S PARADISE THEATER

Grand Concourse at 185th Street
Bronx, NY 10458
Tel: 212 367 3227
Subway: C/D trains to Fordham Road
Films shown from 1pm
Atmospheric cinema, built 1929 by John Eberson; originally part of the Loew group; lobby largely intact with Baroque/Chinese decoration; auditorium divided but otherwise well-preserved, with original seats decorated with Egyptian caryatids, star-lit ceiling, walls fitted with exotic architectural scenery.

RADIO CITY MUSIC HALL

Rockefeller Center
1260 Avenue of the Americas
New York, NY 10020
Tel: 212 247 4777
Subway: B/D/F trains or Q train to Rockefeller Center
Open: Mon-Sat 10.15am-4.45pm

Sun 11.15am-4.45pm
Tours leave every 30-45 minutes except when shows are rehearsing
Built 1931-3 as part of Rockefeller Center, to designs of architect Edward Durrell Stone and interior design consultant Donald Deskey; interior designated 1978; exterior designated 1985; outstanding Art Deco decoration throughout.

SAILORS' SNUG HARBOR MUSIC HALL

1000 Richmond Terrace
Staten Island, NY 10301
Tel: 718 448 2500
Transport: Bus S-40 from Staten Island Ferry Terminal
No public access to Music Hall, due to be restored. Main Hall (Newhouse Center for Contemporary Arts) open: Wed-Sun 12pm-5pm.
Guided tours leave Visitors' Center at 2pm on weekends.
Former maritime hospital and home for retired sailors, founded 1801 by Robert Richard Randall; first institution of its kind in US; complex of 28 buildings in various styles (Greek Revival, Italianate, Second Empire, Vernacular, etc), set in 83 acres of waterfront parkland; acquired by City of New York in early 1970s and reopened as cultural center 1976, with museums, workshops, galleries, etc; highlights include Main Hall, Veterans' Memorial Hall, Great Hall and Music Hall.

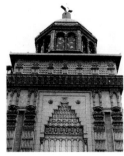

LOEW'S 175TH STREET THEATER

The United Church
175th Street
New York, NY 10033
Tel: 212 568 6700
Subway: 1/9 trains or A/B trains to 168th Street
Services: Fri 7pm, Sun 2.45pm
Originally Loew's Theater, built 1930 to designs of Thomas Lamb; lobby, auditorium and smoking rooms among the best preserved and most spectacular interiors of their kind to be found in the city.

PLACES OF WORSHIP

CHURCH OF THE MOST PRECIOUS BLOOD
32-23 36th Street
Long Island City, Queens 11106
Tel: 718 278 3337
Subway: E/F/R/G trains to Steinway Street
Open: daily 7am-5pm
Built 1931-2 by McGill & Hamlin; Pueblo/Art Deco interior, perfectly intact.

ST PAUL'S CHAPEL
Broadway at Fulton Street
New York, NY 10006
Tel: 212 602 0847/0848
Subway: 2/3, 4/5 trains to Wall Street, 1/9 trains to Rector Street
Open: Mon-Sat 8am-4pm
Sun 7am-3pm
Services: Mon-Fri 1.05pm, Sun 8am
Built 1764-6 to designs of Thomas McBean, with woodwork by Andrew Gautier; Glory attributed to Pierre L'Enfant; tower and steeple added 1796 by James Cromellin Lawrence; interior little changed, with fourteen Waterford crystal chandeliers, original pews used by George Washington and George Clinton, magnificent carved pulpit.

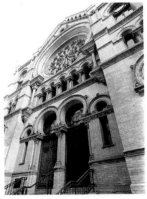

ELDRIDGE STREET SYNAGOGUE
12-16 Eldridge Street
New York, NY 10002
Tel: 212 941 5652
Subway: B/D trains to Grand Street
No public access
Restoration underway
Built 1886-7 by architects Herter Brothers; exterior designated 1980; atmospheric sanctuary reflecting Moorish, Gothic and Romanesque influences.

TRINITY CHURCH
Broadway at Wall Street
New York, NY 10006
Tel: 212 602 0800
Subway: 4/5 trains to Wall Street
Services: Mon-Fri 8am, 12 noon

Sat 9am, Sun 9 am, 11.15am
Built 1839-46 to designs of Richard Upjohn; designated 1966.

FRIENDS MEETING HOUSE
137-16 Northern Boulevard
Flushing, Queens 11354
Tel: 718 358 9636
Subway: 7 train to Main Street, Flushing
Sun Meeting: 11am
Discussion Group: 10 am
Built 1694; architect unknown; enlarged 1716-19; occupied by British 1776-83; in continuous use since.

BARS AND RESTAURANTS

EXSPO
565 West 23rd Street
New York, NY 10011
Tel: 212 229 1123
Subway: C/E trains to 23rd Street
Open nightly: 6pm-4am
Originally Hollings' working men's club, built c.1880; architect unknown; bar room largely intact.

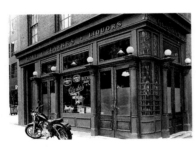

P J CLARKE'S BAR
915 3rd Avenue
New York, NY 10022
Tel: 212 759 1650
Subway: 4/5/6 trains to 59th Street
Open: daily, bar 10am-4am
restaurant 12pm - 4am
Late nineteenth-century bar found by Irishman Patrick Joseph Clarke; surviving decoration, including pressed-tin ceiling, tiled floor, and urinal with stained-glass roof.

CAFÉ DES ARTISTES
1 West 67th Street
New York, NY 10023
Tel: 212 877 3500
Subway: A/B/C trains to 72nd Street or 1/9 trains to 66th Street/Lincoln Center
Open: Mon-Sat 12-3pm, 5.30pm-12.30am
Sun 10am-3pm, 5-11pm
Bar open nightly, closing 12pm
Part of the Hotel des Artistes, built 1915-17 to designs of George Mott Pollard; interior murals 1933 by Howard Chandler Christy; acquired 1975 by

restaurateur George Lang and subsequently restored.

GAGE & TOLLNER
372 Fulton Street
Brooklyn, NY 11201
Tel: 718 875 5181
Subway: 2/3, 4/5, F and A trains to Fulton Street, Borough Hall
Open: daily lunch 11.30am-3pm
dinner Mon-Thur 5pm-10pm
Fri, Sat 5pm-11pm
Sun 5pm-9pm
Opened 1892 under management of Charles M Gage and Eugene Tollner, who previously ran a restaurant of the same name nearby, founded 1879; building designated 1974; interior designated 1975; atmospheric dining room with many original fittings and furnishings.

THE AIRLINE DINER
Now Jackson Hole Wyoming
69-35 Astoria Boulevard
Astoria, NY 11375
Tel: 718 204 7070
Subway: N train to Astoria Boulevard (then walk)
Open: Mon-Thur 5am-1am, Fri 5am-3am
Sat 7am-3am, Sun 7am-1am
Built 1954 by Mountain View Diner Company in New Jersey; originally sited nearer La Guardia airport; transferred to present location 1957; recently restored.

MCSORLEY'S OLD ALE HOUSE
15 East 7th Street
New York, NY 10003
Subway: 6 train to Astor Place
Open: Mon-Sun 11am-1am
Originally McSorley's Saloon, opened 1854; original bar room and rear dining room little changed since nineteenth century.

HOTELS

THE CHELSEA HOTEL
222 West 23rd Street
New York, NY 10011
Tel: 212 243 3700
Subway: 1/9 trains to 23rd Street
No public access to manager's office
Originally Chelsea Apartments, built 1883 by Hubert, Pirsson & Co; converted for use as hotel 1905; the eleven-storey staircase with wrought iron balustrade, and the Artistic Style decoration in manager's office are particularly spectacular.

THE PLAZA
Fifth Avenue at 59th Street
New York, NY 10019

Tel: 212 759 3000
Subway: N/R trains to Fifth Avenue, 4/5/6 trains to 59th Street
Built 1905-07 by Henry J Hardenbergh; French *château* exterior designated 1969; interiors recently refurbished.

THE CARLYLE
35 East 76th Street
New York, NY 10021
Tel: 212 744 1600
Subway: 6 train to 77th Street
Built 1929-30 by Bien & Prince; extensively remodelled; sequence of frescoed interiors, including Bemelman's Bar.

ST REGIS-SHERATON HOTEL
2 East 55th Street
New York, NY 10019
Tel: 212 753 4500
Subway: E/F trains to Fifth Avenue or 6 train to 51st Street
Completed 1904 to designs of Trowbridge and Livingston for John Jacob Astor; restored 1988-91 by architects Brennan, Beer, Gorman in association with Graham Design; exterior designated 1988; of special note: the lobby, Old King Cole Bar, and Louis XVI-style reception rooms on the first floor.

HELMSLEY PALACE HOTEL
455 Madison Avenue
New York, NY 10022
Tel: 212 888 7000
Subway: 6 train to 51st Street or E/F trains to Lexington/3rd Avenue
Originally Villard Mansion, built 1883-6 by McKim, Mead & White; exterior designated 1968; principal interiors restored by Helmsley Corporation for use as hotel reception rooms; outstanding craftsmanship and design.

THE ROYALTON HOTEL
44 West 44th Street
New York, NY 10036
Tel: 212 869 4400
Subway: B/D/F Train to 42nd Street
Circular Bar open: 5pm-midnight
Built 1898; refurbished 1988 under supervision of Ian Schrager and Steve Rubell in consultation with Philippe Starck.

THE PARAMOUNT HOTEL
235 West 46th Street
New York, NY 10036
Tel: 212 764 5500
Subway: A/C/E trains to 42nd Street, 1/9, 2/3, 7, N/R trains to Times Square
Originally Century Paramount Hotel designed by Thomas Lamb, inaugurated 1927; exterior restored and interior remodelled by Ian Schrager and partners;

interior designer Philippe Starck; highlights include foyer, lobby, restrooms and children's playroom.

CLUBS AND INSTITUTIONS

PELHAM-SPLIT ROCK GOLF CLUB
870 Shore Road
Bronx, NY 10464
Tel: 212 885 1258
Subway: 6 train to Pelham Bay Park; then bus W45 or taxi
Public course. Open: daily dawn-dusk
Built c.1931; Art Deco interiors on first floor; ground-floor lobby with surrealist murals by Allan Saalburg.

RACQUET AND TENNIS CLUB
370 Park Avenue
New York, NY 10010
Tel: 212 753 9700
Subway: 6 train to 51st Street
Open to members and guests only
Built 1916-18 in the image of a sixteenth-century Florentine *palazzo* designed by McKim, Mead & White in sober wartime mood; exterior designated 1979.

COSMOPOLITAN CLUB
122 East 66th Street
New York, NY 10021
Tel: 212 734 5950
Subway: 6 train to 68th Street
Open: to members and guests only
Built 1932 by Thomas Harlan Elett; highlights include staircase hall, Neo-Empire Library, Dining Room and Ball Room.

LOTOS CLUB
5 East 66th Street
New York, NY 10021
Tel: 212 737 7100
Subway: 6 train to 68th Street
Open to members and guests only
Originally Margaret Vanderbilt Shepard residence, built 1898-1900 by Richard Howland Hunt; occupied since 1946 by Lotos Club; highlights include staircase and ground-floor dining room with chimney-piece carved by Karl Bitter.

ELKS LODGE
82-10 Queens Boulevard
Elmhurst, NY 111373
Tel: 718 639 4000
Subway: E/F, G or R trains to Elmhurst Avenue
Open to members and guests only
Built 1923; behind Italianate facade interiors include Adamesque dining room with orchestra stand, mahogany and stained-glass bar room, functioning

bowling alley and the extraordinary assembly hall in Mayan/Incan style.

MONTAUK CLUB
25 Eighth Avenue
Brooklyn, NY 11217
Tel: 718 638 0800
Subway: D/Q trains to 7th Avenue or 2/3 trains to Grand Army Plaza
Open to members and guests only
Built 1891 by prominent New York architect Francis H Kimball; many outstanding interior features, notably in entrance foyer and principal apartment on ground and first floors.

CLOUD CLUB
Chrysler Building
405 Lexington Avenue
New York, NY 10174
Subway: 4/5/6 trains or 7 train to Grand Central Station/42nd Street
No public access
Situated on 66th-68th floors of Chrysler Building, sequence of interiors designed c.1929 by William Van Alen in association with Myers, Mindt & Co.

UNIVERSITY CLUB
1 West 54th Street
New York, NY 10019
Tel: 212 247 2100
Subway: E/F trains to Fifth Avenue, B/Q trains to 57th Street
Open to members and guests only
Built 1897-9 by McKim, Mead & White. Florentine *palazzo* exterior encasing eclectic sequence of sumptuously decorated interiors. Designated 1967.

CLUB EL MOROCCO
307 East 54th Street
New York, NY 10022
Tel: 212 750 1500
Subway: E/F trains to Lexington Avenue/3rd Avenue
Nightclub open to the public
Tue 6pm-4am
Fri, Sat 10pm-4am

Founded 1932; designer unknown; original decor embellished but little changed.

NATIONAL ARTS CLUB
15 Gramercy Park South
New York, NY 10010
Tel: 212 475 3424
Subway: 6 train to 23rd Street
Open to members and guests only
Originally built as private residence in 1845, remodelled 1881-4 for Samuel Tilden by Calvert Vaux in association with John La Farge; adapted as clubhouse for National Arts Club by Charles Rollinson Lamb 1906; exterior designated 1966.

DOMESTIC INTERIORS

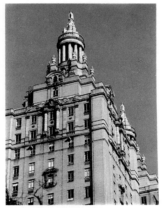

THE SAN REMO
145-6 Central Park West
New York, NY 10023
Subway: A/B/C trains to 72nd Street
Private residence
Built 1929-30 by Emery Roth; exterior designated 1987; twin Pueblo Deco lobbies with Adamesque trim.

STEINWAY MANSION
Private address
Built c.1858 for scientific instrument manufacturer Benjamin T. Pike Jr; architect unknown; sold following Pike's death to piano manufacturer William Steinway c.1870; acquired by Halberian family 1926; restoration program undertaken 1978 but since suspended; exterior designated 1967.

PARK PLAZA APARTMENTS
1005 Jerome Avenue
Bronx, NY 10452
Subway: 4 train to Jerome Avenue and 170th Street
Private residence
Built 1928-31 by Marvin Fine and Horace Ginsberg; exterior designated 1981.

THE ELDORADO
300 Central Park West
New York, NY 10024
Subway: A/B/C trains to 86th Street
Private residence
Built 1929-31 by architects Margon & Holder in consultation with Emery Roth; exterior designated 1985.

ROCKEFELLER RESIDENCE
Philip Johnson House
242 East 52nd Street
New York, NY 10022
Subway: 6 train to 51st Street
Private residence
Modernist town house, built in shell of 1860s coachhouse, commissioned by Rockefeller family and designed by Philip Johnson, 1950; subsequently presented to Museum of Modern Art for use as guest house; since reinstated as private residence.

43 FIFTH AVENUE
43 Fifth Avenue
New York, NY 10003
Subway: B/F trains to 14th Street, L, N/R, 4/5/6, Q/B trains to Union Square
Private residence
Built 1903-05 to designs of Henry Andersen, architect of the Semiramis apartment building; Parisian-style exterior with hybrid lobby blending late Gothic and Rococo.

34 GRAMERCY PARK EAST
34 Gramercy Park East
New York, NY 10010
Subway: 6 train to 23rd Street
Private residence
Originally the Gramercy Park Hotel, built 1883 to designs of George W da Cunha; subsequently converted to use as apartment building; elaborate lobby (visible from street), with some surviving features within.

7 GRACIE SQUARE
7 Gracie Square
New York, NY 10028
Subway: 4/5/6 trains to 86th Street
Private residence
Built 1929 with muralist Arthur Crisp as design consultant.

THE OSBORNE
205 West 57th Street
New York, NY 10019
Subway: N/R trains to 57th Street, B/D/E trains to Seventh Avenue
Private residence
Completed 1885 to designs of James E Ware and sculptor and painter Jacob Adolphus Holzer; opulent entrance foyer and lobby retaining original Byzantine Revival decoration.

INDEX

Page numbers in italics refer to illustrations

Airline Diner, *88, 89,* 89, 126
Appellate Courthouse *22,* 22, *23,* 123
AT&T Building 8, 55, *56,* 125
AT&T Building (former)
 see 195 Broadway
Bailey Residence
 see M Marshall Blake Funeral Home
Barclay-Vesey Building *44,* 45, 124
Belmont Madison Building *46,* 47, 124
Bemelman's Bar
 see Carlyle Hotel
Bleeker subway station *41,* 42, 124
Borough Hall subway station *41,* 41, 124
Bowery Savings Bank *24, 25,* 25, 123
Broadway Barbershop *38,* 38, 124
Broadway, no. 195 *52,* 53, 125
Bronx Community College
 see Gould Memorial Library
Brooklyn Museum
 see The Moorish Room
Burden Mansion
 see Convent of theSacred Heart
Café des Artistes *84, 85,* 85, 126
Carlyle, The *94,* 94, 126
Chanin Building 12, 13, *54, 55,* 55, *125,* 125
Chelsea Hotel *92,* 93, 126
Chrysler Building *4,* 4, 8, *49,* 50, 124
Church of the Most Precious Blood 76, 77, 126
City Hall *1,* 4, 9, 12, *19,* 20, 123
City Hall subway station *40,* 41, 124
Cloud Club (Chrysler Building) *106,* 106, 127
Columbia University subway station 41, *42,* 124
Convent of the Sacred Heart (Burden Mansion) 66, *67, 68-9,* 125
Convent of the Sacred Heart (Kahn Mansion) *60,* 61, 125
Cosmopolitan Club *102,* 102, 127
Cottage The
 see King's County Savings Bank
DeLamar Mansion
 see Polish People's Republic, Consulate General of the
Dime Savings Bank *28, 29,* 29, 123
El Morocco Club *108,* 108, 127
Eldorado, The 114, *115,* 127
Eldridge Street Synagogue 77, *78, 126,* 126
Elks Lodge *104,* 105, 127

Exspo *82,* 83, 126
Fabbri Mansion
 see Johnson O'Connor Research
 Foundation
Fifth Avenue, no 43 *117,* 117, 127
Film Center Building *53,* 53, 125
Friends Meeting House 9, *80,* 80, 126
Fulton Street subway station 41, *42,* 124
Gage & Tollner *86,* 86, 126
GE Building
 see RCA Building
General Electric Building *50,* 50, *51,* 125
Goelet Building
 see Swiss Center Building
Gould Memorial Library (Bronx Community College) 12, 61, *62,* 125
Gracie Square, no. 7 118, *119,* 127
Gramercy Park East, no. 34 *118,* 118, 127
Grand Central Station 9, 42, *43,* 124
Hall of Fame (Bronx Community College) 61, 125
Hall of Records
 see Surrogate's Court
Helmsley Palace Hotel *96,* 96, 126
Hollings' (working men's club)
 see Exspo
Irving Trust Building 12, *27,* 27, 123
Johnson O'Connor Research Foundation *66,* 66, 125
Kahn Mansion
 see Convent of the Sacred Heart
King's County Savings Bank *29,* 29, 124
Loew's 175th Street Theater *74, 75,* 75, *125,* 125
Loew's Paradise Theater *70,* 71, 125
Lotos Club *102, 103,* 127
M Marshall Blake Funeral Home *37,* 37, 124
Mark Hellinger Theater *2,* 4, 123
McGraw Rotunda (New York Public Library) *endpapers,* 4, 31
McSorley's Old Ale House *90,* 90, 126
Montauk Club *105,* 105, *127,* 127
Moorish Room (Brooklyn Museum) 32, *33,* 124
National Arts Club *110,* 110, *111,* 127
New School for Social Research *63, 64,* 64, *65,* 125
New York County Courthouse
 see Tweed Courthouse
New York Public Library *endpapers,* 9, *30,* 31, 124

Osborne, The 12, *120,* 120, 127
P J Clarke's Bar *83,* 83, *126,* 126
Paramount Hotel 12, *99,* 99, 126
Park Plaza Apartments *114,* 114, 127
Pelham-Split Rock Golf Club *100,* 101, 127
Philip Johnson House
 see Rockefeller Residence
Pierpont Morgan Library *34,* 34, *35, 124,* 124
Plaza, The *93,* 93, 126
Polish People's Republic, Consulate General of the *16,* 17, *123,* 123
Racquet and Tennis Club *101,* 101, 127
Radio City Music Hall *71,* 71, 125
RCA Building (now GE Building) 4, 123
RCA Victor Building
 see General Electric Building
Rockefeller Residence *116,* 117, 127
Royalton Hotel *98,* 99, 126
Sailor's Snug Harbor Music Hall *72,* 72, *72-3,* 125
St Paul's Chapel 9, *77,* 77, 126
St Regis-Sheraton Hotel *95,* 95, 126
San Remo, The *112,* 113, *127,* 127
Seagram Building *45,* 45, 124
Seventh Regiment Armory 20, *21,* 123
Solomon R Guggenheim Museum *34,* 34, 124
Steinway Mansion *113,* 113, 127
Steinway Showroom *36,* 37, 124
Surrogate's Court *14, 15,* 15, 123
Swiss Center Building 12, 47, *48,* 124
Times Square Church
 see Mark Hellinger Theater
Trinity Church *79,* 80, 126
Tweed Courthouse *20,* 20, 123
United Church
 see Loew's 175th Street Theater
University Club *106,* 106, *107,* 127
US Bankruptcy Court *17,* 17, *18 ,* 123
US Custom House
 see US Bankruptcy Court
Van Cortlandt Mansion *32,* 32, 124
Villard Mansion
 see Helmsley Palace Hotel
West 116th Street subway station 41, *42,*
Williamsburgh Savings Bank *26,* 26, 123
Woolworth Building 7, 12, *58,* 58, *59,* 125

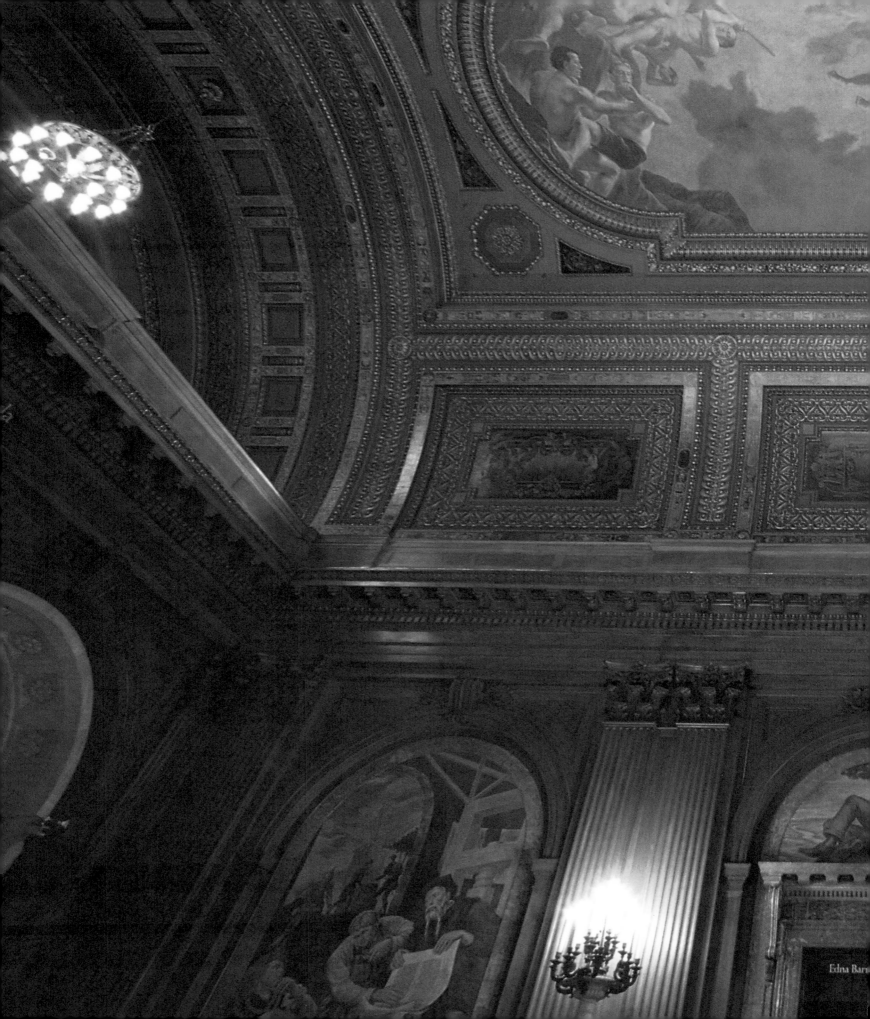